# Graphic Novels and Visual Cultures in South Asia

*Graphic Novels and Visual Cultures in South Asia* explores the shifting landscapes of the graphic narratives and related visual cultures scene in South Asia today.

This exciting volume explores the ever-developing scene of graphic novels, graphic narratives and related visual cultures in South Asia. Covering topics such as Tamil comics, material memory, the politics of graphic adaptation, the fandom of *Ms. Marvel* as well as watching Pakistani social lives on Indian TV, this collection of essays are testament to how visual cultures across South Asia are responding to a new world order. The collection examines how certain visual cultures in South Asia are attempting to re-shape previous modes of visuality by unpacking what it means to be living in South Asia today.

Through its inclusion of articles, visual essays and in-conversation pieces, this book offers insight into the ways in which this narrative is unfolding, the kind of stories which are being told and how, in telling these stories, South Asian society is called upon to engage and crucially, to react to what we see, how and why we see it.

This book was originally published as a special issue of the *South Asian Popular Culture* journal.

**E. Dawson Varughese** is an Independent Scholar and a Senior Fellow at Manipal Centre for Humanities, India. She publishes on Indian genre fiction in English, see *Genre Fiction of New India: Post-Millennial Receptions of "Weird" Narratives* (Routledge), as well as on public wall art and Indian graphic narratives. Further information about her work can be found at beyondthepostcolonial.com and seeingnewindia.com.

**Rajinder Dudrah** is a Professor of Cultural Studies and Creative Industries in the School of Media, Birmingham City University, UK. He has researched and published widely across film, media and cultural studies. His books include, amongst others, *Bollywood Travels: Culture, Diaspora and Border Crossings in Popular Hindi Cinema* (Routledge). He is also the founding Co-Editor of the journal *South Asian Popular Culture*.

# Graphic Novels and Visual Cultures in South Asia

*Edited by*
E. Dawson Varughese and Rajinder Dudrah

Routledge
Taylor & Francis Group

LONDON AND NEW YORK

First published 2020
by Routledge
2 Park Square, Milton Park, Abingdon, Oxon, OX14 4RN

and by Routledge
52 Vanderbilt Avenue, New York, NY 10017

*Routledge is an imprint of the Taylor & Francis Group, an informa business*

© 2020 Taylor & Francis

*British Library Cataloguing-in-Publication Data*
A catalogue record for this book is available from the British Library

ISBN13: 978-0-367-43711-4

Typeset in Minion Pro
by codeMantra

**Publisher's Note**
The publisher accepts responsibility for any inconsistencies that may have arisen during the conversion of this book from journal articles to book chapters, namely the inclusion of journal terminology.

**Disclaimer**
Every effort has been made to contact copyright holders for their permission to reprint material in this book. The publishers would be grateful to hear from any copyright holder who is not here acknowledged and will undertake to rectify any errors or omissions in future editions of this book.

# Contents

*Citation Information*                                                                 vii
*Notes on Contributors*                                                                ix

Introduction                                                                            1
*E. Dawson Varughese and Rajinder Dudrah*

1  Graphics of the multitude: reading figure and text in
   *Drawing from the City*                                                             6
   *Filippo Menozzi*

2  Development narratives, media and women in Pakistan:
   shifts and continuities                                                            18
   *Shirin Zubair*

3  Diasporic (dis)identification: the participatory fandom of *Ms. Marvel*            32
   *Winona Landis*

4  Visualising caste: *A Gardener in the Wasteland* and the politics of
   graphic adaptation                                                                47
   *Deepali Yadav*

5  Watching *Zindagi*: Pakistani social lives on Indian TV                            59
   *Spandan Bhattacharya and Anugyan Nag*

6  War Cry of the Beggars: an exploration into city, cinema
   and graphic narratives                                                            71
   *Madhuja Mukherjee*

7  Remnants of a separation: *a ghara and a gaz: from Lahore to
   Amritsar to Delhi*                                                                86
   *Aanchal Malhotra*

8  Tamil comics: new media, revival, and the recovery of history                     98
   *Swarnavel Eswaran Pillai*

CONTENTS

9 'IMPOSTERS': an interview with graphic artist and
designer Orijit Sen 107
*E. Dawson Varughese*

*Index* 117

# Citation Information

The chapters in this book were originally published in the journal *South Asian Popular Culture*, volume 14, issue 1–2 (April–July 2016). When citing this material, please use the original page numbering for each article, as follows:

**Introduction**
E. Dawson Varughese and Rajinder Dudrah
*South Asian Popular Culture*, volume 14, issue 1–2 (April–July 2016) pp. 1–5

**Chapter 1**
*Graphics of the multitude: reading figure and text in* Drawing from the City
Filippo Menozzi
*South Asian Popular Culture*, volume 14, issue 1–2 (April–July 2016) pp. 7–18

**Chapter 2**
*Development narratives, media and women in Pakistan: shifts and continuities*
Shirin Zubair
*South Asian Popular Culture*, volume 14, issue 1–2 (April–July 2016) pp. 19–32

**Chapter 3**
*Diasporic (dis)identification: the participatory fandom of* Ms. Marvel
Winona Landis
*South Asian Popular Culture*, volume 14, issue 1–2 (April–July 2016) pp. 33–47

**Chapter 4**
*Visualising caste:* A Gardener in the Wasteland *and the politics of graphic adaptation*
Deepali Yadav
*South Asian Popular Culture*, volume 14, issue 1–2 (April–July 2016) pp. 49–60

**Chapter 5**
*Watching* Zindagi: *Pakistani social lives on Indian TV*
Spandan Bhattacharya and Anugyan Nag
*South Asian Popular Culture*, volume 14, issue 1–2 (April–July 2016) pp. 61–72

## Chapter 6

*War Cry of the Beggars: an exploration into city, cinema and graphic narratives*
Madhuja Mukherjee
*South Asian Popular Culture*, volume 14, issue 1–2 (April–July 2016) pp. 73–87

## Chapter 7

*Remnants of a separation*: a ghara and a gaz: from Lahore to Amritsar to Delhi
Aanchal Malhotra
*South Asian Popular Culture*, volume 14, issue 1–2 (April–July 2016) pp. 89–100

## Chapter 8

*Tamil comics: new media, revival, and the recovery of history*
Swarnavel Eswaran Pillai
*South Asian Popular Culture*, volume 14, issue 1–2 (April–July 2016) pp. 101–109

## Chapter 9

*'IMPOSTERS': an interview with graphic artist and designer Orijit Sen*
E. Dawson Varughese
*South Asian Popular Culture*, volume 14, issue 1–2 (April–July 2016) pp. 111–119

For any permission-related enquiries please visit:
http://www.tandfonline.com/page/help/permissions

# Contributors

**Spandan Bhattacharya** works with the Department of Film Studies, Jadavpur University, Kolkata, India as a Postdoctoral Research Fellow.

**Rajinder Dudrah** is a Professor of Cultural Studies and Creative Industries in the School of Media at Birmingham City University, UK.

**Winona Landis** is a Visiting Assistant Professor of Asian/Asian American Studies at Miami University, Ohio, USA.

**Aanchal Malhotra** is an independent oral historian working with memory and material culture, based in New Delhi, India.

**Filippo Menozzi** is a Lecturer in Postcolonial and World Literature at Liverpool John Moores University, UK.

**Madhuja Mukherjee** is an Associate Professor in the Department of Film Studies at Jadavpur University, India.

**Anugyan Nag** is Assistant Professor of Film, Media and Cultural Studies at AJK Mass Communication Research Center, Jamia Millia Islamia University, New Delhi.

**Swarnavel Eswaran Pillai** is an Associate Professor in the Departments of English, and Media and Information at Michigan State University, East Lansing, USA.

**E. Dawson Varughese** is an Independent Scholar and a Senior Fellow at Manipal Centre for Humanities, India.

**Deepali Yadav** is an Assistant Professor in the English Department at Banaras Hindu University, Varanasi, India.

**Shirin Zubair** is Professor of English and Linguistics at Kinnaird College for Women, Lahore, Pakistan.

# Introduction

E. Dawson Varughese ⓘ and Rajinder Dudrah ⓘ

The post-millennial years have been witness to significant developments in the field of popular visuality in South Asia. For India at least, a liberalised economy, advancements in digital technology, satellite television, urban beautification projects and a publishing boom have all shaped what we see, how we see it and why we see it. From the enormous, roadside posters advertising a television serial's next cliffhanger, the special effects of Anubav Sinha's 2011 blockbuster *Ra.One* to the social messaging of public wall art in Mumbai, Indians are being called to see more, and to see differently. Other South Asian countries are experiencing similar trajectories in terms of what is seen and also how it is seen; Pakistan's television serials have travelled beyond the country's own transmission circuit, Bangladesh is nurturing an emerging graphic narrative scene and in Sri Lanka, visual practices in the field of modern art are involved in remembering and narrating post-conflict society.

Across South Asia and particularly within India, it has been argued that the role of visuality is defining given that the concepts of *darshan* and *drishti* (as ideas of 'seeing' or 'gazing') are often at the heart of Hindu modes of haptic visuality (see Ramaswamy xxv), and the same can also be said of broader (non-Hindu) Indian and thus broader South Asian cultural practices in a related haptic notion such as *nazar*. Transcending language and ethnic or religious belonging, 'seeing' in South Asia is more than simply looking upon or gazing, Bhatti and Pinney (224–40) write:

> Vision in South Asia, it seems, has never been concerned with just looking: it has always sought in many arenas to incorporate other senses and emotions, uniting vision with the somatic while concurrently diminishing the distance between subject and object. (Bhatti and Pinney 227)

Moreover, Freitag (366–97) suggests that the visual realm is a critical component in South Asian modernity because 'acts of seeing become acts of knowing as viewers/consumers impute new meanings to familiar images' (Freitag 366). Such a process enables change to take place and this is particularly important when societies are evolving at pace, which has been and continues to be the case for post-millennial India and for parts (such as urban centres) of the wider South Asia region. Globalisation, increased domestic and international travel, regional partnerships and changes to society in terms of education, job opportunities and shifting perceptions of women's roles have all contributed to the field of visuality in new and often unanticipated ways.

Although this Special Issue explores a range of visual cultures and practices, the graphic novel as a material mode of 'seeing' is discussed in some detail. There can be no doubt that the Indian graphic novel in particular is a site where the process described above by Freitag is enacted. It is thus a site where old and new modes of visuality confer and where India is represented anew but often in an uncomfortable or an inauspicious manner. This new trajectory of text–image production has partly come out of a tradition of Indian comics combined with heightened consumerism in South Asia, particularly in India following the liberalisation of the economy, felt most intensely post-2000. This moment where competing factors have been at play has allowed the graphic novel to develop and grow to find a unique voice and an ever-expanding domestic readership, including an increasingly international one too. The public and popular nature of these new modes of visuality must not be ignored, whether television serials, films, posters or animation, the visual is almost always '*material in nature*' (Freitag, 399–9) and in this respect, the graphic novel format is no exception. Freitag (399–9) says that:

> [i]mages – whether framed, viewed as bound objects, or recombined on a wall by owners/viewers [ … ] involve vision and the gaze; thus it is important to remember that 'the *handling* of an object, or *interactions* of bodies' are equally important aspects to consider when we talk about visuality (Freitag 399, original emphases).

The material object that is the graphic novel clearly embodies the visuality that Freitag invokes here, given the 'handling' of the graphic novel that takes place whilst 'consuming' it. The graphic novel therefore marks out this realm of the visual as different from the interactions with television serials, films or other media. Furthermore, the graphic novel anchors itself in the moment, in the publishing scene of the contemporary moment and thus acts as and indeed is a cultural and literary 'product' of our times. Importantly, the economic changes and development over the last 10 years in the region have significantly impacted the publishing scene of which Narayanan (77–112) describes as the new de/reterritorialisation (Narayanan, 107) of publishing houses. Citing the example of Penguin, she writes:

> No longer identified as just a UK-based company, the publisher is regarded as a 'worldwide' corporation since its locations are spread across the US, Canada, the UK, Ireland, Australia, New Zealand, India, South Africa and China. This polycentric configuration has made it possible for books, like other commercial products, to be produced, designed, translated and marketed across the world. (Narayanan 107)

Other such publishing companies with an office in India include HarperCollins India and Hachette India – both have significantly grown their graphic novel catalogues in the last 10 years – but as Narayanan warns, 'if the global visuality of Indian writers is a significant consequence of de/reterritorialized corporations, its most adverse effect is the hegemony of these corporations as the prime global producers of Indian writing' (Narayanan 107). In a complementary move of sorts, the independent presses of India have also flourished under this post-millennial sky and are heavily involved in the proliferation of genre fiction with some publishing short- and full-length graphic novels.

The appetite in South Asia for comics and graphic novels is nascent in Bangladesh and Nepal but is clearly gathering pace in India, and their representation within this Special Issue is testament to this trend. The graphic novel and comics' production referred to in this issue of *SAPC* talks to and of the legendary *Amar Chitra Katha* comic series of the 1970s and 1980s. Introduced in 1967, the publications concerned themselves with Indian epics as well as the *Puranas*, classics from Indian literature, fables and humour as well as

stories of Indian brave hearts and visionaries. The post-millennial years however have brought about a sea-change in the way India recognises and indeed defines its comic and graphic novel production. The growing number of independent comic and graphic novel presses, the diverse and challenging array of narrative, as well as the quality of production and print, have meant that Indian graphic novels (and comics) are unrecognisable when compared to the *Amar Chitra Katha* works of the 1970s and 1980s. Borne out of Orijit Sen's revolutionary *River of Stories* (1994), these post-millennial Indian graphic narratives often pursue difficult topics, they engage critically with Indian cultural practices and traditions and have even brought taboo subjects to light through the text–image medium. The difficulty of the content is echoed through the graphic narratives' craft and artistic styles; stark lines, heavily inked drawings, sketchy amorphous characterisation and non-linear narrative forms all coalesce in order to imagine the unimaginable, the inauspicious and the reality of old and new India, in all its pluralities. These 'uncomfortable' depictions of India (and Indian cultural practices) are in complete divergence from the *Amar Chitra Katha* tradition which celebrated India and Indianness through bold colours, neat line drawings and auspicious iconography found particularly in public calendar art and religious imagery (see Jain, 160–85). The graphic novel's 'double marginality' in terms of form and content allows for a certain creativity through which unsavoury or inauspicious representations of Indian society are communicated (see Dawson Varughese, 495–9) and thus demand new ways of 'seeing' beyond the darśanic.

The pluralities of India and the South Asia region, with its contradictions and possibilities of modern living alongside older practices and customs across the region are brought into sharp relief in the collection of essays presented here. Through the graphic novel and other related visual forms, one of the tasks we set ourselves as artists, scholars, practitioners, readers and fans was to explore how best might we articulate a sense of situating and critically reading some of the products in this arena? To this end, Filippo Menozzi uses the graphic novel *Drawing from the City* to argue for and illustrate a specific aesthetic that can be seen in this graphic fiction and literature about caste. Menozzi demonstrates the multiplicity of caste lives and capital labour alongside understandings about caste exploitation and social agency to offer readings about the individual and the collective as embedded in the aesthetic. Using the case of the Pakistani TV drama *Uraan*, Shirin Zubair illustrates a complex aesthetic at work in the series which simultaneously represents Pakistani women's agency in the public sphere, while also still offering ambivalent possibilities about femininity in the developing South Asian urban context. From the South Asian subcontinent to the international and diasporic space of South Asian lives in the USA, Winona Landis offers a compelling reading of *Ms. Marvel*, featuring its teenager South Asian American Muslim leading protagonist. Drawing on work around fans of popular genres as readers and consumers of visual and literacy texts, Landis goes on to argue beyond the South Asian-Americanness of the Ms Marvel figure as being able to appeal cross-racial identifications. Deepali Yadav poses the question of how a graphic representation of caste might work in the contemporary Indian context, not least when it involves the adaptation of a nineteenth-century novel based around caste as slavery? By considering the visual depictions of caste in the present she poses a prescient question for us – what connections and possibilities does this render for our understanding of caste in the past and present? Spandan Bhattacharya and Anugyan Nag in their analysis of tele-serials from Pakistan aired on Indian television illustrate the possibilities for a changing visual landscape of Pakistani and Muslim representations in

India, not least in the context of a contemporary BJP-led political public sphere. Madhuja Mukherjee critically reflects as an artist and practitioner of the graphic novel form on the processes involved in creating her own graphic novel in Bengali, *War Cry of the Beggars*. The ways in which literary style, cinematic evocation and sequential art are used and brought into dialogue with each other are given careful attention, as well as the political content of the social outsider within the text.

In the Working Notes section we offer three contemplative, artistic, commentary-based and interview pieces by Aanchal Malhotra on Partition through memory and material objects, Swarnavel Pillai on the revival and related historical overview of Tamil comics, and an interview with one of the founding and leading proponents of the graphic novel form in India, Orijit Sen, by Emma Varughese. Collectively, what is presented in this Special Issue is a juxtaposition of form and content of graphic novels and visual culture in terms of their aesthetics, forms of production, their possible critical readings, and the different relationships and points of intersections across text, genres, different media and the cultural politics that they occupy amongst artists, practitioners of the form, fans and readers, scholars and consumers. These configurations chart how visual cultures across South Asia are responding to a new world order. At times these visual cultures attempt to re-shape previous modes of visuality by elaborating on what it means to be living in South Asia and across its connected global cultural politics today. Thus, this Special Issue offers some insight into the ways in which this narrative is unfolding, the kind of stories which are being told and how, in telling these stories, society is called upon to engage and crucially, to react to what we see, how and why we see it.

## Disclosure statement

No potential conflict of interest was reported by the authors.

## ORCID

*E. Dawson Varughese* http://orcid.org/0000-0001-6337-4462
*Rajinder Dudrah* http://orcid.org/0000-0002-0295-724X

## References

Bhatti, Shaila, and Christopher Pinney. "Optic-Clash: Modes of Visuality in India." *A Companion to the Anthropology of India*. Ed. Isabelle Clark-Decès. West Sussex: Wiley-Blackwell Publishing, 2011. 223–240.

Dawson Varughese, E. "'The Cracks of Post-Liberalized India': Storying the 'New Society' through Banerjee's *The Harappa Files* (2011), in 'Trans/forming Literature: Graphic Novels, Migration, and Postcolonial Identity." *Journal of Postcolonial Writing* 52.4 (2016): 494–509.

Freitag, S. "The Realm of the Visual: Agency and Modern Civil Society." *Beyond Appearances? Visual Practices and Ideologies in Modern India*. Ed. Sumathi Ramaswamy. New Delhi: Sage, 2003. 365–397.

Freitag, S. "The Visual Turn: Approaching South Asia Across the Disciplines." *South Asia: Journal of South Asian Studies* 37.3 (2014): 398–409.

Jain, K. "The Efficacious Image: Pictures and Power in Indian Mass Culture." *Polygraph* 12 (2000): 159–185.

Narayanan, P. *What are You Reading?: The World Market and Indian Literary Production London*. New York: Routledge, 2012. 76–112.

Ramaswamy, S., ed. *Beyond Appearances? Visual Practices and Ideologies in Modern India*. New Delhi: Sage, 2003. 365–397.

# Graphics of the multitude: reading figure and text in *Drawing from the City*

Filippo Menozzi

**ABSTRACT**

This essay interrogates the question of reading graphic novels from South Asia by proposing the analysis of *Drawing from the City*, the visual autobiography of Teju Behan, a contemporary artist from Rajasthan. The essay introduces the text and the author, who belongs to Jogi, a group classified as one of the 'other backward classes' in contemporary India. Instead of treating the book as ethnographic document or simple social testimony, this essay argues that Teju's narrative needs to be understood in its aesthetic dimension. Teju Behan is hence shown as an artist concerned with the passage from casteised labour to artistic work, and the possibility of linking individual experience to the formation of a collective. Indeed, a striking element of Teju's visuals is the use of artistic expression to envisage a multitude. From this point of view, the graphics are affiliated to the concept of art as 'liberated labour' necessary to the making of the multitude proposed by Italian philosopher Antonio Negri. In conclusion, this reading interprets *Drawing from the City* as an intense meditation on art and the possibilities of resistance to marginality.

> Art can only live within a process of liberation. Art is, so to speak, always democratic – its productive mechanism is democratic, in the sense that it produces language, words, colours and sounds which pull together into communities, new communities … in order to construct art, we have to construct liberation in its collective figure. (Negri 51)

*Drawing from the City* is a graphic narrative produced by Tara Books, an independent publisher based in Chennai, in 2012. Tara is specialised in works by Adivasi writers and this specific book is authored by Teju Behan, the wife of a devotional singer belonging to the Jogi caste, one of the 'other backward classes' that have traditionally occupied a 'subaltern position' in Indian society (Jaffrelot 86).[1] The book's main plot revolves around the life of Teju, who in her youth had to leave her native village in Rajasthan because of a drought. Teju moved to Ahmedabad where, after years of poverty, she encountered artist Haku Shah, who encouraged Teju's husband Ganesh to translate his musical performance into drawing. Teju followed Ganesh by becoming an artist herself. *Drawing from the City* is Teju's work, dedicated to the memory of her husband, who passed away during the production of the volume. The book consists of visual and written elements, and has been manufactured

with the help of Salai Selvam, V. Geetha and Gita Wolf, who contributed to the editing and translation of the oral narrative into written text.

*Drawing from the City* can be affiliated to other books disseminated by Tara, especially the visual narrative of tribal artists who emerged through the Pardhan Gond art movement initiated in the late 1980s. Like other authors published by Tara, the making of the text entails the transformation of oral tradition into visual narrative (Bowles 18–20). An important aspect of this work concerns its status as a book, now available to an international audience well beyond India, within what has been called a 'world literary space' of circulation and exchange (Casanova 82–102). By being bound into a book, Teju's visual narrative is disseminated globally. However, the pages of the volume bear the trace of modes and media of expression which transcend the limits of the written page, especially Teju and Ganesh's devotional songs. The text is, in itself, a work of translation, which attempts to reproduce on the written surface the songs and performances of the Jogi caste.[2] One of the main traditional economic activities of the Jogi is 'a routine practice of performing song fragments and implicitly protecting a village from several agricultural pestilences, in exchange for payment, traditionally uncooked flour, but more commonly other readily available foodstuffs or money' (Napier 86). Ethnomusicologist John Napier shows how Jogi caste was described in derogatory terms in colonial ethnographies and how their traditional occupation continues to be seen in unfavourable terms as a kind of 'begging' (Napier 87). *Drawing from the City* is a reflection on the figure of Teju herself, her passage from devotional singer to visual artist.

Reading this book, there needs to be an awareness of the distance that divides a reader outside India, only able to get access to Teju's experience through the medium of the book, from the real life that is represented through its pages. Yet, can critical writing become a way to bridge this distance? One of the most controversial issues in current global literary studies concerns the distinction between the idea of close reading, established as hallmark of English and Comparative Literature, and the exigency of techniques of 'distant reading', which contextualise works of literature within a global frame of reference, beyond the nation, able to place each individual work within the history and geography of a global modernity. Close reading is based on the individual text, but in order to 'understand the system in its entirety', writes Franco Moretti, we need to go beyond it and 'focus on units that are much smaller or much larger than the text: devices, themes, tropes – or genres and systems' (Moretti 48–49). As the Warwick Research Collective explain in *Combined and Uneven Development*, Moretti's intervention allows us to grasp world literature 'as neither a canon of masterworks nor a mode of reading … but as a system; and … this system is structured not on *difference* but on *inequality*' (7). World literature should not be reduced to a way of reading or a set of exemplary texts. World literature identifies a system of production that mirrors the material grounding of the global economy. Texts circulate – unevenly – in a worldly context of cultural and material reproduction. Within this systemic viewpoint, could close reading retain some value for grasping the unequal economic system that underlies the making of literary and artistic objects?

In the debate between close and distant reading – or text and system – a book like *Drawing from the City* shows that close reading is still crucial because artistic work takes the form of a textual object in order to circulate within an uneven global marketplace. The text cannot be separated from its material appearance in works and books, that is, objects of consumption. Yet, as Roland Barthes famously remarked in his reflections on text and work, the text is 'experienced only in an activity of production' (Barthes 157). The text, Barthes

remarks, 'decants the work … from its consumption and gathers it up as play, activity, production, practice' (162). By being circulated internationally, the productive activity of the text becomes, unavoidably, the commodity-form of literature. As with any commodity, so the distribution of the text as a book embodies 'the social relation of the producers' (Marx 165) as a quality of the final product. Confronted with the text as commodity, the activity of close reading may still be necessary as alternative to a simple 'consumption' of literature. Indeed, close reading can be the prerequisite for connecting the nuances of poetic expression to the materiality of artistic production. The concept of the text in current debates on world literature can be helpful to signal the crucial interaction between art as material activity and art as commodity or product. For this reason, the act of reading South Asian graphic novels needs to achieve both closeness to the text and the awareness of global capitalism as material horizon, paying attention to the problem of material work in world literature. My reflections aim to propose a response to the question of world literature as mode of material production by emphasising the work of reading as possible counterpart to the art of writing, and radical alternative to mere cultural consumption. As James Procter points out, there are important 'questions of both proximity *and* distance that remain crucial to reading after empire' (Procter 7): how can attention to form become the precondition for engaging with the global and uneven context of circulation of literature?

Teju Behan's drawings tell the story of her life, especially the passage from her native village to life in the city and then the discovery of drawing as a medium of expression. These images do not simply represent a caste-based religious practice in commodified, textual form; they are the creative and critical thoughts of Teju as an artist. Doing justice to the book involves being able to respond to the narrative presented in it, in order to retranslate it into the experience of the reader. The following analysis will offer a reading of images from *Drawing from the City*, including references to the explanatory notes, which are contributed by the editors and translators at Tara. In the conclusion, I will return to the initial reflection on reading South Asian visual narratives today.

## 1. Girls with bicycles, or, art as liberated labour

After describing her childhood in Rajasthan, Teju mentions the event of a drought that compelled her community to flee the region and move to the neighbouring state of Gujarat. Rajasthan is a 'chronically drought-prone area' (Bokil 4171), where water scarcity occurs cyclically every few years. In the recent past, some droughts have proven devastating, deeply affecting the livelihood of the region. The 2000 drought caused a near-famine, with ruinous social, economic and environmental consequences. *Drawing from the City* documents how drought compelled Teju to move away from her village. The book reports her journey by train and her arrival in the city, Ahmedabad, where she starts a new life. In the city, Teju marries Ganesh, a traditional devotional singer, whom Teju joins by becoming a singer herself. After a year in Mumbai Teju and Ganesh decide to return home because life conditions become too difficult. It is at this point of the narrative that the passage from singing to drawing is described as a life-changing element by Teju. One image of the book captures the transition: across two pages, dots and lines represent a crowd of women riding bicycles. The image is very dynamic, giving a sense of speed and movement, and yet there is no central subject, no main character. The space of the page is filled with dots and lines, faces, bodies, bicycles, without apparent hierarchy. There is neither foreground nor background.

Spatial coordinates are displaced by a swarming aggregate of human figures. The image is black and white, but the use of different intensities of lines and dots creates a sense of varying tonalities and concentrations of mass and colour. All human figures are staring at the reader. Below the image, the text provides an explanation, which is a transcript of Teju's oral narrative, composed originally in Tamil and translated in English by the editors of the book, V. Geetha and Gita Wolf:

> It is like magic. I sit in one place with paper and pen, and it is my hand that starts to move. Lines, dots, more lines, and more dots, and you have a picture. I can bring to life things that I have seen and known, but also things that I imagine. I can even bring the two together. (*Drawing* n.p.)

The image of the girls with bicycles is directly linked to the experience of drawing. The reason leading to the making of the image is explained by Teju, who says that she saw a girl on a bicycle going somewhere, and thus decided to represent a 'whole group of girls, all of them on the way somewhere' (*Drawing* n.p.). The image may seem simple, even playing with naivety and primitivism. There is no perspective, and pictures resemble tattoos or graffiti more than a drawing on paper. How can readers approach this image, as part of Teju's visual autobiography? The arrangement of textual and graphic representation provides two clear, unequivocal messages: the first one is about the 'magic' of drawing. The second one is about the subject: a girl on a bicycle turned into a crowd of girls staring back at the beholder of the image. I am going to consider these two aspects of the image.

Teju explains that drawing enabled her to depict real things alongside imagined ones. Drawing is hence implicitly different from any of the activities she did in her youth. Whereas devotional singing, her previous occupation, was linked to a casteised mode of survival, drawing allows a step beyond the immediate socio-economic context. Drawing brings the imagination and the real together. This may be reduced to a simple, even naïve reflection on the power of pen and paper, but it is in reality a deep reflection on the powers of artistic expression. The main quality of drawing is, according to Teju's explanatory note, 'the imagination'. And yet, Teju's decision to turn to drawing cannot be detached from her economic issues, caused by the unsustainability of devotional Jogi singing in contemporary India. A note in *Drawing from the City* explains that Ganesh and Teju became visual artists after their encounter with Haku Shah, an artist and anthropologist renowned for having promoted the inclusion of folk and tribal art into the Indian art scene. Drawing is today Teju's main work. And yet, what is the difference between caste-based devotional song and drawing for books that are commercially distributed worldwide?

Teju has become part of what is today an increasingly commodified art scene in India, where traditional forms of expression are caught into what Saloni Mathur describes as the 'merging of marketing and culture' (3) in the dissemination of contemporary Indian art. However, as Rashmi Varma remarks about the commercialisation of Pardhan Gond art, the inclusion of marginalised communities into the culture industry of Indian art is not simply reiterating economic exploitation. Varma writes:

> [T]he art itself offers an allegory, however partial and incomplete, of the process by which it enters the world and is both transformed by it and transforms it ... I depart from accounts that see Adivasi or indigenous art as having been simply ravaged and desecrated by commercialization; instead I look at how the art itself exposes that process of commodification and accumulation on a global scale, and offers resistance to it. (Varma 749)

Indeed, Teju's work testifies to a new economic regime, where devotional singing is unsustainable and the making of a Jogi visual narrative can attract the attention of readers globally.

As an artist, Teju has been inserted in what Pierre Bourdieu called the 'field of cultural production', a space where 'works of art exist as symbolic objects only if they are known and recognised, that is, socially instituted as works of art and received by spectators capable of knowing and recognising them as such' (Bourdieu 37). The symbolic aspect of works of art, hence, cannot be divided from the material production of the work inside a field of institutions, publishers, readers and critics able to receive Teju's visuals *as work of art*. Indeed, the interplay of image and text in the book testifies to the needs of an international audience: the text is written in English, and it introduces the context of Teju's work, her life-conditions and life story. The links between figure and word exhibit the making of Teju's activity through the channels of an uneven economic system of global dimensions. Teju's image of the girls with bicycles can be approached as a profound meditation on this process. The first thing that should be noted is that the image does not represent a scene of traditional life in the village, nor is it a denunciation of the impoverished life-conditions of 'other backward classes' in India. *Drawing from the City* does not claim to be portraying any essence of cultural authenticity, nor can it be understood as a political work reporting the harsh life-conditions of the Jogi, though aspects of culture and politics do enter into the narrative. The reader gets to know about Jogi devotional singing. Furthermore, there are images in *Drawing from the City* that provide a testimony of the precarious situation of Teju's community, and the displacement caused by social and environmental devastation in Rajasthan. Other images in the text witness the extreme poverty Teju had to endure while fleeing her native region, and the dispossession of the poor living in slums in Ahmedabad.

The image of the girls with bicycles, however, signals a change in the graphic narrative. From autobiography of a Jogi artist, the book becomes reflection on the possibilities of art: bringing the real and the imagination together. The scene of the crowd of girls is suggestive because it shifts *Drawing from the City* from being a work by an 'other backward class' artist to be a reflection on the differences between art and labour. Drawing is presented by Teju herself as a kind of 'magic', which is opposed to all forms of labour and occupation she had known before: gathering food in the forest, doing domestic work, working in fields, and singing for the coins that people throw at Jogi singers in the streets. Drawing is different because it still is a form of labour – she has to draw for a living – but it is, at the same time, a kind of work with extraordinary potentialities. The question that the image in Teju's book raises can be expressed as follows: what kind of activity is drawing? The question is inherent to the graphic narrative itself, because Teju meditates on it. The author provides a reflection on drawing as a life-changing experience, a new activity that is substantially different from her previous jobs. This does not mean that links to devotional singing are severed. Rather, it means that drawing enables Teju to reflect further on her status as an artist, bringing the imagination together with the everyday. *Drawing from the City* can be read, from this point of view, as a work of art, because the book envisages a kind of 'artistic' labour that is not entirely submitted to the poverty, displacement and marginality that Teju had to experience. Drawing becomes, in Teju's captivating narrative, liberated labour.

In a series of letter published with the title *Art and Multitude,* Italian philosopher Antonio Negri provided a redefinition of art as a liberated, disalienated labour that corresponds to the potentialities of drawing explored by Teju in her work. The aim of juxtaposing Negri's reflection on art to Teju's graphic narrative should not be mistaken for forcing Indian art within the strictures of Continental theory. Instead, a reading of *Drawing from the City* through the concepts of art and multitude developed by an Italian philosopher can be seen as a way of translating

the experience of the author into the experience of the reader. Instead of attributing Teju's expressive activity to the tradition of Hinduism or the ethnographic file on Jogi communities, my reading attempts to reflect on the transformation of Teju's labour from devotional singer to accomplished visual artist inserted in the global channels of circulation of late capitalism. As a graphic narrative, *Drawing of the City* embodies this passage from regional ethnographic context to global capital. The paradox of the situation captured by Teju in her picture of girls with bicycles is that her work becomes, at the same time, part of an economic regime of exploitation – as image that is printed, sold and reproduced – and yet a way of setting free creative abilities that are not exhausted by the re-appropriations of the art market.

Negri developed his concept of art as liberated labour in order to express a paradox that lies at the core of contemporary capitalism, in its abstract, cognitive, financial and neoliberal aspects. Negri writes that 'artistic labour is the index of human being's inexhaustible capacity to render being excedent – labour liberated … from the obligation of exploitation, from alienation to a boss, from servitude' (Negri 49). Artistic activity, indeed, as Teju's drawing makes clear, is work, productive action. The acts producing the pictures that compose the book, *Drawing from the City,* are a form of labour, and they produce a commodity, the book itself, which is then distributed and purchased. But this process also entails the liberation of productive and creative potentialities that go beyond the product itself and create an excess. Liberated labour is human activity when it is not subjugated by forms of exploitation or dispossession; it is a 'constituting power' (Negri 60): whereas alienated labour is aimed at making profit, hence capital, liberated labour is the production of life through free creative energies. Teju discovers that drawing is a kind of 'magic' that enables her to link the world around her to the imagination, transgressing the narrative of poverty that her life seemed to incarnate after the escape from the drought in Rajasthan. Drawing becomes, for Teju, an expressive activity that cannot be reduced either to the biographical element or the commercialisation of her work. Antonio Negri's reflections resonate with Teju's work because they provide a theoretical formulation of the transformation involved in the liberation of creative ability enabled by drawing. Negri writes:

> The work of art is always indissociably two things – incidentally, like all objects produced in the era of capitalism: it is both activity and commodity. And it is on the basis of this two-sided-ness of productive activity that one can grasp … the inner reality of the contemporary artistic relationship: not only a manner of producing art which could be understood as a simple production of commodities, but also a manner of production in general which becomes the very figure of *potenza* [strength and potentiality], in other words of the being-creative in the world. Labour power, a free bird in the forest of life. (Negri 109)

The picture of girls with bicycles included in *Drawing from the City* expresses this double-sidedness of artistic work in an era of capitalism. Sold and produced as commodity, the image is also sign of a labour-power that has the potential to elude the system of exploitation and appropriation of the market. It is not by chance that the episode narrating the discovery of drawing in Teju's graphic autobiography becomes a crucial step in the book, and the beginning of the representation of an important theme that Teju develops in the remaining pages of her volume.

## 2. Drawing the multitude

How does Teju's graphic narrative continue, after the crucial passage represented through the image of the girls on bicycle? The image derives, as Teju makes clear, from a scene

actually seen, a girl riding a bicycle. The reader does not know when and where Teju saw the scene, nor why has it become so important to be included in the volume. The image is captivating. The figures stare at us, readers of the text. It is very important to register what happens to Teju's story after her reflection on the liberation of creative potentialities engendered by the 'magic' of drawing. Before the image of the girls riding bicycles, the graphic narrative provided a linear account of Teju's life: childhood in a village, then the main event of the drought and relocation to slums in the city, the marriage with Ganesh and the beginning of an itinerant life as Jogi devotional singer. Then, the topic of the narrative changes abruptly. The remaining pages of the book do not tell Teju's life, but explore and expand on the potentialities that drawing gave Teju as an artist. After the image of girls with bicycles, other similar graphic elements follow: a kind of traffic jam, represented by cars, depicted with dots and lines. Two girls sit in each car, one of them watching outside. After the crowd of cars and girls, another crowd, packed on an airplane, and lastly, in the concluding image of the book, a group of women, this time using a parachute to escape from the cabin of the airplane. Teju writes that 'my women are not content to sit still. So I float them down, wondering where they should go next. Should they fly forever like birds? Or should I draw some lines taking them down to the sea?' (*Drawing* n.p.).

How to read the concluding images of Teju's graphic autobiography? The images have a figural value, being seemingly irreducible to any kind of narrative or symbolic structure. The distinction between textual and figural space has been developed by French philosopher Jean-François Lyotard, who writes in *Discourse, Figure*: 'The two spaces are two orders of meaning that communicate but which, by the same token, are divided … the text and the figure each engender, respectively, an organisation specific to the space they inhabit' (205). In *Drawing from the City*, the captions tie the images to Teju's autobiography – a narrative, a discourse – while the pictures gradually detach themselves from the text, becoming figural elements, especially in the conclusion of the volume, where the visual is almost independent of any narrative frame. Images exceed the enclosure of the narrative and any symbolic aspect of the work. They do not really conclude the book, which is rather interrupted by the explanatory note, 'I rest my pen here, for a moment, I have time to decide' (*Drawing* n.p.). The interruption may or may not be part of Teju's own authorial intention. The caption is, in fact, a transcript from Teju's oral narratives, but it is written, edited and composed by the editors. The interruption that provisionally concludes the book can be grasped as the inability of the book-form, the commodity, to capture fully the artistic activity of Teju, especially her discovery of drawing. Teju interrupts the work, but the work does not end with the book. The interruption expands on the opening already announced by the divide between image and narrative: the commodity-form is overwritten by a reference to the materiality of a continuing creative activity. The narrative is in abeyance; the gap between image and text deconstructs the ensemble of the graphic narrative. The graphic part and the narrative element take different paths: whereas the narrative of Teju's story is interrupted with the reflection on the potentialities of drawing, images continue to flow, to evade storytelling, thereby manifesting Teju's creative power, her skill as a visual artist in a pure state. One of the aims of reading the visual narrative should hence be to find a story for the arresting pictures that conclude the book. What do they represent? Why were they included in the text? The most evident and striking element of the concluding pictures of *Drawing from the City* is that the images do not represent Teju or her family or surroundings. The end of the graphic narrative tends towards de-individuation. The subject that is

constantly represented in the concluding images is a multitude. A single girl on a bicycle becomes a crowd of girls and women in constant motion: with bicycles, cars, airplanes and parachutes. Teju's multitude has no identifiable character but a movement that cannot be interrupted. The breakdown of familial and individual narrative coincides with the emergence or prefiguration of a collective entity. These images can be read as a transition from Teju's reflection on the potentialities of the visual medium to prefiguring an as-yet inexistent collective of the poor, a multitude that, in Teju's work, has neither direction nor clear political orientation. The work does not provide a political statement on fighting for the rights of 'other backward classes', to which Jogi community belongs, alongside Dalit and tribal populations in India. There is no such thing as a political message in *Drawing from the City*. And yet, the figures represented by Teju seem to connect the transformation of one's own productive potential to an aesthetic of the multitude, a concept that Negri defined in many of his works, which also finds expression in *Art and Multitude*. The element of the 'multitude' that can be found as poetic element of *Drawing from the City* has to do with the creative potential of art. Indeed, the multitude is, first of all, a constructive, creative, even poetic process – an assembling, gathering together of what Negri calls 'singularities', that is, elements that cannot be reduced to the logic of equivalence imposed by capitalism and the market (Negri 87). The multitude is the expression of liberated labour and human creative strength; it can be seen as a collective movement that is not blocked by apparatuses of capture such as political parties or modern concepts of communal unity: proletariat, people or working class. The multitude is the coming together of irreducible stories and subaltern living experiences, with no pre-given political programme, but only a common resistance to inequality and the dispossession of productive resources.[3]

It is worth noting how Teju's multitudes could be connected to a rethinking of collective belonging in India, a country where since Independence, as Arundhati Roy points out in her recent introduction to Ambedkar's *Annihilation of Caste*, '"the people" was not a homogeneous category that glowed with the rosy hue of innate righteousness' (45). Rather, the making of a unified idea of 'the people' has led to suppression of minorities, marginal communities, Dalit, Adivasi and other backward classes. The 'idea of India', as Perry Anderson makes clear, should be rather seen as 'the Indian ideology' (Anderson 3–4), a structure of feeling that keeps the country together at the price of what Roy calls a widespread 'quotient of Brahminism' that corresponds to violence and discrimination at any level of the social hierarchy. As Arundhati Roy writes:

> It is the ultimate means of control in which the concept of pollution and purity and the perpetration of social as well as physical violence – an inevitable part of administering an oppressive hierarchy – is not just outsourced, but implanted in everybody's imagination, including those at the bottom of the hierarchy. (Roy 51)

Against hierarchical discrimination and a homogeneous idea of 'the people', Teju's multitudes construct a sense of belonging that is horizontal, de-individualised and linked to the possibilities that the channels of global capitalism could give, in spite of its violence and inequality.

Teju's concluding graphics are intimations of a multitude to-come. Her pictures do not express any unifying vision but provide a graphic representation of the possibility of collective existence. A single girl becomes, in Teju's imagination, a multitude of figures elegantly moving across an empty space, at the same time independent of each other and interdependent, gathered together in a common tension or movement. In *Art and Multitude*, Negri

points out the indissoluble link between art, creative labour, and collective existence. He remarks that there is

> no production without collectivity. There are no words without language. There is no art without production and without language. Art is, above all, this synthesis. Art is the construction of a new language which, first, alludes to a new being. (40)

Art becomes, from this point of view, the 'allusion' or suggestion of a new collective being, and the artist is redefined by Negri as an 'intermediary' (73) between collectivity and the occurrence of a revolutionary event.

For this reason, *Drawing from the City* needs to be approached on a purely aesthetic level – without being reduced to political programmes or to sociological/ethnographic pigeon-holing. A way of reading the book closely is by detecting the shifts, transitions and allusions presented by the graphic narrative itself. Without mentioning any politics, the graphics drawn by Teju envisage and imagine the making of a multitude of women moving restlessly through the spaces opened by the symbols of capitalism and modernity: cars, airplanes, parachutes. Teju's women embark these objects of modernity but also defy their powers of constriction, because they are represented as an elusive crowd, on the move, perhaps on the verge of finding a common direction and creating a real social transformation. The final image represents women escaping from an airplane, trying to find a direction but still not sure where to go. In its engagement with global capitalism – through its symbols but also material forms of production and reproduction – Teju's book is at the same time a commodity and a reflection on the liberation of the potentialities of creative labour. Teju's graphics of the multitude suggest the making of an as-yet non-existent collective subject gathered through the spaces and media of capitalist modernity, and yet constantly challenging the strictures of modern means of transportation.

## 3. Conclusion

> They say the poor have nowhere to go. I am not sure. When people don't have enough to eat, they take the train to the city, to find work. (*Drawing* n.p.)

In these reflections, a graphic narrative by a Jogi artist has been interpreted as expression of liberated labour and prefiguration of the multitude. Her images have stimulated a reading response through references to the concept of art proposed by philosopher Antonio Negri. In the context of contemporary South Asian graphic novels and visual narratives, such reading can suggest a few points, which are still open questions in postcolonial literary studies. First of all, graphic novels by Dalit, tribal or 'other backward classes' artists should be approached as works of art, if their authors want to be recognised as such. There is no point in trying to do justice to the voices of subaltern artists without taking their works as seriously as critics and readers would take a novel by Salman Rushdie or any other internationally recognised creative writer. If 'debased labour is the source of the non-transferable specificity of the caste condition', as Gajarawala (347) points out in an essay on Dalit literature, understanding artistic production as a form of disalienated labour can indicate potentialities that go beyond the specificity of caste discrimination. A subaltern aesthetics could suggest the making of collective subjects, future multitudes at the same time eluding caste violence and capitalist dispossession. This requires, hence, a practice of close reading, which does not overlook the social context in which the texts are produced, but rather rethinks the position of texts within a global circuit of circulation and reproduction.

In the case of graphic novels, this effort requires that pictures are not always reduced to the narrative frame. Teju's book can be partly read as an autobiography, but there is a point at which the text moves away from the autobiographical on a purely figural level. The richness of graphic narrative derives from the coexistence of visual and written elements, which should maintain a relative autonomy and independence from each other. In *Drawing from the City*, graphics are a counterpoint to the text, which does not always register in full what is happening in the image. The book registers a difference between the image and the narrative, which appears in the captions in English translation, mainly aimed at an international audience. The narrative hence indicates the entanglement of the work within an uneven economic system of circulation. Yet, the figural density of Teju's drawings escapes the capture of the narrative frame. Close reading can fine-tune the understanding of the book to those aspects or details that cannot be fully explained and absorbed by the narrative. This excess, or interruption of the narrative, is the space where, within the commodity-form of the book, a glimpse of the material activity of art as liberated labour can emerge. Therefore, Teju's drawings appear as a counter-discourse that silently exceeds editorial work, packaging and commodification. Accordingly, reading South Asian graphic novels can be a productive intervention in current controversies over the concept of 'reading' in world and postcolonial literature. As Aamir Mufti writes in an important essay:

> The universalism that is inherent in the task of rethinking the concept of world literature and its usefulness … has to be confronted with linguistic heterogeneity and the concept itself uncoupled from the effects of standardization and homogenization both within and across languages and cultures that come masked as diversity. (Mufti 493)

Reading graphic narratives, indeed, should contribute to a rethinking of world literature in postcolonial contexts, by focusing on inequality, injustice and exclusion instead of the reifications of 'diversity' or 'identity'. What is needed is a practice of reading that is not 'distant', Mufti writes,

> [B]ut neither can it take the form of close reading for its own sake. What is needed is better close reading, attentive to the worldliness of language and text at various levels of social reality, from the highly localized to the planetary as such. (Mufti 493)

Graphic novels can complicate the concept of a worldly close reading with references to the intersection of text and image, and the use of different media and tools of expression. Instead of collapsing narrative and figure, close reading can provide a way of exploring histories, experiences and structures of feeling that are not always registered in the plot or verbal language. The combination of visual and written elements can express an idea of art that is not only commodity, object of spectacle and consumption, but also productive activity and creation of subjectivities. In the context of South Asian visual narratives, Teju's work can be approached as a reflection on the role of art in liberating labour against the grain of the channels of global capitalism. Whereas Teju's work circulates as a commodity produced for an international audience, the discrepancies between narrative and figure indicate a space of production, activity and practice that is not exhausted by the appropriations of the capitalist world system. Teju's creative activity is merely paused in the concluding pages of the book: images overflow the enclosure and binding of the book by gesturing towards potentialities that go beyond the commodity.

For this reason, a practice of close reading needs to be attentive to the nuances of the image alongside the questions of economic dispossession, uneven circulation and

commodification. It can be a way of relating the study of graphic novels to what Stephen Morton, following Walter Benjamin's theses on the concept of history, refers to as the 'tradition of the oppressed': '*both* the histories of anti-colonial resistance and struggle *and* the different aesthetic forms in and through which these histories are mediated in postcolonial writing' (Morton 23). Instead of treating these 'aesthetic forms' as a 'fixed object of knowledge', an emphasis on disalienated labour can be a way of approaching what Morton calls the 'emergent and often unarticulated forms of knowledge and agency of people whose lives are subjected to the forces of imperialism' (23). The liberation of labour registered in *Drawing from the City* could hence indicate a step in the making of a future collective engagement, which will hopefully dismantle caste violence and, at the same time, the inequality that capitalism constantly reproduces, in India as elsewhere.

## Notes

1. Christophe Jaffrelot shows that the recent political mobilisation of other backward classes 'for the first time seriously questions upper-caste domination of the public sphere' (86). In 1989, the attempt by the Indian government to implement the Mandal Commission, which attributed seats and reservations to other backward classes, provoked strong protests by upper-castes (Omvedt 87).
2. Ann Grodzins Gold provides a remarkable description of Jogi performances, which are based on the idea of generosity as 'awakening to the imperceptible', an expression meaning 'waking up their listeners to the existence of invisible realities far more significant than the mundane ones' but also warning the listener that not giving to the performer may bring greater calamities (Gold 91). Gold also makes clear how performers make a sharp distinction between 'begging' and Jogi ritual performances. A selection of songs by Ganesh and Teju can be found online through the 'Beat of India' website, which includes a brief biographical note: http://www.beatofindia.com/arists/gjtb.htm
3. Hardt and Negri write in *Multitude*:

   The multitude is an internally different, multiple social subject whose constitution and action is based not on identity or unity (or, much less, indifference) but on what it has in common … the multitude is the common subject of labour, that is, the real flesh of postmodern production, and at the same time the object from which collective capital tries to make the body of its global development. (100–101)

   Interestingly, the multitude and the work of art have, according to Negri, a crucial element in common: both are instances of liberated labour with the potential to dismantle forms of power, hierarchy and exploitation, and yet always at risk of being constrained by the reifications of capitalism. The horizontal, anti-hegemonic and heterogeneous aspects of the multitude prevent it from being ascribed to a political programme that would replicate exclusions and force irreducible singularities into newly founded structures of domination.

## Disclosure statement

No potential conflict of interest was reported by the author.

## References

Anderson, Perry. *The Indian Ideology*. London: Verso, 2013. Print.

Barthes, Roland. *Image, Music, Text*. Trans. Stephen Heath. London: Fontana, 1977. Print.

Beat of India. Web. 15 Jan. 2015. <http://www.beatofindia.com/arists/gjtb.htm>.

Behan, Teju. *Drawing from the City*. Chennai: Tara, 2012. Print.

Bokil, Milind. "Drought in Rajasthan. In Search of a Perspective." *Economic and Political Weekly* 35.48 (2000): 4171–5.

Bourdieu, Pierre. *The Field of Cultural Production*. Ed. Randal Johnson. Cambridge: Polity, 1993. Print.

Bowles, John. *Painted Songs and Stories. The Hybrid Flowerings of Contemporary Pardhan Gond Art*. Bhopal: INTACH, 2009. Print.

Casanova, Pascale. *The World Republic of Letters*. Trans. M.B. DeBevoise. Cambridge, MA: Harvard UP, 2007. Print.

Gajarawala, Toral Jatin. "The Casteized Consciousness: Literary Realism and the Politics of Particularism." *Modern Language Quarterly* 73.3 (2012): 329–49.

Gold, Ann Grodzins. "Awakening Generosity in Nath Tales from Rajasthan." In David N. Lorenzen and Adrián Muñoz, eds. *Yogi Heroes and Poets: Histories and Legends of the Naths*. Albany, NY: SUNY P, 2011. 91–108. Print.

Hardt, Michael, and Antonio Negri. *Multitude*. London: Penguin, 2004. Print.

Jaffrelot, Christophe. "The Rise of the Other Backward Classes in the Hindi Belt." *The Journal of Asian Studies* 59.1 (2000): 86–108.

Lyotard, Jean-François. *Discourse, Figure*. Trans. Antony Hudek and Mary Lydon. Indianapolis: U of Minnesota P, 2011. Print.

Marx, Karl. *Capital*. Vol. 1. Trans. Ben Fowkes. London: Penguin Classics, 1990. Print.

Mathur, Saloni. *India by Design. Colonial History and Cultural Display*. Berkeley: U of California P, 2007. Print.

Moretti, Franco. *Distant Reading*. London: Verso, 2013. Print.

Morton, Stephen. *States of Emergency*. Liverpool: Liverpool UP, 2013. Print.

Mufti, Aamir. "Orientalism and the Institution of World Literatures." *Critical Inquiry* 36 (2010): 458–93.

Napier, John. *They Sing the Wedding of God: An Ethnomusicological Study of the Mahadevji ka byavala as Performed by the Nath-Jogis of Alwar*. Jefferson, NC: McFarland, 2013. Print.

Negri, Antonio. *Art and Multitude*, Trans Ed Emery. Cambridge: Polity, 2011. Print.

Omvedt, Gail. *Dalit Visions: The Anti-caste Movement and the Construction of an Indian Identity*. Hyderabad: Orient Longman, 2006. Print.

Procter, James. "Introduction: Reading After Empire." *New Formations* 73 (2011): 5–10.

Roy, Arundhati. "The Doctor and the Saint." *Annihilation of Caste*. Ed. B.R. Ambedkar. London: Verso, 2014. 15–179. Print.

Varma, Rashmi. "Primitive Accumulation." *Third Text* 27.6 (2013): 748–61.

Warwick Research Collective. *Combined and Uneven Development*. Liverpool: Liverpool UP, 2015. Print.

# Development narratives, media and women in Pakistan: shifts and continuities

Shirin Zubair

**ABSTRACT**

The influences of globalization and global imagery are redefining Pakistani women's social roles and identities. This article seeks to explore the ways in which media representations of Pakistani women are understood to represent broader international development discourses. By focusing on development narratives with regard to women's empowerment and, their social and political positioning, and by looking at the visual and linguistic representations, images and portrayals of women, this article aims to capture the competing discourses of femininities offered on the cable television channels in Pakistan. For instance, while a drama like *Uraan* (Flight), shown on the most popular channel, Geo, may depict an independent career woman exercising her autonomy and freedom in decision-making, thus illustrating a clear departure from patriarchal structures, it simultaneously, offers ambivalent or competing discourses on femininities. How these images are received and interpreted is captured through focus group data of women discussing media representations. This data provides useful insights into the ongoing constructions of their selfhood and identity in relation to these media representations.

## Introduction

State media in the Islamic Republic of Pakistan has always been controlled by the government, although in the 1970s the policies were relatively liberal in that programs featuring dance performances were shown which were later banned during General Zia's military dictatorship in the early 1980s. At that point in time, the media was strictly controlled under the policy of Islamization, to the extent that female announcers and newsreaders could not appear on state television without a head-scarf. Later, during the 1990s, General Musharraf, with his views of moderate enlightenment, lifted some of these restrictions and paved the way for a free media by issuing licences to several private channels. Today, Pakistani audiences have unprecedented access to foreign channels, including Indian satellite channels, as well as to several private cable channels in Pakistan. Traditionally, the social roles of Muslim women were defined by the male clergy, who confined them to the domestic domain,

curtailing their freedoms and their basic rights to education and citizenship. Until very recently, women had very limited access to higher education. Their literacy was confined to learning the rudiments of Arabic as part of their religious education; secular education was denied them, causing an epistemological colonization which deprived them even of the right to become *alima* (female religious scholar; Zubair 119). The rise and proliferation of cable channels, coupled with easy access to other electronic media, has revolutionized both the social lives of Pakistani women and their sense of selfhood.

The rise of electronic media, such as the Internet and cable channels, has given many Pakistani women unprecedented access to new worldviews, cultures and ways of being thus posing new challenges to women's socio-political and religious identities in their indigenous context. The advent of such globalizing influences from around the world, spreading new ideas about gender development and empowerment narratives with regard to women's social, political and economic positioning, shifts the focus on the local realities. These influences cannot be underestimated in the lives of women living in the Southern Punjab region of Pakistan where literacy rates – the usual indicator of development – are extremely low at 43% (ASER Report 69). However, the impact of unlimited exposure to television channels across the board remains under-researched while its influence on women in this underdeveloped region is perhaps overestimated.

An essential aspect of the development narratives on the media is connected with global imagery or images that transcend the local. The images and themes spreading through electronic media such as cable channels and Internet include, among others, Western styles of dress, ideas of romance and courtship, pre- and extra-marital love affairs as opposed to arranged marriages, representations and discussion of erstwhile taboo issues such as divorce, women's employment, sexual harassment, rape and prostitution . These images pertain to several facets of women's lives, reshaping and repositioning their social and familial identities in the Pakistani context in the wake of narratives of globalization and development. This paper primarily focuses on two themes: (1) images of women's economic empowerment through education and work in television fiction juxtaposed with images of women in the advertisements working in the domestic sphere; (2) images of romantic love and relationships as emblematic of women's modernity and empowerment.

Such visual images are increasingly viewed and received with keen interest by millions of literate, illiterate and semi-literate populations across the entire country, the majority of whom are women. For instance, media channels are increasingly showing themes and images of dating, romance, extra-marital and pre-marital affairs and divorce initiated by liberal, educated and working women; such themes and images, relatively new and unprecedented in Pakistan, are linked to dominant globalization and development narratives. Laura Ahearn's (311) work on literacy, agency and social change in rural Nepal has shown how the literacy practices of writing love letters emerged among rural youth as a consequence of textbooks saturated with the discourses and imagery of modernity and development. As a result, contrary to traditional views and practices of arranged marriages, marrying for love after courtship was considered a sign of development and modernity. To illustrate the point, I refer to the widespread celebrations of Valentine's Day and associated imagery in the Pakistani media and on university campuses. Nearly a decade ago, Valentine's Day was a western concept that we only read about in English literature textbooks. Over the past decade, a growing trend of celebrating the Valentine's Day at public sector universities has been observed.[1]

During the first phase of data collection in 2011 prior to the focus group recordings cited in this article, while I viewed several television channels, I also used the participant observation method to observe students and research participants at Baha-ud-Din Zakriya University, Multan. It was observed that Valentine's Day was celebrated with much enthusiasm on the university campuses in Pakistan, as well as by couples outside the university. Young men and women were seen dancing together on the campus, exchanging cards, flowers, cakes and chocolates. In the media, the television advertisement for Cornetto ice cream says: 'this Valentine's day celebrate your love with…Cornetto Butterscotch', while visuals are shown of two ice cream cones entangled in a heart and a happy young couple in Western clothes eating ice cream.

On the campus, young women were seen wearing specific colours on this day to indicate their relationship status: for instance, wearing red signalled that a woman was already in a relationship or spoken for; similarly, green indicated availability, blue, 'I am not interested', and so on. The semantics of colour codes are well known among the young university populations. The local shops are full of cards with two hearts entwined with a cupid's arrow, cakes packed with red ribbons and other sweets. This imagery is all-pervasive on almost all the television cable channels (except the religious ones) for at least three or four weeks leading up to Valentine's Day: commercials with tempting offers and deals by restaurants, jewellery, dress and gift shops among others, thus promoting the idea of romance and love relationships among the general public in this region. Even though these kinds of advertisements, with their global imagery, are also directly connected to the rise of consumer culture and popular marketing strategies in the rapidly changing Pakistani society, these themes remain outside the scope of this paper.

## Development discourse and the media: theoretical insights

I draw on theoretical insights from media studies, development studies and cultural studies. Much of my analysis stems from and builds on the theorizing that emerged out of the UK Gramscian tradition, represented in the works of Raymond Williams, Stuart Hall, Paul Willis and Angela McRobbie. During the 1970s, researchers used critical perspectives on popular culture to find forms of resistance to the dominant highbrow culture. In one of the earliest studies of girls' youth culture, McRobbie (61) emphasized that the girls' abilities to subvert consumer culture signified their valuing of working class femininity, their mothers and home over the middle-class values of the school.

Within cultural studies and social theory, the debates have continued to centre around questions of changing national cultures and a unitary cultural identity. With the advent of globalization and the blurring of national and geographic boundaries, 'culture' has been questioned as a category since it often implies fixed categories of deterministic behaviour; various new terminologies and conceptualizations of culture were proposed in the 1990s by scholars like Street and Hall. In his seminal article, 'Culture is a Verb', Brian Street argues that we must go beyond the deterministic definitions of culture as fixed, static and reified or the nominalizing senses in which culture is usually employed (23). Writing on globalization and mass culture, Hall (27) observes:

> Global mass culture is dominated by the modern means of cultural production, dominated by the image which crosses and re-crosses linguistic frontiers much more rapidly and more easily, and which speaks across languages in a much more immediate way. It is dominated by

all the ways in which the visual and graphic arts have entered directly into the reconstitution of popular life, of entertainment, and of leisure. It is dominated by television and by film, and by the image, imagery, and styles of mass advertising. Its epitomy [*sic*] is in all those forms of mass communication of which one might think of satellite television as the prime example. (27)

He further elaborates that identity is grounded 'not only in a whole history, a whole set of histories, a whole set of economic relations, a whole set of cultural discourses, it is also profoundly grounded in certain forms of sexual identity' (21). Escobar citing Foucault, thinks of development in terms of discourse, focusing on the themes of power and domination, and at the same time the conditions of possibility and the most pervasive effects of development. Furthermore, he goes on to argue that 'it gives us the possibility of singling out 'development' as an encompassing cultural space and at the same time of separating ourselves from it by perceiving it in a totally new form' (6).

With the advent of the new millennium, scholars like Martha Nussbaum and Amartya Sen from development studies have advocated for the Capability Approach to mitigate violence and injustice against women. The oppression and marginalization of women in diverse settings across the globe have led scholars like Mackinnon (4) to argue for international legislation and justice; while others like Sen and Nussbaum have emphasized the development of capabilities, agency and well-being to ameliorate the quality of women's diverse lives globally. For instance, Sen points out linkages between women's agency and social change. He argues:

> Perhaps the most immediate argument for focusing on women's *agency* may be precisely the role that agency can play in removing the inequities that depress the *well-being* of women. Empirical work in recent years has brought out very clearly how the relative respect and regard for women's well-being is strongly influenced by such variables as women's ability to earn an independent income, to find employment outside the home, to have ownership rights and to have literacy and be educated participants in decisions within and outside the family. (191)

However, scholars of postcolonial and transnational feminism argue that such universal and monolithic notions of feminism and women's empowerment are neither practical nor workable.

The Millennium Development Goals (MDGs) envision gender equality and women's empowerment across the globe as well as eradication of poverty, hunger and disease. Jeffrey Sachs (2206) observes that there is widespread feeling among policy-makers and civil society that progress against poverty, hunger and disease is notable. However, the MDGs envision not only economic development, but also human happiness and well-being in various geographical regions across the globe. He goes on to argue that the idea of Sustainable Development Goals (SDGs) has gained ground for human well-being across the globe. 'Almost all the world's societies acknowledge that they aim for a combination of economic development, environmental sustainability and social inclusion, but the specific objectives differ globally, between and within societies' (2206).

Another theoretical strand that I draw upon in this research is from media studies, wherein previous research has shown that people draw on media representations in an ongoing process of identity construction and that media is not simply representational, it can also be seen as the sites for the discursive construction of knowledge, beliefs, values, social relations and identities (Cameron and Kulick 12; Fairclough 52, 53; Zubair 190). Similarly, feminists like Kate Millet (23), Toril Moi (6), Chris Weedon (5) and Virginia Woolf (344) have argued that the way women are represented in literature and media greatly impacts

the way they define themselves as subjects in their own lives. With regard to post-feminism and popular culture in the west, MacRobbie (256) observes:

> The body and also the subject come to represent a focal point for feminist interest, nowhere more so than in the work of Butler [1990, 1993] The concept of subjectivity and the means by which cultural forms and interpellations (or dominant social processes) call women into being, produce them as subjects. (256)

She goes on to argue that post-feminism can be explored through what she calls a 'double entanglement'. This comprises the coexistence of neo-conservative values in relation to gender, sexuality and family life. Thus, post-feminists view popular culture as a site where 'power … is remade at various junctures within everyday life, [constituting] our tenuous sense of common sense' (Judith Butler, Ernesto Laclau & Slavoj Zizek 2000, cited in McRobbie, 28).

These theoretical observations provide a useful framework in which to locate and understand the changing media representations of Pakistani women – and to explore the impact of these globalizing influences – within the different and wider context of Pakistani women's historical, religious and socio-cultural positionings.

## Research setting and methods

The research reported in this article was conducted by me as a self-funded project at a state-run university in the city of Multan Pakistan during 2011–2012. It forms part of a broader project on the teaching of English literature and Western feminism in the region of Southern Punjab. Later, in 2014, the project earned me a senior fellowship at the Center for Global Co-operation Research, University of Duisburg-Essen in Germany. The decision to include research questions on the television images of women in this region stemmed from my research interest in women's engagement with various literacies (English, Urdu, Seraiki, Punjabi), and reception studies of women's representations in the local print media including a previous study of the reception practices of women's magazines which specifically focused on Southern Punjab (Zubair 176). I wanted to pursue further research into the ways in which the media imagery is received and understood to represent the broader international development discourses related to women's education and empowerment in this region. As compared to the relatively more developed cities of Lahore, Karachi and Islamabad, the Southern Punjab region remains relatively underdeveloped with regard to women's literacy, education and participation in workforce. More importantly, the expectation that the exposure to this global imagery coupled with women's higher education would yield significant findings in terms of shifts in their identity formation was based on the all-pervasive nature of external globalizing influences.

When travelling from the capital of the Punjab, Lahore, to the more remote city of Multan in Southern Punjab – commonly referred to as 'less developed areas', one does not leave the discourses, imagery and semantics of development behind. On the contrary, these discourses and images are present everywhere in the form of huge billboards displaying images from popular media soap operas, advertisements. Tellingly, although most female university students in urban Multan observe *purdah* or are veiled, even a surface reading of the urban semiotics of Multan reveals advertisements with images of modern, unveiled women. There are a large number of slogans, names of organizations and buildings with the terms 'develop' and 'development' written on them: governmental organizations, such as Multan Development Authority (MDA), and non-governmental organizations such as the

Pattan Development Organization, the Awaz Foundation Centre for Development Services, and the Ufaq Development Organization, to name a few. As Grillo (1) points out, referring to different studies on the social anthropology of development and exposure to development are a fact of everyday life for most peoples of the world. Within these development frameworks, this article explores the following two questions in regard to the promise, ideology and discourses of development:

- What specific messages are being conveyed/received through such images?
- How is this new imagery of development and globalization being received by women in this region?

I conducted and led focus group discussions with sixteen, young, working, middle class women between 22 and 30 years of age in groups of four. They formed a homogeneous cohort in terms of age group, social class, education and profession. Each focus group discussion lasted for 50–60 min. All the research participants were lecturers in English, with MPhil degrees in English from the department of English at Bahauddin Zakariya University in Multan. They were all familiar with Western feminist theory. They were all personally known to me, either as colleagues or as researchers; some of them were working on their research projects for their MPhil degree, and two of them had completed MPhil projects under my supervision on gender and feminist theory and its application in the Pakistani context. The participants were briefed about the research study; consent was obtained prior to the audio recordings of the focus group discussions.

Some prompts were used to initiate the group discussions, which were largely semi-structured and free-flowing. An example of the kind of questions that were asked is 'What is your take on the new media representations of women and feminist issues in our context?' In addition to questions like the one above, women's representations in popular television fiction (specifically *Uraan*, and *Khuda aur Mohabbat*) were brought up specifically as prompts to initiate in-depth discussion of the role of media in changing perceptions regarding women's social roles.

## Images of women in television fiction

Prior to the focus group recordings in the summer of 2012, during 2011, I spent several months watching *Geo* – the most popular and the most widely watched channel in Pakistan– to collect data. Some other channels were also watched for random sampling of the images. During this data collection, phase I saw several fictional teleplays including *Uraan, Khuda aur Mohabbat, Zip Bus Chup Raho and Ladies Park*. Most of these were weekly serials which took up themes and issues related to women's everyday lives by positioning them within the domestic domain. The themes included romantic love and relationships, extra-marital affairs, marital discord, infidelity and divorce, women's employment, and prostitution. In my analysis, I concentrate on two of these serials, *Uraan* and *Khuda aur Mohabbat*, for the following reasons:

- Both depict stories of several young women from the middle and working classes positioned in different domains, roles and identities.
- *Khuda aur Mohabbat* is chosen for analysis because it explicitly takes up the theme of romantic love or 'love marriage' as it is increasingly viewed as an indicator of modernity

and is part of development discourses, in that it highlights women's autonomy in decision-making, although traditionally the concepts of dating, courtship leading to marriage were totally unacceptable and hence, are still looked down upon by rural and lower income groups among urban populations.

Uraan, meaning flight, suggests falling from heights and falling from grace in popular culture and literature. While carrying an ambivalent connotation for a woman, the idea of flight also suggests endless possibilities or options if a woman is educated and ambitious. The metaphor of 'taking off' or of 'reaching great heights' is often used in relation to a successful career person having vision, imagination and the motivation to achieve success. Understood in this way, the show's title envisages the concept of 'female success' (McRobbie 14) as opposed to women's subjugated roles. The serial follows the story of a young working woman who seeks divorce after being trapped in an abusive marriage. Such portrayals of a young independent, middle class woman protagonist who makes autonomous decisions and also has the moral courage and strength to stand by them are increasingly common in the aforementioned TV serials. Traditionally, divorce was hugely stigmatized, as it was hard for a divorced woman to live on her own. She had to return to her natal home where it was deemed the duty of her male kin to protect her honour while she remain unattached. Not only does the serial depict an independent career woman exercising her will in making decisions, it represents a clear departure from patriarchal structures, in that the central figure or the hero of the story is a woman and the title of the show refers to her ambition, drive and success as a professional, independent, strong-headed woman who stands by her decisions.

The second drama, *Khuda aur Mohabbat* (*God and Love*), is about a girl from a lower socio-economic class who falls in love with a boy from the upper middle class. She is the daughter of an *imam* (prayer leader in a mosque) while he is the son of a bureaucrat. The title itself suggests a dichotomous relationship between religious identity and the emotion of love, two incompatible forces. The Moroccan feminist scholar Fatima Mernissi (41–44) argues that falling in love with a woman distracts devout Muslims from single-mindedly loving God. She goes on to link this argument to the issue of polygamy in Islam, arguing that since in polygamy a man is not devoted to only one woman, his ultimate love remains the love of God. Her argument is based on the theoretical premise that the discourse of Islamic jurisprudence and Quranic texts is predominantly male-centric.

Translating this argument to the serial implies that the father of the girl, the imam, interprets the emotion of love as un-Islamic and thus, through his power over the processes of meaning-making in Islamic jurisprudence, exercises his control over his daughter in terms of epistemological hegemony. The discourse and text of the drama also bring out this dichotomy by reinforcing the patriarchal interpretations of religion by the family and the wider community who join forces to denounce and lash out at the emotion experienced by the young lovers. Since the girl is shown as uneducated and economically dependent on her father, she does not exercise her agency against the patriarchal structures of family or religious jurisprudence. These visual representations clearly illustrate the intersections of class with the positioning of women in the social hierarchy through their dress codes, body language, choices and autonomy in decision-making. While the highly educated upper middle class protagonist in *Uraan* is shown as independent and capable of autonomous decision-making, thus resisting official discourses on traditional femininities and societal and familial pressures, the daughter of the imam in *Khuda & Mohabbat* is shown to have

little choice but to obey her father. Moreover, she is portrayed as demure, less confident, less expressive and less vocal about her desires and wishes than the women from upper and middle classes. Her dress code, demeanour and body language all point to her positioning on the social scale as semi-literate, backward and oppressed by patriarchal traditions, whereas the middle and upper class, highly educated heroes of *Uraan* are portrayed as having more control over their bodies, physical mobility, initiating decisions regarding relationships, divorce and employment. They follow Western dress codes, work in offices, drive their own cars, move freely and independently, make their own decisions vis-à-vis marriage, divorce and employment. Hence, they signify 'female success' in the modern development narratives.

## Globalizing narratives on romance, courtship and sexuality

Falling in love signifies female desire and agency, in that choosing one's life partner can be viewed as signalling women's autonomy and control over major decisions in their lives. It may be viewed differently in different cultures and by different groups within societies. From a Western feminists' perspective, the notion of romantic love culminating in patriarchal, heterosexual marriage has also been criticized. They argue that as a social construct, it perpetuates women's exploitation within the institution of marriage by reinforcing asymmetrical and conservative gender relations. The Western notion of romantic love as an all-consuming passion which sweeps women off their feet and culminates in patriarchal marriage debilitates women instead of empowering them.

On the other hand, in Muslim societies and cultures, romantic love is imbued with negativity because it signals female desire and agency. Female sexuality, which is seen as having the power to wreak havoc in the social fabric, is not only abhorred, it is feared, deemed *fitna* (evil) by the Muslim clergy, and thus a force that needs to be regulated and controlled (Mernissi 41; Shahnaz Khan 10).Some patriarchal Muslim texts, forbid the overt enjoyment of sex particularly by women, as the husband is allowed to use force to have sex with his wife even if she is unwilling. So, sex is a husband's right and a wife's conjugal duty in return for *naan nafqa* – alimony, or literally bread and maintenance.

Even today, the concept of 'love marriage' is a contentious subject in Pakistani society. Marrying for love is common only among the westernized urban elites. In the middle and upper middle classes, marriages are arranged by family, mostly within family or within the same social class. However, in urban centres, middle-class working couples may also sometimes marry for love. Such marriages are usually approved by the families because if they are not, the couple could find themselves socially ostracized. Nevertheless, the practice is still, to a great extent, looked down upon, and even regarded with disapproval.

## Data from focus groups

The following excerpt from one of the focus groups recorded during the summer of 2012, throws some light on the complexities of a love marriage:

- In my family, love marriage is literally a gaali (expletive) although there are some instances but they are looked down upon ... to their face its fine but behind their backs

... even though I do have some of the elements of love marriage, I am not allowed to admit it ... I must not say it out loud ...

Here the young woman – a lecturer, an independent, middle class, working woman, stops short of calling her decision of marrying a man she met at the university a 'love marriage', saying only that there are 'some elements of love marriage'. She takes an ambivalent position here signifying that although it is a marriage of her choosing, she is hesitant to label it as such to conform to familial and social expectations of chastity and virginity.

The following excerpts from the focus group data illustrate women's take on the relatively new global imagery of development: women increasingly tend to distance themselves from these narratives of development associated with the Western ideals of freedom:

- Well, I think it is bad, I think its bad ... I mean if you want to keep some relationship ... leaving (a husband) is easy. To live together is the more difficult thing ... its like a challenge ... take it as a challenge that yes I can do that ... you are in a relationship maintaining it ... what do you get if you walk out of it? That is an easy escape.
- As far as the traditional roles are concerned, I think we should do away with those roles ... but that does not necessarily entail that we should embrace the roles that are being imported here in our country from the West ... the Western images that are being rather reinforced through the media representations in our society ... it is another kind of hegemony. We women living in Pakistan we rather need to be beware of that and we are also a bit sceptic about those I mean about the parallel hegemony that is being created because again that binary does get reinforced ... here we have the religious ideals, here we have the Western ideals of what it means to be a proper or a new woman
- they show an extramarital affair, they show something bad happening to them in the end but during the play they show them (unclear) ... the teenagers think that these options are available to them ...
- I think to some extent these realities that are shown are around us ... they depict the pictures that are already around us, so as far as this thing this eroding of values is concerned that these dramas and these issues are provoking such new issues, this is also true to some extent, in my opinion because to those who are not mature they have a negative effect on them ... like we have knowledge, we have read theories about it, we can see it critically but like teenage girls they do perceive things differently ... they think what is shown on the media can be done ... they think we can do like this ... they take those pictures as role models .... My sister knows a girl who was commenting on a relationship between a young man and a girl on the media ... she said that this play was showing her story and if the girl in the play can do this why can't I?

In the above quotes from focus group discussions, not only do these women distance them-selves from these new discourses, they construct the Western influences and imagery as the 'other' to define their essentially different identities as Pakistani Muslim women. Hall (20) has observed that identity is always crucially constructed as part of an 'othering' discourse. Here, Pakistani women are constructing their own differentiated meanings of the media images, showing complexities, ambivalences and contradictions inherent within their own identities as well as within media images of a developed modernity. Ayesha Khurshid's recent research on Pakistani women's education and international development discourses shows similar results. Her data on the lived experiences of educated Muslim women com-plicates the prevalent narrative of modernity that presents women's education and gender

empowerment as an expression of individual women's choice and free will against the oppressive frameworks of family, community and Islam (1).She shows that women teachers who enact a middle class modern muslim subjectivity are not victims of their culture but rather active agents who stand in tension with as well as shape power hierarchies in their contexts (119).

## Images in media advertisements

Contrasting the imagery of liberated, independent working women in television fiction are the images in the advertisements that are shown during the commercial breaks. These images reinforce traditional, patriarchal roles and ideologies by placing women and girls in the domestic domain as daughters, wives, mothers and caretakers. For instance, the portrayal of a 10-year-old girl who seeks approval – with an apprehensive and demure look on her face – from her entire family sitting around the dining table for making her first perfectly round *rotis* (traditional Pakistani bread) is a discursive socialization of girls into the traditional roles of homemakers as these images effectively relegate women to the domestic sphere.

Such imagery is linked to and reinforces the well-known proverbs in Urdu and Punjabi translated as: *She who cannot make her rotis round does not qualify to be a woman.* Her mother is shown initiating her into her future role of a woman by saying: *Choti ki pehli gol roti* (little one's first round bread). The advertisement captures a little girl's initiation ritual of making the first round *roti* and her socialization into the prescribed notions of traditional patriarchal femininity.[2]

Similarly, another advertisement (Fair and Lovely skin lightening cream) shows a father pressuring his young daughter to accept a marriage proposal. When the daughter says that she would first like to establish her career, he emphasizes that she does not need to do so because her prospective husband has a lucrative job and is well-placed. The daughter hesitates but then agrees on the condition that she can wait three years, the time to establish a career of her own. The next scene shows her consulting her friends, who reiterate her father's words. She is then shown thinking 'maybe Dad is right, I should get married'. This signals a message to Pakistani daughters: because, as young women, they are unsure and wavering in terms of their career choices and aspirations, they should therefore take the cue from their fathers like the daughter in the advertisement, who needs little or no convincing to agree to an arranged marriage. The message that such advertisements send to millions of young women aspiring to their own careers is clear: they should opt for an arranged marriage with a man who has a lucrative job and bright future prospects and give up their own career ambitions. They only need to work on lightening their skin tone to get hold of a good marriage proposal and increase their desirability in the marriage market. The images of fair-skinned models abound in advertisements for skin lightening products and cosmetics in the media (Haider nee Zubair 232). Marriage with a well-established man is portrayed here as both the inevitable and the most desirable option for young women and daughters as opposed to being career women. The transition envisaged implicitly in the advertisement is from being a young daughter to being a prospective future wife, rather than to being a career woman. As discussed above, however, the serials during which the commercials are aired, depict images of successful career women making independent decisions vis-à-vis employment, marriage, divorce, foreign travel and so forth.

## Conclusion

Earlier research on magazine representations in Southern Punjab showed an absence of any serious issues pertaining to the lived realities of women's lives in this region (Zubair 193). However, the television fiction cited in this study takes up issues of domestic violence, sexual harassment, exploitation of women at work and in educational institutions, and women's economic and social empowerment through work: issues which are political and hence central to development imagery across the globe. At the same time, the imagery used in television advertising continues to cast women into traditional femininities which are restrictive, reductive and sexist, focusing primarily on women's bodies and how they are controlled through patriarchal marriage, as well as women's reproductive and nurturing roles as wives and mothers. Such media representations discursively socialize girls and young women into traditional patriarchal notions of femininities, assigning them the roles of demure and submissive homemakers and thus repositioning them back within the domestic domain. Commercials seldom show men or boys making tea, serving food or doing housework; older, working and working class women are also conspicuous by their absence/invisibility. Thus, the counter-imagery in the commercials obfuscates the development images presented in the fictional narratives and discourses.

As feminist scholars of Western media have observed that 'mass-mediated feminism is as much about marketability as ideology' (Dow 26) and that 'the keen interest across the quality and popular media (themselves wishing to increase their female readers and audiences), in ideas of female success' (McRobbie 14) has been quite ambivalent and complex even in Western contexts:

> As feminist values are indeed taken on board within a range of institutions, including law, education, to an extent medicine, likewise employment, and the media, high profile or newsworthy achievement of women and girls in these sectors shows the institutions to be modern and abreast with social change. (McRobbie 257)

A discussion of media marketability is beyond the scope of this paper; however, I hope to have illustrated the ambivalences and complexities inherent within the competing discourses, ideologies and identities that are discursively constructed for women's consumption.

Notwithstanding the normalizing power of these media myths and imagery, the findings of the present study support the claim of earlier studies that young women negotiate and experience transcultural and shifting identities instead of wholly buying into the media imagery (Durham 201; Zubair 268).

Although the women in the focus groups found that the on-screen fiction resonated with reality in some ways yet simultaneously the way they speak disparagingly of this new imagery and narratives of development and modernity hints at the way the Western development narratives in particular those related to the themes of romantic and sexual relationships and women's participation in workforce – are received and engaged with by Muslim Pakistani women in this very different ethnic, socio-cultural and religious context. Through analysis of some media texts, and by placing these texts in the context of women's lives in which they are received and understood, I have illustrated how the media images function as political and ideological messages, influencing women's thinking and initiating meaningful discourse and negotiation about their social roles, social change and notions of development in the wake of globalization. The findings of this small-scale study reported here go some way towards confirming the findings of similar studies on the influences of

global imagery and globalization in African contexts in which young girls and adults both expressed concerns regarding the negative influences of this globalized imagery on young women. (Sommer 116–316). Similar results were reported about the polysemic nature of this visual imagery, in a study of images of girl's education conducted for the United Nations Girls' Education Initiative which showed ambivalence and plurality in the meanings the viewers derived from images (Mango and Kirk 30). 'Such polysemic potential(Fiske 1984 cited in Dow) is what makes television watchable by so many people and what allows its popularity' (Dow 20).

The research has demonstrated that the young women are confronted with the discourses of 'women empowerment' which are culturally and contextually contingent and that, in developing countries like Pakistan, women's understanding of their own identities (religious, social, familial) and their agency and resistance are contingent upon inter-related and asymmetrical cultural relations of power within patriarchal structures, cultural productions and capital.

## Notes

1. In February 2016, the interior minister of Pakistan announced a ban on Valentine Day celebrations deeming it a western import and cultural invasion which led to heated discussions and public debates on the media channels for a week or so, then died out without reaching any consensus. People in urban centres and upper echelons did celebrate it privately.
2. The advertisement has now been removed from channels after civil society groups and human rights organizations protested against the inherent sexism and humiliation of women. It is pertinent to mention here that recently it was reported in the news that a 12-year-old girl was so brutally beaten by her father for not making proper round bread that the beating proved fatal.

## Acknowledgements

This paper is an outcome of my research stay at the Center for Multilingualism and the Center for Gender Research at UiO, Norway funded by Scholars-at-Risk networks in Norway and NYC. I acknowledge with gratitude their support as well as the research facilities I availed during my stay in 2014–2016. I am also thankful to the editors and the referees of *South Asian Popular Culture* for their suggestions on the earlier drafts of the paper. The paper is from a project on transcultural issues in the teaching of English in Pakistan which earned me a senior fellowship at University of Duisburg-Essen, Germany during the summer of 2014.

## References

Ahearn, Laura M. "Literacy, Power, and Agency: Love Letters and Development in Nepal." *Language and Education* 18.4 (2004): 305–316. Print.
Butler, Judith. *Gender Trouble: Feminism and the Subversion of Identity*. New York: Routledge, 1990. Print.

Butler, Judith. *Bodies that Matter*. New York: Routledge, 1993. Print.

Butler, Judith, Ernest Laclau, and Slavoj Zizek eds. *Contingency, Hegemony and Universality*. London: Verso, 2000. Print.

Cameron, Deborah, and Don Kulick. *Language and Sexuality*. Cambridge: Cambridge UP, 2003. Print.

Fairclough, Norman. *Media Discourse*. London: Arnold, 2005. Print.

Fairclough, Norman. *Language and Power*. London: Longman, 1989. Print.

Foucault, Michel. *The Will to Knowledge: The History of Sexuality*, vol. 1. Trans. Robert Hurley. London: Penguin, 1976. Print.

Foucault, Michel. *The History of Sexuality Vol. 1. Introduction*. Hammondsworth: Penguin, 1980. Print.

Escobar, Arturo. *Encountering Development: The Making and Unmaking of the Third World*. Princeton, NJ: Princeton UP, 1995. Print.

Dow, Bonnie J, and Prime-Time Feminism. *Television, Media Culture, and the Women's Movement since 1970s*. Philadelphia, PA: Pennsylvania P, 1996. Print.

Durham, Meenakshi G. "Out of the Indian Diaspora: Mass Media, Myths of Femininity, and the Negotiation of Adolescence." *Growing up Girls: Popular Culture and the Construction of Identity*. Ed. Sharon R. Mazarella and Norma Pecora. New York: Peterlang, 1999. 189. Print.

Fiske, John. "Television: Polysemy and Popularity." *Critical Studies in Mass Communication* 3.4 (1986): 391–408. Print.

Grillo, R.D. "Discourses of Development: The View from Anthropology." *Discourses of Development: Anthropological Perspectives*. Ed. R.D. Grillo and R.L. Stirrate. Oxford: Berg, 1997. 1. Print.

Haider, Shirin. "Semiotics Ideology and Femininity in Popular Pakistani Women's Magazines." *Hawwa; Journal of Women of the Middle East and the Islamic World*. 7.3 (2009): 229–248. Print.

Hall, Stuart. "The Local and the Global: Globalization and Ethnicity." *Culture, Globalization and the World-System: Contemporary Conditions for the Representation of Identity*. Ed. Anthony D. King. Minneapolis, MN: University of Minnesota Press, 1997. 22. Print.

Khan, Shahnaz. *ZinaTransnational Feminism and the Moral Regulation of Pakistani Women*. Vancouver: University of British Columbia Press. 2006. Print.

Khurshid, Ayesha. "Islamic Traditions of Modernity: Gender, Class, and Islam in a Transnational Women's Education Project." *Gender & Society* 29.1 (2015): 98–121. Print.

Mango, Cathryn, and Jackie Kirk. "Sight Unseen: Re-viewing Images of Girls' Education." *Girlhood Studies* 3.1 (2010): 9–33. Print.

Mackinnon, Catharine. *Are Women Human? Nd Other International Dialogues*. Cambridge, MA: Harvard, 2006. Print.

McRobbie, Angela. "Post-feminism and Popular Culture." *Feminist Media Studies* 4.3 (2004): 255–264. Print.

McRobbie, Angela. "The Culture of Working Class Girls." *Feminism and Youth Culture*. Ed. Angela McRobbie. New York: Routledge, 1978. 61. Print.

Millet, K. *Sexual Politics*. London: Virago, 1970. Print.

Moi, Toril. *Sexual/Textual Politics*. London: Methuen, 1985. Print.

Mernissi, Fatima. *Beyond the Veil: Male-Female Dynamics in Modern Muslim Society*. Rev. Ed. Bloomington, IN. 1987. 159. Print.

Nussbaum, Martha. *Women and Human Development: The Capabilities Approach*. Cambridge: Cambridge UP, 2000. Print.

Sen, Amartya. *Development as Freedom*. New York: Alfred A. Knopf; Toronto: Random House, 2000. Print.

Sommer, Marni. "The Changing Nature of Girlhood in Tanzania: Influences from Global Imagery and Globalization." *Girlhood Studies* 3.1 (2010): 116–316. Print.

Street, Brian V. "Culture is a Verb: Anthropological Aspects of Language and Cultural Process." *Language and Culture*. Ed. D. Graddol and M. Byram. Clevedon: BAAL in association with Multilingual Matters, 1993. 23–43. Print.

Weedon, Chris. *Feminist Practice and Poststructuralist Theory*. Oxford: Blackwell, 1987. Print.

Woolf, Virginia. "Women and Fiction." *Collected Essays*. London: Hogarth P, 1966. 146–147. Print.

Zubair, Shirin. "Women's Literacy in a Rural Pakistani Community." *Languages and Literacies*. Clevedon: BAAL in association with Multilingual Matters, 1999. 198. Print.

Zubair, Shirin. "Literacies, Gender and Power in Rural Pakistan." *Literacy and Development: Ethnographic Perspectives*. Ed. B.V. Street. London: Routledge, 2001. 188–204. Print.

Zubair, Shirin. "Women, English Literature and Identity Construction in Southern Punjab, Pakistan." *Journal of South Asian Development* 1.2 (2006): 249–271. Print.

Zubair, Shirin. "Not Easily Put-downable: Magazine Representations and Muslim Women's Identities in Southern Punjab, Pakistan." *Feminist Formations* 22.3 (2010): 176–195. Print.

## Websites

ASER Report, 2005. 29 Jan. 2015. <http://www.aserpakistan.org/document/aser/map/Multan.pdf>. Web.

*Khuda aur Mohabbat*. Dir. Anjum Shehzad. Geo Television Channel. 2011. Drama. Web.

*Uraan*. Dir. Yasair Nawaz. Geo Television. 2010–2011. Drama. Web.

*Zip Bus Chup Raho*. Dir. Shaquielle Khan. Geo Television. 2011. Drama. Web.

*Ladies Park*. Dir. Nadeem Baig. Geo Television. 2011. Drama. Web.

Fair and Lovely. Dad and Daughter Ad. 27 Jan. 2015. <https://www.youtube.com/watch?v=kDMT9e5Wb2Y>. Web.

Cornetto Butterscotch ad. 27 Jan. 2015. <http://www.brandsynario.com/cornetto-butterscotch-celebrates-valentines-day-2014>. Web.

Sachs, Jeffrey. "From Millennium Development Goals to Sustainable Development Goals." *Lancet* 379 (2012): 2206–2211. <www.thelancet.com>. Web.

# Diasporic (dis)identification: the participatory fandom of *Ms. Marvel*

Winona Landis

**ABSTRACT**
This article examines Marvel Comics' decision to recast their heroine Ms. Marvel as a Muslim, Pakistani-American teenager. Specifically, I will investigate the ways in which Ms. Marvel's racialization challenges the conventions of American citizenship in the post-9/11 United States and how the comic depicts and constructs South Asian diasporic locations and subjectivities. My investigation includes an analysis of the comics and the external texts that surround these works, such as author and editor interviews, reviews, and various forms of public response. By reading the larger cultural materials surrounding *Ms. Marvel* in conjunction with theorists such as Gayatri Gopinath and Bakirathi Mani, I demonstrate the ways in which this popular visual genre becomes a vehicle for its producers to enact their South Asian/ American identities. Furthermore, *Ms. Marvel* invites South Asian/ American readers to do the same through engaged, participatory, and (dis)identificatory fan practice, which I theorize through the work of José Esteban Muñoz. Although I read *Ms. Marvel* through the consumer and coming-of-age experiences of young women in South Asian/American diasporic locations, I also demonstrate the possibilities of reading to identify with the character of Ms. Marvel across racial and ethnic lines. Such cross-racial identification may allow for a complex and politically powerful form of subject formation through (dis)identificatory reading and consumer practices.

Jersey City, New Jersey and its surrounding suburbs are a significant location in the context of both US immigration and Asian-American studies. Specifically, the metropole is marked by its noticeable South Asian diasporic population, which has been growing since the early 1980s. This racialized population has been the subject of criticism, ire, and hatred for nearly three decades. In 1987, for example, a gang of white men with the racist, xenophobic moniker 'The Dotbusters' harassed and beat several South Asian immigrants, with one of their victims ending up in a coma for over a week. A little more than two decades later, Joel Stein, a writer for *Time Magazine*, published a cringeworthy and supposedly humorous op-ed entitled 'My Own Private India,' in 2010. In his essay, Stein bemoans the fact that his hometown of Edison, New Jersey, named for the 'all-American' inventor Thomas Edison, has become

This article was originally published with errors. This version has been amended. Please see Erratum (http://dx.doi.org/10.1080/14746689.2017.1280955).

almost unrecognizable due to the influx of South Asian/American businesses and bodies. He expresses nostalgic longing for a time when his town was full of chain pizza restaurants and fast food establishments, rather than family-owned businesses serving curry and samosas (Stein n.p.). Cathy Schlund-Vials rightly explains that both the vicious attacks of the Dotbuster gang and Stein's racist article stem from a 'conservative politics of white victimhood based on an "understandable" anomie of racialized anxiety' (183). It is true that Stein claims he was only trying to be funny and the violence committed by 'The Dotbusters' did result in the passing of New Jersey's 'Bias Crimes' legislation, which called for greater punishment for perpetrators of similar hate crimes (Schlund-Vials 182). However, it is worth noting that in March 2015 the New Jersey Supreme Court struck down a crucial component of the Bias Crimes legislation, which stated that individuals cannot be convicted of a hate crime based only on the victim's perception that it was racially motivated (Zernike n.p.). This, in conjunction with the content of Stein's article, indicates that discomfort surrounding and animosity toward racial others in Jersey City has tempered, but is a problem that remains unsolved.

The timing of Stein's op-ed also points toward a renewed anxiety regarding supposedly unassimilable brown bodies in the wake of 9/11. Jersey City in particular is a short ride across the river from New York and is thus a location that would have been a literal witness to the terrorist attacks in 2001. The South Asian/American population therefore becomes the subject of racist rhetoric and targeting through their perceived connection and resemblance to the Muslims who perpetrated the attacks against the United States. Locations like Jersey City, then, are contentious and contested spaces through which Asian and American citizenship and identity are hotly debated and negotiated. Considering this, what can we make of the emergence of a literal hero from Jersey City, one who is framed as a vigilante protecting her hometown not unlike the Dotbusters, but whose heroic subjectivity is South Asian and Muslim rather than white?

This hero I refer to is the most recent iteration of the American superhero Ms. Marvel who, as her name would suggest, is part of the *Marvel* comic universe. Originally, Ms. Marvel's alter ego was Carol Danvers, a stereotypical blonde white woman with the powers of flight and superhuman strength who fought alongside her male counterpart Captain Marvel. In her newest form, or what is commonly referred to in the comics genre as a 'reboot,' Ms. Marvel's alter ego is now a 16-year-old Pakistani–American girl from Jersey City named Kamala Khan. Considering the fact that comic book fans are notoriously resistant to significant plot and character changes, coupled with attitudes toward South Asian/ Americans which I have previously mentioned, it seemed reasonable to assume that the reaction to changes in the *Ms. Marvel* franchise would be heated. And indeed, Stephen Colbert, a political performance artist specializing in lampooning right-wing beliefs and values, hyperbolically exclaimed in a segment on his satirical new show *The Colbert Report* that, 'Muslims can't be superheroes; for Pete's sake, they're on the no-fly list!' I therefore assumed that procuring a copy of the first issue would be all too easy when it was initially released in February 2014. I visited two comic bookshops, known for having a wide-selection, and neither of them had the comic in stock. Not, as I had figured, because of a resistance to the reboot, but because it was totally sold out. At one particular store, the clerk told me that they had even gotten in a second shipment but they simply 'couldn't keep it on the shelves.' The popularity of the new *Ms. Marvel* comic surprised me, but in hindsight perhaps it shouldn't have. Both the novelty of the new *Ms. Marvel* and its direct appeal to the South Asian/American reading public seems to indicate that this particular text carries a kind of critical weight among both collectors and casual readers alike.

The origins of this critical weight are twofold. First, it productively uses and reimagines comic book tropes and characters in order to craft what I argue is a specifically South Asian/American diasporic text. Its producers and writers make clear that Kamala's own (admittedly fantastic) coming of age draws on the personal experience of the text's creators and subsequently speaks directly to a South Asian/American and Muslim identity. The editor of *Ms. Marvel*, Sana Amanat is, like Kamala, a Pakistani–American Muslim and, as I will discuss later in this article, explicitly considered questions of her own identity when crafting the character of Ms. Marvel. In addition, *Ms. Marvel* is written by G. Willow Wilson who, although a white American woman, converted to Islam in college and spent several years living and writing in Cairo. Her religious practice allows her to be sensitive, thoughtful, and reflective about her representation of a Muslim superhero. Furthermore, she explains:

> I spent a lot of time talking to colleagues and friends of mine who have grown up with those hyphenated identities, who come from immigrant backgrounds – Arab or Pakistani, South Asian, African – and sort asking them, what was it like? What did you have to go through in high school, you know, growing up, that maybe is not as obvious to me or somebody who is not from that background? So I feel very strongly about these things and about the need to create space in which it is okay to talk about them. ("The Woman Behind Marvel's" n.p.)

The comic therefore engages with a specific racial, ethnic, and regional community in a meaningful way; one which complicates the definition of 'fans,' 'comic book readers,' and 'heroes.' At the same time, *Ms. Marvel* validates certain fan practices of personal identification, inviting readers to 'read themselves' into the comic and the character of Kamala Khan and, more importantly, to reconceive of the character to serve their own experiences. In this way, *Ms. Marvel* also invites its readers, to use José Esteban Muñoz's terminology, to disidentify with comic book heroes in general and Kamala more specifically, just as the young protagonist herself disidentifies with the hero from whom she receives her extraordinary powers.

When Kamala receives her super powers in a dream sequence brought on by exposure to a mysterious mist that descends on the city, she perceives that they are bestowed upon her by Carol Danvers, of whom Kamala is a great fan; she even has a poster of Carol Danvers in her new form as Captain Marvel in her bedroom. And when Kamala first 'transforms' into Ms. Marvel with her new abilities, she becomes a carbon copy of Ms. Marvel, complete with flowing blonde hair (Wilson, issue 2, 1). Notably, however, Kamala's personification of Ms. Marvel is not mere simulacra, but rather her donning of Ms. Marvel's 'drag' demonstrates the gaps and fissures that emerge in the continued performance of this superhero over distinct times and spaces. In the second issue, Kamala is depicted walking down the street in full Ms. Marvel gear, reflecting on the sense of frustration she feels in her current form. She thinks to herself,

> I always thought that if I had amazing hair, if I could pull off great boots, if I could fly – that would make me feel strong. That would make me happy. But the hair gets in my face, the boots pinch … And this leotard is giving me an epic wedgie. (Wilson, issue 2, 18)

In this moment, Kamala indicates that she is aware of the performative nature of her role as Ms. Marvel; that it is tied to certain iconic and recognizable images and embodiments. Moreover, she also shows that taking on this recognizable form does not provide the fulfillment that she was seeking. There is a noticeable, palpable tension between the outfit she wears and the way she actually feels. This tension evokes the practice of disidentification, which Muñoz defines as a potential 'mode of resistance' for marginalized groups. Instead of

merely identifying with dominant forms, bodies, and stereotypes or, conversely, disavowing or counteridentifying with them, disidentification allows marginalized individuals to adopt the dominant forms as a means of enabling critique and carving out a specific space for themselves where there was previously no such space. Often, disidentification involves a kind of performance of various roles and types, with an awareness of their performativity. It is therefore through a constant reiteration or repurposing of old forms, styles, and even icons that individuals like Kamala Khan and her readers find important ways to articulate and formulate their identities. To be more specific, the newest reimagining of Ms. Marvel leaves a certain amount of space for Kamala to develop her own identity and, similarly, prompts readers to look for moments and places of connection between themselves and the young hero. Kamala Khan's 'restaging' of Ms. Marvel serves to archive this decades old superhero and convey her history to current readers, while her own awareness and reflection on her performance create a space for her own South Asian and Muslim subjectivity and, as I will subsequently argue, the reader's subjectivity as well. Kamala is Ms. Marvel while at the same time she is also *not* Ms. Marvel, despite her appearance. And the citations embedded in the text exposes the productive tensions of her performance. As Kamala explains for the readers, '... [B]eing someone else isn't liberating. It's exhausting' (Wilson, issue 2, 18). *Ms. Marvel*, as hero and series, demonstrates the productive potential in the copy failing to completely and accurately resemble the original.

Kamala herself makes certain identificatory moves, as she is described as being 'into Avengers fan fiction' (Wilson, issue 2, 5).[1] Her identity as a superhero becomes connected to her identity as a consumer and fan of superheroes, and most notably one who is invested in certain reimaginings through fan fiction. Readers of *Ms. Marvel*, consequently, are scripted toward similar identifications and reimaginings, justifying their own fan and consumer practices, even (or perhaps especially) when they are resistant to the dominant narrative. In the final page of the second issue, for example, Kamala gazes at her poster of Captain (the former Ms.) Marvel, pondering her destiny as a superhero. She then uses her transformative, shape-shifting powers, but without morphing into a Ms. Marvel doppelganger. (Wilson, issue 2, 27). This moment, I argue, is one of productive and powerful disidentification. Kamala both identifies with this dominant, canonical figure, but adapts and (re)performs it to suit her own subjectivity. Furthermore, although Kamala ostensibly receives her powers from Captain Marvel, she is not written as a mere inheritor. In fact, as depicted in issue three, Kamala actively pursues the explanation for her sudden ability to stretch and shapeshift using the internet (or, as she refers to it, in recognizable millenial youth lingo, the 'interwebs'). She googles any and all related phrases, convincing herself that she 'can't be the only one that this has happened to' (Wilson, issue 3, 4). Rather than merely accepting her new identity, Kamala actively interrogates it and, moreover, seems to think she can find a community of others like her; what Muñoz might call a powerful 'counterpublic' (5). Kamala Khan, as Ms. Marvel, therefore provides a model for readers to engage in similar practices of (dis)identification, finding something recognizable in her character and her story, even in spite of (or perhaps because of) points of difference.

(Dis)identificatory readership of *Ms. Marvel* adds complexity to what is otherwise considered a flat and formulaic genre, placing the comic in line with other more 'serious'[2] or canonical visual forms like the graphic novel. And it is Kamala's development and growth that give it the *bildungsroman* quality that gestures toward its inclusion in this visual canon. *Persepolis* by Marjane Satrapi emerges as an obvious point of comparison, as both narratives

detail the identity struggles of young Muslim girls amidst political and cultural conflict. In fact, both *Persepolis* and *Ms. Marvel* have an autobiographical component, the former a bit more directly than the latter. In an interview with the *Washington Post*, Sana Amanat, the editor of the *Ms. Marvel* series, notes that part of the genesis of Kamala Khan's character came about from her own experiences 'what it was like to grow up in this country as a Muslim-American.' Like Kamala, Amanat says that she 'had all these questions' about her identity: 'Am I Muslim? Am I American? Am I Pakistani?' (Amanat n.p.) It is clear, then, that *Ms. Marvel* is noteworthy for not only being a female-created comic in a male-dominated industry, but also for demonstrating the ways in which authors and editors, even in serialized pop culture, often embed something of themselves in their work. And significantly, as a Muslim South Asian/American, Amanat has created a character who, although obviously not exactly like her, does provide something of a heroic counterpart – one which other young Muslim women would also undoubtedly admire. Gayatri Gopinath explores this kind of engaged readership through her analysis of queer South Asian diasporic texts, the goal of her project being to 'conceptualize diaspora in ways that do not invariably replicate heteronormative and patriarchal structures of kinship and community' (*Impossible Desires* 6). Specifically, in her review and analysis of Chitra Ganesh's visual art collection 'How Amnesia Remembers Roxanne,' which directly plays on the genre of the comic and graphic novel, Gopinath notes that in these female-centered 'revisions' of a classic genre, the 'girl/woman has untold powers, to create new worlds and other ways to inhabit bodies, time, and space' ("Queer Revisions" 471). By altering the subject and disrupting visual and generic expectations, Ganesh creates a critically diasporic cultural object. Similarly, I argue that *Ms. Marvel* can be read as a cultural object in this same vein as, although it utilizes certain comic book conventions, the reader is always aware that a young Muslim girl still exists beneath the flashy costume. Such an awareness is especially crucial for Muslim, South Asian/American, and even Asian/American readers broadly speaking, as their identities as heroes and as consumers are frequently overlooked and ignored. In fact, that *Ms. Marvel* as text does make use of superhero comic tropes, often purposely altering them to account for Kamala's notable differences, is further evidence of its productive use of disidentification as a means of subject formation through the creation of a '"disidentificatory subject" who tactically works on, with, and against a cultural form' (Muñoz 12). Reading Kamala and *Ms. Marvel* in this disidentificatory manner allows for an understanding of this text as not only a popular comic, but also as a 'diasporic text' that foregrounds 'female subjectivity' – a generic categorization that highly complicates expectations and understandings of comic books and their target audience.

More specifically, *Ms. Marvel* is a text that allows South Asian/American and/or Muslim readers to make sense of and articulate a space for their identities. In other words, they read themselves and their '[lives] in a moment, object, or subject that is not culturally coded to 'connect' with the disidentifying subject' (Muñoz 12). The aforementioned 'space' also becomes literal in the way that certain diasporic locations or 'localities' (to use Bakirathi Mani's term) are evoked. In *Aspiring to Home*, Mani writes that for South Asian immigrants (women in particular) part of defining themselves in relation to both their homeland and the United States involves a negotiation of 'locality,' which she defines as 'the means through which first- and second-generation immigrants of varying regional, linguistic, and religious backgrounds come to experience what it means to belong' (3). Kamala and her family live in Jersey City, a location marked by the strong South Asian immigrant presence, but

also by its diversity more broadly. Kamala's high school contains teenagers from various backgrounds (many of them Asian judging by their last names). Not only does Kamala feel an affinity for and desire to defend her own city, but this city is also legible and recognizable for readers who identify with Kamala. They are able to see themselves in Jersey City, attending Mosque, interacting with their various communities – South Asian and otherwise – and carving out a space for themselves in a location that, in its proximity to New York, also contains the lingering traces of 9/11. Therefore, *Ms. Marvel* renders Jersey City as an important diasporic location, one in which young South Asian Muslims like Kamala may 'make sense of citizenship, particularly cultural citizenship or everyday understanding of belonging and exclusion, a charged trope in the War on Terror' (Maira 10). Moreover, as Mani explains, South Asian/Americans come to know themselves as South Asian *and* as American through their consumption of various diasporic cultural objects, such as the Miss India USA pageant and popular Indian-American fiction. It is beyond simple representation; it is also about becoming. That is, the media that the South Asian/Americans at the heart of Mani's study consume is what enables them to be and to enact their subjectivity. Although Mani is speaking most concretely about Indian-American subjects, it is evident that Kamala herself comes to appreciate her multiplicitous subject position through both American and Pakistani cultural objects.[3] And crucially, she literally *becomes* Ms. Marvel (albeit with her own racial and ethnic twist) as a kind of climax of her fan and consumption practices. *Ms. Marvel*, therefore, invites readers (Pakistani, Indian, and otherwise) to participate in this same 'becoming' through consumption of her locally specific text.

Beyond locality, *Ms. Marvel* not only constructs a reading public, but also taps into one that already exists. Although South Asian/Americans are not commonly thought of as comic readers, there is in fact long history of comic culture and readership South Asia, specifically the Indian subcontinent. Karline McClain, in *India's Immortal Comic Books*, writes that Indian comic books, such as the widely read *Amar Chitra Katha*, were and are an integral part of articulating national and cultural belonging. As she states:

> …Indian comic books draw upon a long tradition of Indian visual and literary culture, and they have been especially influenced by the nationalist period in the late nineteenth and early twentieth centuries when popular images and texts were employed in India's struggle for independence from British colonial rule. Second, in indigenizing the comic book medium, these Indian comic books combine mythology and history, sacred and secular, in their effort to create a national canon of Indian *heroes*. (3, emphasis mine)

Indian comics, in style and structure, clearly draw from the Western superhero genre; however, they also craft specifically Indian and Hindu stories and characters in order for their readers to make sense of their history, their culture, and themselves. And not only are they read on the subcontinent, they are also recognized, consumed, and at time repurposed by South Asians in diaspora, as is evident in Chitra Ganesh's use of the familiar imagery in her artwork and Gopinath's appreciation of this fact as a viewer. More importantly, as I highlight in the previous quote, Indian comics create and depict *heroes* that their readers can admire and identify with, just as Kamala, in becoming Ms. Marvel, adds to this now transnational canon of heroes. Again, Kamala is not Indian, but rather Pakistani in heritage and this analysis should not suggest that the two can be readily interchanged. Rather, it is the fact that Kamala and *Ms. Marvel* has been taken up by Indian Americans – as I've learned in my conversations with various South Asian/American consumers – that signals some of the text's political and cultural power, suggesting the possibility of cross-cultural

and cross-racial fandom and coalition that may arise from the comics' appeal to varied transnational and diasporic publics.

In this regard, *Ms. Marvel* also becomes part of a legacy of Arab and Islamic comics, both from the Middle East and its diasporic locations. In *Arab Comic Strips*, Allen Douglas and Fedwa Malti-Douglas explain that, although comic readers do not often consider the Arab world as a source location for this popular genre, there is in fact a long history of comics emerging from this part of the world, both of the religious and secular variety. These comic strips, depending on their specific national location, are often explicitly political, which also means that, 'In the political environment of the Arab world, where formal censorship is ubiquitous, concern about the political and ideological content of comics is all the greater' (Douglas and Douglas 4). This anxiety surrounding comic content is exacerbated by the fact that comics often take children as their target audience – an audience that many feel must be 'protected.' However, 'even when comic strips are destined for children (the majority of the cases) their authors take them quite seriously as political and cultural products' (Douglas and Douglas 6). When reading *Ms. Marvel* through this culturally specific lens, one can see that, although on the surface her story is heroic and fantastic entertainment, her Muslim readers may also already be attuned to the political messages beneath the surface through their cultural and (trans)national readership practices. Just as with Indian comics, *Ms. Marvel* recognizes an existing, but often overlooked group of comic book consumers by crafting a superhero who moves beyond a purely Western context and location.

Despite this socially significant potential, what is noteworthy about *Ms. Marvel* is that, in the aforementioned interview, Amanat makes the claim that this comic is not political in nature, that it 'did not come about based on any agenda.' Instead, she explains that Kamala's popularity stems from the fact that her story is recognizable and easy to consume. In a review in the Washington Post entitled, 'Why Does Marvel's Reboot Succeed?' Sabaa Tahir[4] answers the question thusly: '[Kamala] could be a Latina or an African American, a descendant of Chinese immigrants or a blonde Daughter of the American Revolution. Her struggles will be familiar to anyone who has tried to figure out where they belong' (n.p.). In this way, Kamala is both a superhero and a kind of universal symbol of US girlhood, making her story that much more desirable, based on its proclaimed apolitical nature. This surface level disavowal of the religious and the political places *Ms. Marvel* in line with a particular Arab comic series marked by its Muslim characters: *The 99*. Created by Kuwaiti clinical psychologist Naif Al-Mutawa, *The 99* (which is a reference to the 99 names of Allah) features a wide swath of superheroic characters from across the globe, joining together to fight crime and, notably, terrorism. The heroes of *The 99* even teamed up with characters from DC Comics' *Justice League of America* to 'work together to save the planet from a worldwide threat and also help bridge the ever-widening gap between the West (especially the United States) and the East' (Alawadhi 272). Hend Alawadhi notes, however, that although the comic and its characters are framed by an explicitly Islamic origin story, *The 99* ultimately 'neutralizes' or fails to mention the faith and culture of its characters. '… [T]he plots in *The 99* rarely carry religious undertones. Aside from some of the characters having Muslim names, only five of the 50 heroines wear headscarves' (Alawadhi 269). It is this tempering that allows the series to be so internationally popular, even in the largely Islamophobic United States. Alawadhi writes that, 'Al-Mutawa neutralized Islam for many, including Muslim children, by simply promoting universal ideas and ethics' (276). It would seem, then, that to be truly popular and marketable, the differences of these characters must remain safe and palatable.

And the ethical and moral motivations must be framed as 'universal' rather than culturally and religiously specific. Like the heroes of *The 99*, Ms. Marvel is Muslim, but her Islamic background does not matter, it's a mere aspect of her unique cultural identity. She's an American hero for everyone.

Such a conception of Ms. Marvel is saturated in multicultural neoliberal rhetoric and good feeling that, of course, makes this reboot easy to market, but does not begin to touch on the real power of Kamala Khan. Admittedly, Kamala's synthesis of American and South Asian cultures is not altogether surprising and may indeed be what makes her so easy to connect with, not only for the dominantly situated white reader, but for her South Asian/American readers as well. In her study *Salaam America: South Asian Muslims in New York*, Aminah Mohammad-Arif writes of second-generation South Asian/American youth that:

> Externally, [they] look very American. This can be observed in their speech, in their accent especially, which makes it difficult on occasion for their own parents to understand them; ... They also display a desire for independence and intimacy; this last is often expressed by locking themselves into their bedrooms, which leads to surprise, even dismay in their parents, who see this as a most unusual way to behave from a 'South Asian point of view'. (91)

Kamala, with her interest in American popular culture and her resistance to her parents' protective and watchful eye, fits this image of teenage 'conformity' that Mohammad-Arif describes. In particular, Kamala both wants to appease her parents, but also desires the 'independence' that her newfound superpowers grant her. Her parents, as first-generation immigrants, often cannot understand Kamala's bold and secretive behavior, as evident when Kamala tries in vain to sneak in after a night of fighting crime, and is caught by her mother, who exclaims: '*Acha*. So *this* is how you repay your father and me for all that we have *sacrificed* to raise you!' (Wilson, issue 5, 10). Although second-generation South Asian youth ostensibly don't sneak out to fight crime, Kamala's rebellion and the pained response of her hard-working, self-sacrificing parents is undoubtedly an image that will resonate with these readers. Thus, Kamala's 'Americanization' and her resistance to cultural and religious traditions may appeal on a 'universal' level to white and South Asian/American readers alike.

On the other hand, many readers still make special note of Kamala's ethnic and religious background in their consumption of the text. In one of the comments left on Tahir's article, a user named Jamesonian states, 'Religion just wasn't an issue in the [comic] books I read, and I can't help feeling that including it as a primary character trait will make them less universal. Sad if true' (Tahir n.p.). Kamala's Muslim identity cannot be overlooked; it is important. And it would seem to almost undermine any claims to some kind of universal identity. Even though Amanat disavows any political motivations, one wonders if it is ever possible to create a strong Muslim character completely separate from the political atmosphere in which they're embedded, particularly in a post-9/11 United States and particularly by foregrounding the experiences of a young Muslim woman in the culturally diverse (and tense) Jersey City. 'Muslim' and 'Islam' are terms that carry heavy connotation and biases, and often evoke either the hypermasculine, extremist terrorist or the oppressed, veiled woman, at risk of arranged marriage and honor killing, who needs to be 'rescued' from her patriarchal oppressors. As an example, Amit Rai and Jasbir Puar, in their article 'Monster, Terrorist, Fag' note that in post-9/11 contexts, the War on Terror has been justified by the conception of Muslim men as hypersexual, racialized monsters, demonstrating both the US hegemony's belief in their violence toward their own women and also other (i.e. our) nations. In addition, Rai and Puar, as well as Shireen Roshanravan in her article, 'Post 9/11

Shifts in Racial Formation,' further illustrate the lengths to which this 'mistake' is corrected, within the Muslim community and the related South Asian community, who attempt to disavow or create distance between themselves and the terrorists – the 'bad guys' – through their heteronormativity and assimilability. Is Ms. Marvel, then, another attempt to correct this mistake, with her 'All-American' subjectivity and conventional family structure?

Maybe, but also maybe not. To take a particular moment from the text as an example of more nuanced reading of the representation of Muslims and Islam, I turn to the beginning of issue six, wherein Kamala's parents have ordered her to visit the youth leader of her local mosque, Sheik Abdullah, to seek penance for sneaking out and breaking curfew in order to fulfill her secret heroic duties. Kamala goes to the meeting with dread and assumes that Sheik Abdullah will chastise and lecture her. Instead, he listens to her (admittedly incomplete) explanation for her behavior – that she's been going out to help others who can't help themselves – and advises her to seek out a teacher. Kamala is stunned by his response and asks 'Wait – you're not going to tell me to be a good girl, focus on my studies, and do *istaghfar* (penance) or something?' (Wilson, issue 6, 6), to which Sheikh Abdullah replies: 'If I told you that, you'd ignore me. I know how headstrong you are. So instead, I will tell you to do what you are doing with as much honor and skill as you can' (Wilson, issue 6, 6). This exchange illustrates the complexity of with which this text defies expectations without relying on distance and disavowal. It is certainly the case that the dialogue between Kamla and Sheikh Abdullah serves to 'correct' certain misconceptions about Islam, particularly those related to the severity of its teachings and its attitude toward young women. However, it is noteworthy that Sheikh Abdullah recognizes Kamala's unique identity as independent and 'headstrong,' a word which the text chooses to bold for the reader, and does not necessarily equate these traits with 'Americanization' and assimilation. He encourages Kamala's vocation and character, and does so through his position as a religious leader and a decidedly Islamic context, which the reader cannot overlook because both he and Kamala are depicted in traditional dress (headscarf, cap, and salwar kameez) and seated on the floor of the mosque. Therefore, while *Ms. Marvel* does indeed recuperate negative portrayals of Islam in popular media, it does so in a way that does not simplify it or minimizes its important to Kamala's subject formation and even heroism.

Noah Berlatsky points to this productive tension when he explains that *Ms. Marvel* seems to offer the trope of an 'assimilation fantasy,' a means to fit in, gain popularity, and otherwise distance yourself from any marginalized status by virtue of superheroism, while actually repurposing it. He writes that:

> Superheroic assimilation is also complicated by the fact that, for Kamala … one's heritage is hard to separate from one's strength. Kamala finds the courage to use her newfound, not-quite-under control powers to save another girl after she remembers a passage from the Quran: 'Whoever saves one person, it is as if he has saved all of mankind.' She may look like Ms. Marvel on the outside, but that's just a costume. What's inside is Kamala, and part of who Kamala is, is her family, her religion, and her ethnicity. (Berlatsky n.p.)

Kamala's difference is important, as well as the many and varied ways she and her friends exercise and perform their difference from the dominant majority. For within the text, we are presented with several Muslim characters with complicated perspectives on their own identities. Kamala's brother is a devout Muslim who encourages her to attend Mosque and the youth lectures held by Sheik Abdullah more frequently, out of concern for her spiritual well-being. In addition, although Kamala does not wear a headscarf of any kind,

her friend Nakia or Kiki does and rather than being simply a sore subject between the two or a non-issue, it prompts difficult discussion and an awareness of the stereotypes that surround their subjectivity. For example, a less culturally adept friend asks, 'Your headscarf is so pretty, Kiki. But … nobody pressured you to start wearing it, right? Nobody's going to, like, honor-kill you?' (Wilson, issue 1, n.p.). It is noteworthy that Kamala understands the connotations that surround her identity, the misconceptions, and acts of racism (direct or inadvertent) that may arise. And I think that it is even more interesting that instead of outright attempting to correct such misconceptions within the text, Kamala and her author G. Wilson identify them, draw the reader's attention to them, but avoid being didactic. Indeed, Wilson's skill writing a compelling and believable female Muslim protagonist stems from her own experiences a Muslim woman from New Jersey, as well as her attentiveness to creating an 'authentic' teenage hero. In an interview with the online magazine *Vulture*, Wilson explains her inspiration for Kamala: 'I write about real life as it is lived by the young American Muslim women that I've had the pleasure of meeting throughout the course of my travels as a writer' (Riesman n.p.). Put another way, Wilson allows the stories and voices of actual Muslim women to emerge in characters like Kamala and her friend Nakia, lending a sense of thoughtful realism to an otherwise fantastic and 'geeky' text. For example, in a scene that takes place during a Saturday youth lecture at their neighborhood mosque, Kamala questions why women and men must be segregated during the service, citing the Koran in support. When her question is dismissed, Nakia tells her 'Don't bother,' but then both girls quietly sneak out of the lecture to go get slushies from the nearby convenience store. Nakia reassures Kamala by telling her, 'It's not like they're gonna notice we're gone' (Wilson, issue 3, 7).

In what I would also argue is a disidentificatory move, Nakia appears to adhere to her religious doctrine, while also recognizing its problematic quality and using these moments of disconnect as a (literal) escape. Despite Amanat's disavowal of any sociopolitical motivation, there are critiques and commentary nonetheless embedded in the comic, especially in Wilson's skillfully crafted dialog, which then become an integral part of the readership practice. Therefore, unlike Al-Mutawa's series *The 99*, perhaps *Ms. Marvel* does claim (if sometimes quietly) its Muslim background and framework in a manner that prompts identification, but also critique and political engagement. Sunaina Maira writes that, especially in the wake of the post-9/11 war on terror and earlier acts of (often violent) discrimination, there is a need to investigate the experiences of South Asian/American youth in order to 'help us understand the possibilities and limitations of agency and resistance in these everyday encounters with the state' (26). Within *Ms. Marvel*, it is evident that Kamala decides that, in order to protect Jersey City, she cannot rely on 'the state,' but instead must take matters into her own hands. While vigilante justice is a common plot point in superhero comics, Kamala's identity also illuminates the fact that 'the state' already excludes, overlooks, and chooses not to protect certain citizens and locations. She, therefore, becomes her city's alternative to state protection – and state violence. Similarly, South Asian/American consumers, who are not frequently interpellated as comic readers, demonstrate the discursive absence and the material presence of their subjectivity through their eager consumption of *Ms. Marvel*, what Maira would call an 'expression of cultural citizenship' (13).

On a broader consumer level, I argue that readers, even and especially those who are dominantly situated, are invited to figure out these moments of connection as well as notable difference as Kamala also navigates her own heroic *becoming*, which is complicated by

conformity as well as a desire for critical reimagination. This experience will likely often fail to produce clear-cut answers or even generate moments of discomfort. Perhaps, instead of relating to Kamala, for example, the readers will recognize their own biases, will realize that they too held misconceptions about Kiki's headscarf, that they good-naturedly, but problematically have been attempting to correct certain misconceptions and mistakes. What Ms. Marvel might instead be asking us to do is instead dwell in certain contradiction; to do as Roshanravan asks when she says, 'What if the attempt to 'correct the mistake' was oriented towards dialogue between those with whom we are mistaken instead of with those who do the mistaking as a justification for violence?' (155)

Because *Ms. Marvel* is a serialized text with no conclusion on the horizon, it has yet to be seen whether these productive moments of self-awareness, disidentification, and critical cultural engagement will continue in subsequent volumes. However, taken as an object, it is already apparent that *Ms. Marvel* is immensely popular to a degree that the producers perhaps did not fully anticipate. The speed and eagerness with which it is being consumed, while other new comics linger on the shelves, seems to signal that *Ms. Marvel* is doing something notably different. The difference, I argue, lies in the fact that Wilson's text invites readers and fans to *disidentify* with Kamala and to *participate* and engage with text, character, and author in ways that are meaningful to their own subject formation. *Ms. Marvel* has been constructed to speak to this particular generation of comic book readers and also invite them to respond in turn. It obviously speaks to the often overlooked female comic-book readership, especially fellow Muslims and South Asian/ Americans, as evidenced by the eagerness with which they have broken their silence to proclaim their affection for this new hero; a hero which they say *finally* speaks specifically to them. As Alawadhi notes, up until the present moment

> … Muslims who read superhero comics were forced to either identify with heroes who were unsympathetic to Muslims and/or Islam, thus creating a friction with their own identity, or not identify with the heroes at all, and lose a very important and basic experience of comics in the process. (268)

Despite its creators' reliance on the neoliberal rhetoric of sameness amidst difference, it is Kamala's distinct difference which creates an axis of identification for her readers, especially those who are members of the South Asian/American and Muslim diaspora. In a piece of fan mail published at the end of issue eleven, an avid and educator writes:

> As a high school English teacher in a diverse district with many Muslim students and the fifth highest rate of refugee enrollees, I want to thank the creators and editorial staff for the blessed gift of Kamala Khan. … [M]y students adore her – my students of ALL races. One of my girls has even started making her Kamala outfit for Comicon this year! Through Kamala, I have been able to draw out some of my shy, displaced and culturally isolated students through a character who they relate to and for that I can never repay you. (Wilson, issue 11, 28)

From this perspective, reconceiving a canonical Marvel superhero does hold important political power, whether the creators realize and claim it or not. And Kamala's power is tied directly to (dis)identification and imaginative possibility, not only for Muslim American readers, but for Asian/Americans more broadly. Kamala Khan, then, fills a specific gap for South Asian/American consumers, who have been waiting for 'comic book superhero' more like them. McClain explains that Indian comic books serve as a 'medium for identity formation' within the 'wider, intertextual context of public culture, both in India where a wide range of other visual media exist and where new comic book brands have now arisen, and

*transnationally among other world comic book cultures*' (23, emphasis mine). *Ms. Marvel*, I argue has become an integral part of the transnational space of 'world comic book cultures,' for although produced by a major comics publisher in the United States, it speaks directly to and allows for identification with a global South/Asian and Muslim reading public.

Moreover, *Ms. Marvel*'s emphasis on engaged and participatory readership is what allows for such powerful disidentification, as is evident from the reactions from students in the above letter, as well as from the more overt social critique that Kamala has facilitated. In January 2015, the American branch of the Freedom Defense Initiative, whose main cause seems to be to stand against the 'Islamization' of the US, took out advertisements on the sides of San Francisco transit buses that urged viewers to vilify Islamic nations. In response, an unknown fan painted over several ads with images of Kamala as Ms. Marvel, with speech bubbles encouraging viewers to instead 'Stamp out racism' and announcing that 'Free speech isn't a license to spread hate' (Wang n.p.) (Figures 1 and 2). In this instance, Kamala Khan literally moves beyond the panel borders and leaps off the page to become a crusader for justice and anti-racism, just as in Chitra Ganesh's diasporic reimaginings of Indian mythological comics, 'we are faced with the threat and possibility of the figures escaping the confines of the frame, spinning off and floating outside it' (Gopinath 471). The dynamic movement of Kamala is directly enabled by the way her readers connect with her and reconceive her. And, more importantly, these reconceptions allow Kamala and her fans to address other audiences, even (and especially) those in the hegemonic majority who

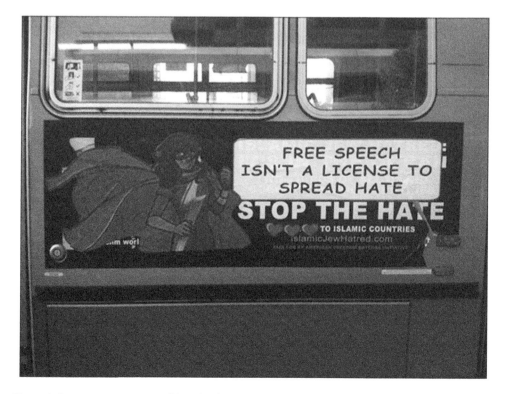

**Figure 1.** Anonymous street art of Kamala Khan as Ms. Marvel, pasted over Islamophobic bus ads in San Francisco. Images reproduced with permission from Street Cred - Advertising for the People.

might require a hero like Ms. Marvel to call them out and ask them to stand up against racism and violence, in spite of their differences.

Read in this way, *Ms. Marvel* prompts reader disidentification, as a means of deliberately restaging or reappropriating previous cultural objects in novel ways to provide an important platform for marginalized voices, as well as to justifiably question and critique the canonical original. As Alwadhi notes in reference to *The 99*, heroes like them and like Kamala,

> are a stark contrast to the Muslims depicted in many mainstream comics such as X-Men, but they are slowly, yet surely, creating a counter narrative of Muslims utilizing the same medium that has been entrenched in racial and religious prejudice against them for far too long. (276)

These counter narratives operate beyond simply a United State framework, as is evident from other such emergent heroes in Muslim nations, such as Pakistan's Burka Avenger and Egypt's web-based hero Qahera, both of whom fight injustice and inequality on the streets of their respective home nations. These female heroes become an axis of connection for their readers and viewers. Thus, conceptualizing Kamala and others like her through the framework of disidentificatory counter narrative should also (and, I argue, does in fact) push us to think outside of our own dominant subjectivity, to realize when we are siding with those who do violence rather than those who fight against violence. Kamala Khan as Ms. Marvel and this comic as a text have the ability to recast those individuals who might have been villains or victims as heroes and those who Joel Stein would deem cultural invaders as courageous protectors of a locality they call home.

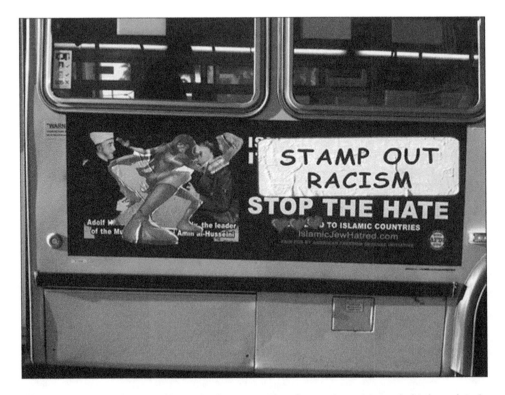

**Figure 2.** Anonymous street art of Kamala Khan as Ms. Marvel, pasted over Islamophobic bus ads in San Francisco. Images reproduced with permission from Street Cred - Advertising for the People.

## Notes

1. The Avengers, for clarity's sake, are a team of some of Marvel's most popular superheroes. They are not the only Marvel characters to make an appearance in *Ms. Marvel*: in issues six and seven Kamala teams up with Wolverine of the X-Men, but turns down an invitation to become a member of the crime fighting team.
2. I place this term in quotation marks to indicate that I take issue with this dichotomy, but nonetheless, it does exist for both casual readers and critics alike.
3. When Kamala makes her first superhero costume, for example, she repurposes a conservative South Asian and Muslim swimsuit which she refers to as a 'burkini,' clearly adapting an object of her ethnic background into an icon of her heroism and her hybrid identity.
4. Tahir is also a Pakistani Muslim woman, which is again very suggestive of the kinds of readers who are consuming and feel they have a stake in the character of Ms. Marvel.

## Disclosure statement

No potential conflict of interest was reported by the author.

## References

Alawadhi, Hend. "Reclaiming the Narrative: The 99 and Muslim Superheroes." *International Journal of Comic Art* 15.2 (2013): 268–77. Print.

Amanat, Sana. Interview. "Meet the New Ms. Marvel: A Muslim Teenager." *Washington Post TV*. 2014. Web. 23 Nov. 2014.

Berlatsky, Noah. "What Makes the Muslim *Ms. Marvel* Awesome: She's Just Like Everyone." *The Atlantic*. n.p. 20 Mar. 2014. Web. 23 Nov. 2014.

Colbert, Stephen. "Ms. Marvel's Reboot." *The Colbert Report*. Comedy Central. Nov. 2013. Web. 23 Nov. 2014.

Douglas Allen, and Fedwa Malti-Douglas. *Arab Comic Strips: Politics of an Emerging Mass Culture*. Bloomington: Indiana University Press, 1994. Print.

Gopinath, Gayatri. "Chitra Ganesh's Queer Revisions." *GLQ* 15.3 (2009): 469–480. Print.

Gopinath, Gayatri. *Impossible Desires: Queer Diasporas and South Asian Public Cultures*. Durham: Duke UP, 2005. Print.

Maira, Sunaina Marr. *Missing: Youh, Citizenship, and Empire After 9/11*. Durham: Duke UP, 2009. Print.

Mani, Bakirathi. *Aspiring to Home: South Asians in America*. Stanford, CA: Stanford University Press, 2012. Print.

McClain Karline. *India's Immortal Comic Books: Gods, Kings, and Other Heroes*. Bloomington: Indiana University Press, 2009. Print.

Mohammad-Arif Aminah. *Salaam America: South Asian Muslims in New York City*. New York: Anthem Press, 2002. Print.

Muñoz, José Esteban. *Disidentifications: Queers of Color and the Performance of Politics*. Minneapolis: University of Minnesota Press, 1999. Print.

Puar, Jasbir K., and Amit Rai. "Monster, Terrorist, Fag: The War on Terrorism and the Production of Docile Patriots." *Social Text* 20.3 (2002): 117–48. Web. 14 May 2014

Riesman, Abraham. "Meet G. Willow Wilson, the Muslim Woman Revolutionizing Superhero Comics." *Vulture*. n.p. 24 Mar. 2014. Web. 5 Aug. 2015.

Roshanravan, Shireen. "Post 9/11 Shifts in Racial Formation: Tracing Complicity and Mapping Possibility for U.S. South Asian Community." *Works and Days* 29.57/58 (2011): 143–57. Print.

Schlund-Vials, Cathy. "Epilogue: 'A Sense of Loss and Anomie:' Model Minorities and Twenty-first Century Citizenship." *Modeling Citizenship: Jewish and Asian American Writing*. Philadelphia, PA: Temple UP, 2011. 177–84. Print.

Stein, Joel. "My Own Private India: How the Jersey Town Named for Thomas Edison became Home to the All-American Guindian." *Time Magazine*. 5 Jul. 2010. Web. 2 Dec. 2014.

Tahir, Sabaa. "MS. MARVEL: Why Does Marvel's Latest Book Succeed? Because its New Muslim Teen Superhero is 'sweet, conflicted and immensely relatable'." *Washington Post*. n.p. 4 Feb. 2014. Web. 14 May 2014.

Wang, Frances Kai-Hwa. "Comic Heroine Ms. Marvel Saves San Francisco from Anti-Islam Ads." *NBC News*. n.p. 27 Jan. 2015. Web. 5 Aug. 2015.

Wilson, G. Willow. *Ms. Marvel* (volumes 1–11). New York: Marvel Comics, 2014. Print.

"The Woman Behind Marvel's Newest Team of Heroines." *NPR: All Things Considered*. n.p. 22 Feb. 2015. Web. 30 Sept. 2015.

Zernike, Kate. "Part of New Jersey's Bias-intimidation Law is Ruled Unconstitutional." *New York Times*. n.p. 17 March 2015. Web. 5 Aug. 2015.

# Visualising caste: *A Gardener in the Wasteland* and the politics of graphic adaptation

Deepali Yadav

**ABSTRACT**

In this article, I look at the graphic adaptation of Phule's *Gulamgiri* (1873) (also known as *Slavery*) and argue how visuality offers a unique approach in the understanding of caste in contemporary Indian society. I explain how the genre, through its pictorial description, extends *Gulamgiri*'s critique of Hinduism by including modern-day debates over caste discrimination. Some of the questions that I discuss in the article include: the necessity of adaptation of a nineteenth-century historical text through the medium of a very nascent contemporary Indian genre; why the issue of caste that has been exhaustively discussed and had stood strong throughout time is being revived by contemporary writers; how the narration in graphic novel form reconfigures (or resembles) the original text and, lastly, does the graphic novel help or hinder in conveying the holistic understanding of the problem of caste from Phule to present times.

## Introduction

The reason behind the growing interest in the adaptation of sociopolitical issues in a graphic genre can be understood in terms of what Sidonie Smith explains in her article 'Human rights and comics':

> Governments [and comic artists of today] too are targeted for employing comic books to propagandize their version of political events, personages, or groups to a broad public and exploiting the mass appeal of the comic form to demonize those they consider 'enemies of the state' … They educate readers in the rights discourse, naming conditions as violations of universal rights, identifying the subject positions of the 'victim', 'perpetrator' and 'rescuer' … (Chaney 62)

I respond here to representation of patterns of historical oppression in the graphic novel form by looking at Aparajita Ninan and Srividya Natrajan's *A Gardner in the Wasteland: Jotiba Phule's fight for Liberty*. This graphic novel is an illustrated revisiting of Jotiba Phule's nineteenth-century text *Gulamgiri* (1873) – English translation: *Slavery* – written primarily in Marathi and later published with an English introduction in 1885. The adaptation of *Gulamgiri* in the graphic form through *A Gardner in the Wasteland* (2011) has been more successful in generating awareness of Dalit marginalisation in contemporary India

than the original text. It has achieved this through its linking of the dark days of past caste-based exploitation to that of the same in the present day. By drawing a trajectory of caste exploitation through newspaper articles, demolition of mosques, and Scheduled Caste reservations, the graphic novel has highlighted the ways in which caste discrimination is channelled through child labour, religion and education respectively without limiting itself merely to a direct relationship between Brahmins and Dalits. In addition to exploring the ways in which caste-based oppression is practiced, I also examine the very concept of the graphic novel, which according to Eddie Campbell is generally used in four distinct ways:

> First, it is used simply as synonym for comic books ... Second, it is used to classify a format-for example, a bound book of comics either in soft- or hardcover- in contrast to the old-fashioned stapled comic magazine. Third, it means ... a comic book in narrative that is equivalent in form and dimensions to the prose novel. Finally, others employ it to indicate form that is more than a comic book in the scope of its ambition- indeed, a new medium altogether. (13)

According to Witek, it is preferable to explain social issues in the graphic novel form '... because of the complexity in representation that a mix of illustrative material and written word allows' leading to a unique approach in an understanding of the issue (245).

*A Gardener in the Wasteland* justifies Witek's claim by bringing diverse narratives of caste together and simultaneously visualising them to reveal multiple arguments floating in the public sphere to condemn the caste based structure of Indian society. *Gulamgiri* is a 'scathing and witty attack on Brahmanism and the slavery of India's "lower" castes that it engendered' (Ninan and Natarajan Cover page). Ramchandra Guha in *India after Gandhi* (2007) ironically highlights the significance of caste in India as, 'a principal identity for many Indians, defining whom they might marry, associate with and fight against' (Guha xix). He defines caste as:

> 'Caste' is a Portuguese word that conflates two Indian words: *jati*, the endogamous group one is born into, and *varna*, the place that group occupies in the system of social stratification mandated by Hindu scripture. There are four *varnas*, with the former 'Untouchables' [known as Dalits] constituting a fifth (and lower) strata. Into these *varnas* fit the 3000 and more *jatis*, each challenging those, in the same region, that are ranked above it, and being in turn challenged by those below. (Guha, xix)

In *A Gardner in the Wasteland*, Ninan and Natarajan, have explained, the evils of this hierarchy-based caste system in visual form by illustrating the ways in which Dalits have been exploited, humiliated and tortured for their lowest caste by Brahmins who are proud to belong to the highest of all castes. I intend to make this multi-divisional caste structure a point of entry to explain how the brand new genre of the graphic novel, through its pictorial description, has freshly experimented with an age old evil of caste as narrated in *Gulamgiri*'s critique of Hinduism. Nonetheless, picture books are not at all a new genre in India. Emma Dawson Varughese in *Reading New India: Post-Millennial Indian Fiction in English* highlights the lineage of comic books in India through *Amar Chitra Katha* (ACK) series from 1967 onwards. This implies that the idea of the graphic novel in India is derived from comic books like *ACK* that had already laid foundations of informing children and adolescents about various Indian historical events and tales as its subject matter. But the two forms, comics and graphic novel, differ in the treatment of the very same historical content which they seek to explain in them. Anant Pai, the creator of *ACK* series says:

> This is the motto I work under: 'One must tell the truth, one must tell what is pleasant; but don't tell what is unpleasant just because it is true ... You know, we promote integration through

*Amar Chitra Katha*' … For Anant Pai, the central characters of the comics must be heroes, and that any violent actions or other repugnancies they have committed must be minimized. (McLain 156)

In contrast to this idea of Pai, a graphic novel like *A Gardener in the Wasteland* is a step forward in such retellings of Indian history where the creators of the novel have chosen to depict even violent and ugly episodes without sanitising any part of the caste based history.

According to Phule, the tenets of Hinduism have been moulded by Brahmins to mark their supremacy over Dalits and thus justify their control over all other Hindu communities as their moral and ethical right. The image of Phule, as represented by the author and artist in the graphic novel, explains how Brahmins formulated *Manusmriti*, a Sanskrit text written by Manu in second century BCE, to serve their selfish interests by prioritising themselves at all levels of human life. It is important to mention that a copy of this text was later burnt as a symbol of protest in 1927 by Bhimrao Ambedkar, the most scathing crusader against the caste system, to mark his support for Dalits and as a sign of his parting ways with Hinduism.

*A Gardner in the Wasteland* visualises many stories mentioned in *Manusmriti*, including the birth of the Brahmins. According to this story, Brahmins were born from the mouth of Brahma (the Absolute) who is considered the supreme god in Hinduism. This privileged birth gave them a reason to justify their superiority over other gods as well as humans, making them extremely pious and different from other defiled castes. *A Gardner in the Wasteland* very skilfully illustrates the contrasts between such fabricated tales of *Manusmriti* and their actual accounts if seen without Brahmanical prejudices. These contrasting images meant for deconstructing the *Manusmriti* myths are widely spread out on entire pages of the novel offering ample space and time for their internalisation rather than making the reader struggle to find its meaning in the density of tightly placed panels.

The politics of adaptation of a nineteenth-century text in a very nascent contemporary genre calls forth an analysis of some extremely serious questions. Why is *Gulamgiri* being revisited in the contemporary moment? Why is the topic of caste being revived by contemporary writers? How does its narration in the graphic novel form differ from or resemble the original text? Does this genre help or hinder in conveying the holistic understanding of the problem of caste from Phule to present times?

## History in the graphic novel

The back cover of *A Gardener in the Wasteland: Jotiba Phule's fight for Liberty* describes it as, 'perhaps the first time that a historical work of nonfiction has been interpreted as a graphic book in India' (Ninan and Natarajan Back cover). The question is why did the graphic novel's author and artist conceive of the idea of representing a historical subject in visual form? The reason behind this unique combination of subject and genre may be found in the argument which states 'that history itself is not simply the open book of the past but rather a story which requires continual interpretation and thoughtful re-examination' (Witek 93). This implies that delving back into history and interpreting the additional meanings that it presents requires experimentation, not just in viewpoints, but also in terms of the genre employed. The graphic novel form, through its use of illustration, has a more direct and instant method of eliciting an immediate response in readers. The images used to depict historical facts present reality in ways that words cannot. The factor that leads to the preference of the graphic novel, instead of exclusively written ones for historical subjects, is that

such texts add to the claim of accuracy. By witnessing the character visually the reader feels close association with the narrated 'I' where they can easily believe in the experiences of the character. Rather than presenting objective truth like the written texts, the graphic novel is able to reach the subjective self of the person by picturing the emotions and psychological situations of the characters. Thus, the genre's truth claim becomes more intense and deep where a reader is able to get extremely close to the narrated characters. In this context, Leigh Gilmore says that graphic novels operate in a 'seemingly substantial [manner where the subject can claim] 'I was there or I am here'. The visual presence of this figure is made all the more 'substantial' when transposed in comics/[graphic novel]' (Chaney 7).

Historical graphic novels are an important medium for raising awareness of serious issues, even among children of a relatively young age, as they offer one of the few means of combining education with entertainment through its 'short and easy' and at the same time 'attractive and readable' format (McLain 13). The genre has been extensively used in India as a way of providing knowledge of complex and abstract episodes of history which are difficult to project for children in mainstream verbal narratives. For example, explaining Buddha's wisdom to children via the medium of comics can be done with a straight forward pictorial representation of a halo emitting rays, a symbol of religious iconography. In *A Gardner in the Wasteland*, each chapter has a defining visual that supports the title of the chapter. The title page of the first chapter 'The wasteland of caste' has a picture of dirty land littered with broken objects and wild plants with flies hovering over them. This is how the visual acquires significance in passing a hint over the filthiness of caste. By drawing a parallel between an actual wasteland as depicted in the image to that of the wasteland of caste, it is made easy for readers to develop an understanding of caste being as ugly as the symbolic visual. The last chapter, titled 'The seeds of change', features a picture of flowers drawn on the tip of the pen nibs. This is one among many implications of education as a major tool in erasing the evil of caste. Talking about how 'traumatic histories of marginalisation and violence' fit well into the graphic novel genre, Chaney says, 'Adapting this persistent form in often-arresting ways, they unsettle readers with their combination of "high" subject and "low" or "mass" form [mainly] associated with limited literacy, juvenilia, renegade outsiderness, or fantasy superheroism' (Chaney 67). Thus, a graphic novel like *A Gardener in the Wasteland* offers new ways of understanding caste that are accessible to readers of all ages.

## Alternate mythologies

At the start of *A Gardner in the Wasteland*, Ninan and Natarajan explain why they consider Phule to be more important than any other author writing on the subject. To them, Phule appears as a superhero who could '… swoop down out of the sky and kick the baddies to bits' (Natarajan and Ninan 9). They write: 'You know, Phule was one of the few people who asked the question: so who made up these stories? Who derived legitimacy from these legends? And why should one follow Vedas?' (30). With an urge to return to the basics and search for answers to the universal problem of caste, Ninan and Natarajan considered *Gulamgiri* perfect for revival in the present day. In the words of Gail Omvedt, a renowned writer on the Dalit cause, Phule is significant and unique because of his 'alternative mythology … [which] evoke(s) an image of … anti-Vedic, anti-Aryan and anti-caste equalitarian message with its use of poetry, dialogue, and drama [that] could reach beyond the literate elite' (Omvedt 26). In other words, Omvedt finds Phule's strategy apt to question the origin of Brahmins

– their extremely respectable and pious status in Vedas and their lineage from the supreme Aryan race – in order to be able to respond to complex question of caste discrimination today. It was Phule first who objected to segregation of humanity into different levels on the basis of religious scriptures as mentioned in the Vedas. *A Gardner in the Wasteland* very artistically draws both – the ignored reality and the prevalent falsehoods – about Brahmins and allows the audience to make up their own minds on the truth of the matter. Phule, while conversing with Dhondiba, lays out the dubiousness of these mythical stories, said to be a part of very sacred Vedas, explaining how they were primarily written by Brahmins as a means of gaining authority over other communities and were subsequently passed on to future generations in the name of religious scriptures. The visuals in the novel explain how Brahmins deluded everyone about their ancestors, Aryans, whom they refer to as the original inhabitants of India, whereas the reality is explained by Phule in the chapter 'The weed-bed of myth':

> the Aryans, who call themselves Brahmans today are said to be descendants of the Indo-European race – the same stock as Persians, Medes and other Iranians. They crossed the great Himalayan divide to the Hindu Kush where they were confronted by the aborigines. What followed was a struggle for ascendancy, about which the Brahmans have fabricated absurd myths in their Vedas and passed them off as history. The wars of the Devas and Daityas or the Rakshasas, about which so many fictions are found scattered through the sacred books of the Brahmans, are certainly a reference to this primeval struggle. (Ninan and Natarajan 34–35)

In the novel, Phule's dialogue with Dhondiba reveals the cunningness of the Brahmins who deify themselves and greedily take away even the basic rights of liberty, fraternity and equality from the Dalits. The dialogic technique employed in the novel between Dhondiba and Jotiba is helpful in distinguishing the truth from fiction, where one character speaks the truth and the other is providing a constructed fiction that the Brahmins are exploiting to maintain their hierarchy of caste. Jotiba provides Dhondiba with a brief overview of the Brahmin invasion in India and emphasises the need for logic and commonsense prior to considering any ridiculous and baseless Vedic claim as truth:

| Dhondiba: | So how did the first Aryans get here? |
|---|---|
| Jotiba: | They came by sea |
| Dhondiba: | But the Brahmans have written that Matsya was born of a fish. |
| Jotiba: | In fast-moving canoes. That was why the chief of the earliest horde was called Matsya. Use your head, Dhondiba. Do you see any similarity between fish and man? (37) |

The keyword to notice here is 'see'. Here, the creators of *A Gardener in the Wasteland* not only intend to draw viewer's attention on the illustration of a fish and man drawn in one panel but also acts as a pun by making an indirect comment on viewers who, like Dhondiba, readily believe even the most nonsensical assertion of *Manusmriti*. When the viewer looks at the image, s/he immediately sees the difference between two images –a fish and a man deliberately drawn on the same page. The first picture, or Brahmanical projection, of a Brahmin being born out of fish's mouth offers a very pleasant and beautiful image, but the same image also turns grotesque, resulting in the shattering of this mythical projection. This illustrative description leads to an awakening of our consciousness in a way that is difficult for a verbal description to achieve. When we see a body of a human and fish forcefully put together to form one being we come to appreciate the absurdity of the story.

Again, the distinction between fiction and reality is highlighted in the chapter 'Roots of tyranny', where a mere glance is sufficient to illuminate both aspects of the story. The panels are drawn in two columns, showing 'Brahman's Perspective' on one side and 'Phule's Perspective' on the other. The two perspectives are illustrated as a kind of mirror image but they inherently contain some significant differences between them. This was a deliberate effort on the part of the artist to illustrate that the two elements – the Vedic stories and their practical implication –generally considered to be the same by the believers of caste, do in fact contradict each other in reality. The contradiction is expressed neatly through the positioning of the images. The binaries of Phule and Brahmin, masked and unmasked illustrations of Brahmins drawn simultaneously, emphasise the importance of questioning even the obvious, as the very obvious can at times be objectionable. Drawing the panels in this way lays everything out for the viewer, with no scope for doubt or further imagination. As a result, the graphic novel outdoes verbal narrative, where, in the case of the latter, readers have to use their mental abilities to strike out differences. The horizontally drawn panels offer ample space to sketch both perspectives (real and mythical) and offer an exact retelling of distorted Brahamanical history in India.

## Critique of nationalism

> … two forms of opposition to Hindutva – the 'secular' and 'Hindu reformist' versions – draw respectively upon Nehruvian and Gandhian traditions. While there is no reason to doubt the genuineness of their attempts to oppose the aggressive politics of the Hindutva forces, what is questionable is that they accept the validity of the general identification of 'Hindu' with 'Bhartiya' of Hinduism with the traditions of India. (Omvedt x)

In *A Gardner in the Wasteland*, it is evident that Ninan and Natarajan draw heavily on the aforementioned argument by Omvedt, substituting Indianness with Hinduism, and vice-versa, during India's struggle for freedom which after a point transformed into a religious movement. The author and artist discuss their doubts in the novel as to what constituted nationalism in India and how some Hindu fanatics at the time of colonisation misinterpreted nationalism by making it a religious affair of Hindus. The graphic novel points out how Hinduism came to be seen as a way of attaining freedom during British rule in India. The illustrations of Bal Gangadhar Tilak and M.G. Ranade in *A Gardner in the Wasteland* are examples of how they yearned to make India free from the British but without any reforms in 'ancient customs and traditions' (Ninan and Natarajan 88). Quite effectively in the novel, the propagators of Hindu Raj are well supplemented with the figures of V.D. Savarkar and M.S. Golwalkar, who supported the Hindu way of life as the only way of life for Indians. Vijay Bhatt, a VHP candidate (Vishva Hindu Parishad, a political party) while assisting Christiane Brosius, a critic on visual politics in India, explains about the working of Hindutva politics in 2003 opines, 'To make a nationalist is difficult. But it's easy to make a man religious. Because *it's in our blood.* In Indians' blood' (Brosius 270). V.D. Savarkar was an extremist Hindu activist who became the leader of Hindu Mahasabha in 1937. Being a leader of such an organisation, he frankly idealised India as a 'Hindu nation' and later conceived the slogan 'Hinduize all Politics and Militarize Hindudom' (Joglekar 137). He also wrote a book, *Essentials of Hindutva*, in which he explained about the importance of being a Hindu and urged people to follow the Vedas in order to realise the dream of a Hindu nation. Hence, Savarkar and other Hindutva leaders are portrayed as sharing the similar aspiration

of turning Indians Hindu rather than patriotic as a means of gaining independence. In the words of Gail Omvedt, 'Savarkar was the first to proclaim a full-Hindu nationalism or Hindutva, linking race, blood and territory' (3). *A Gardner in the Wasteland* through a full-page panel, depicts Savarkar wearing a dhoti and coat with a cap on his head. This cap has come to be considered an important emblem of his personality, and right up to the present day, people believe in his principles and often show their support by wearing similar caps. It is ironic that the same Brahmins whom Savarkar addresses as 'O hindus! Consolidate and strengthen Hindu nationality' are seen in the very same panel engaging in such vile acts as drinking cows' urine in an attempt to purify themselves from the Dalit's touch (Ninan and Natarajan 90–91). This two-page illustration with Phule almost at its centre, looking at both sides, cleverly depicts what it would mean to make India a complete Hindu nation.

Even Gandhi's philosophy of Ram-Rajya, derived from Hindu mythology, a certain type of utopia, is criticised in the text and is thought of promoting Hinduism over nationalism. According to Ambedkar:

> untouchables occupied a 'weak and lowly status' only because they were a part of the Hindu society. When attempts to gain equal status and 'ordinary rights as human beings' within the Hindu society started failing, Ambedkar thought it was essential to embrace a religion which will give 'equal status, equal rights and fair treatment' to untouchables [this justifies his inclination to Buddhism]. He clearly said to his supporters 'select only that religion in which you will get equal status, equal opportunity and equal treatment …'. (Ambedkar.org)

Hence, Gandhi, by convincing people to fight for Ram-Rajya, is indirectly being 'spokesman for upper-castes interests … His clash with Ambedkar at the Second Round Table Conference showed that he put his identity as a Hindu before that as a national leader' (Omvedt 5–6). Thus, not only Brahmins, but many freedom fighters, like Gandhi, have been reconsidered in *A Gardener in the Wasteland* in the light of their caste-based inclination and found guilty of endorsing Hinduism as a way of attaining freedom.

## Past and present

Constantly shifting between two time frames the Indian invasion of Brahmins, centuries ago around 1500 BCE, and modern India in 1900s (twentieth century A.D.), the author and artist have deftly brought together past and present to run parallel with each other throughout the novel. There is a co-relation between Phule's stories of the past and those taking place in the present, implying that caste inequality is a universal problem that continues to exist despite the many social reforms and anti-slavery movements of the past. One such case where this continued presence of slavery can very clearly be seen is through the descriptions of Negro slavery in America and bondage labour in Tamil Nadu, taking place visually side by side. The creators of the graphic novel have skilfully balanced the discussion of Negro slavery in America with a newspaper cutting offering an insight into the lives of Dalit children held captive and forced to work in the southern part of India. The panel with the Negro slaves running away from their masters reminds us of their inhumane treatment and the helplessness which they once experienced at the hands of their white masters. Similarly, when we read about Dalit children being saved from 'bondage … from a brick kiln', we see that there is no difference between the two slaveries but we continue to talk about these similar kinds of slaveries in different nomenclature and definitions (26). The illustration through

the motif of the newspaper cutout is useful in highlighting how openly inhumanity against Dalits continues without anyone bothering to oppose it.

Another example of unity between the past and the present can be observed in the illustrations of the 2002 Gujarat riots. Phule narrates the story of mythical Brahmin leader Parshuram, pompously described by Brahmin's as a philanthropist, but according to Phule:

> He lives by such a barbarous code, that he did not hesitate to behead his own mother, Renuka. He hunted down all the male progeny of kshatriya clans ... captured pregnant kshatriya women ... and killed their male children as they were born. (61)

Similar to the way in which Brahmins have been indifferent to the pains of other communities, the argument has been extended to the reign of Narendra Modi as chief minister of Gujarat, when, during the 2002 riots, numerous Muslims were ruthlessly murdered. *A Gardner in the Wasteland* depicts Modi playing a harp is a sign of him not being sufficiently vigilant in controlling this mass atrocity against the Muslim community. This reaction on part of Modi is quite objectionable to the author and artist, in one panel where he, either oblivious to his surroundings or paradoxically all-knowing, is surrounded by acts of murder, rape, theft, robbery and rioting against Muslims. At this instant, images appear in *A Gardner in the Wasteland* where subjects vent their anger over this delayed judgement on riots, 'Do you think they'll punish him? An elected leader who played the fiddle while Hindu mobs raped and slaughtered Muslims and burnt their homes? ... Some Hindu fanatics boasted of having ripped foetuses from Muslim women's womb' (62–63).

Another event that took place in Ayodhya in 1992 is also discussed in the novel. The passion to serve Hindu gods, as proposed by one of the dominant Hindutva party ruling in India, became extremely intense resulting in the demolition of Babri masjid (mosque) in Ayodhya. Though the fervour to make Hindutva victorious reached at its peak when the historic mosque built by Mughal emperor Babar was demolished in 1992 to be replaced by Rama's temple, some believe that 'the dispute surrounding the Babri Mosque [had already begun] – by drawing upon passions or disillusions – that [were] ... in circulation much before the temple-mosque dispute achieved national prominence' (Brosius 284). The graphic novel draws a parallel to Brosius's argument by depicting the visual of Babri mosque with numerous people with flags standing all around and over the tombs. They shout slogans of 'Jai Sri Ram! Mandir wahi banayenge! Jai Hanuman!' [Victory to Ram! temple will be made there! Victory to Hanuman, the monkey god who is worshipper of Ram] (Ninan and Natarajan 110). At this juncture, Natarajan is seen speaking 'Jotiba in fact seems to have anticipated that the hindutva movement would mobilise people in the name of same monkey god to demolish the Babri mosque ...' (110).

This technique of reading the present through the past culminates in mention of the reservation issue in India. When the Supreme Court of India granted additional reservations to the Other Backward Classes (OBC) in 2007 in addition to the already existing Scheduled Caste and Scheduled Tribe reservations in all Central Government affiliated institutions, there was a major protest all over India against such action. Banners were raised and candlelight marches were held in the name of 'DEATH OF MERIT' (Ninan and Natarajan 65). But according to the author, the protestors belonged mainly to the upper castes and could not bear to see any progress of the OBC, who were now given compensation through reservation to emerge from their years of slavery and humiliation.

## Role of Savitribai

Distinct from the original text, *A Gardner in the Wasteland* gives due acknowledgement to Savitribai, wife of Phule, who was also equally determined and supported Phule in his fight against the evils of casteism. Phule wrote *Gulamgiri* with the sole purpose of attacking Brahmins and defending Dalits but he fails to provide an insight into his wife's role in educating school girls at Poona and the problems faced by her as a woman. Savitribai's character represents the problems of both the sympathiser, siding with the Dalits against a shared contempt of Brahmins, and a woman – in an excessively Brahmanical, patriarchal, and conservative Indian society of the nineteenth century. The author and artist have deftly exploited the medium for creating her as an individual character and not merely as Phule's wife. Savitribai's presence after constant intervals is a reminder of how she supported Phule in the fight against inequality of castes, yet her place within the history of India remains unknown to many. The full-page horizontal panel drawn in the first chapter 'The wasteland of caste' portrays Savitribai's inner strength through her facial expressions in fighting for the Dalit cause. As we proceed from left to right, the black background of the page gets lighter in shade and the rope binding Savitribai's face finally breaks down after several stages in her last portrait. Savitribai's breaking of the rope and the tension visible in her face are indicative of the trouble she had in breaking the societal bond. Despite the immense pressure upon her, she tried and finally succeeded in fulfilling her aim. Illustrating the difficulties she was made to face, such as changing her clothes on the way to and from educating Dalit girls, for fear of being thrown stones, has brought her to life as an individual whose identity was previously restricted to: 'NONBRAHMAN HINDU FEMALE ACTIVIST AND THINKER, WIFE OF BAD PERSON WHO CHALLENGED THE HINDU WAY OF LIFE. CENSORED' (17). This aspect of Savitribai's character was hardly visible in *Gulamgiri*.

## Techniques of illustration

> [Neither should] technique … overpower narration, nor should technique … overpower intellect … It is to tickle the intellect, to tickle the heart … to tickle the … senses technically. (Brosius 277)

Aparajita Ninan's artwork makes a significant contribution to the visuality of the Dalit cause, which would not have been the case had the issue not been restyled in the graphic genre. The novel employs a variety of techniques associated with the genre, including the montage effect, full-page-sized panels, pages illustrated in black and white colour and speech bubbles for dialogue.

The novel features a maximum of three or four panels per page, unlike some other graphic novels that feature a dense presentation of their content with many panels on the same page. Mostly, there are page-size panels depicting only one scene of action. According to Joseph Witek, one panel per page gives 'an 'open' feel to the narrative … a layout which allows more space for incidents which will move the narrative along' where matters of immense gravity can be discussed in an open space, letting readers focus on one issue at a time (88). When *A Gardner in the Wasteland* discusses important aspects such as the Gujarat riots, the unravelling of Vedic myths, Negro slavery, etc., an entire page is used for the depiction of such scenes. This technique of using full-page illustrations to discuss both historical events and the contemporary situation is beneficial for enabling readers to fully

focus on one illustration at a time and not to move quickly to the next image. Almost all mythical stories in the chapter 'The weed-bed of myth' contain no more than two panels, thereby encouraging viewers to deeply absorb the images for further analysis without the pages being too crowded with excessive graphics.

Another important technique used in the novel is that of the repetition of facts through visuals. According to Witek, 'Key incidents, especially those which lend themselves to visual presentation, do receive multipanel treatment' (83). The mythical stories discussed in detail by Phule in 'The weed-bed of myth' are repeated in the chapter 'The roots of tyranny'. This repetition takes the form of both visual illustrations and speech bubbles. The manner in which images are presented, however, is different in each chapter: the former has random images scattered across an entire page, while the latter has structured images in a wide horizontal panel divided into two and summarising the story up to that point. Even the vocabulary of the images used in the two chapters to narrate the stories is at times repeated. For instance, Phule's perspective of narrating the story of Vamana in two different chapters can be seen below:

> During Bali's reign, Vamana was the chief leader of the enemies, the Brahmans. He collected an army to quell Bali. They fought for eight days. On the eighth day of battle, Bali was … killed, … and Vamana looted Bali's capital. ('The weed-bed of myth')

> Vamana- Deceiver, Slimebag, Destroyer of the Golden Age of Bali. ('The roots of tyranny')

This repetition of important facts acts as a marker to make readers believe what they are seeing. It is a technique used by Ninan to over-emphasise the Brahmanical wickedness that forms the basis of the entire graphic novel and that readers should not forget. The repetition leads to magnify the hypocrisy behind construction and prevalence of these stories.

Whilst on the subject of the colouring techniques used in the novel, it is worthwhile considering Art Spiegelman's view of the monochromatic colour technique employed in his graphic novel *Maus*. Speigelman states that colour takes something away that only black and white visuals can offer a text (Mausgraphicmemoir.blogspot.in). Referring to the Holocaust, he says that this is too somber a subject to be portrayed using colour, and since colours come to have their own meanings, he never wished for readers to associate any particular colours with this subject which may lead to a shift in intended meaning. He demands the full attention of readers to the atrocities of the Holocaust and does not wish for them to be distracted with the effects of colour. Quite similarly, in *A Gardener in the Wasteland*, the illustrator chooses not to employ colour to reflect the seriousness of the content but also because the use of black and white enables viewers to easily distinguish between the truth and its misrepresentation in the Vedas, helping them to more easily understand the meaning.

*A Gardner in the Wasteland* also portrays characters in a certain dichotomy rather than laying emphasis on them individually. These dichotomies are constructed through dialogue conversation between Ninan and Natarajan, Jotiba and Dhondiba and between the Dalits and Brahmins. The dialogue carried out in question-and-answer form serves to clear many of the doubts present in the mind of readers. Dhondiba occupies the place of a viewer who is as ignorant as them and is enlightened through his conversation with Jotiba. Natarajan and Ninan, another duo situated in present times like the reader, provide many instances of commentary for the outsider. In doing so they are able to alternate the discourse on caste between the past and the present, which would otherwise have remained restricted only

to Phule's historical context. Moreover, their conversation is also important to provide a break in the story.

Although the appearances of the sets of characters discussed above are well highlighted, there is a risk looming heavily over the novel of relative inattention to the Dalit figure. The Brahmin caricature in the novel benefits from a disproportional advantage owing to its extraordinary appearance in the entire novel. Aparajita Ninan has drawn a typical Brahmin caricature that attracts the human eye more than the image of the Dalit. The Brahmin figure is a fat man with a huge belly, clad in dhoti, with a *tilak* (coloured powder on the forehead of Hindus as a part of their tradition) and a short pony tail on his bald head. The image represents the figure of an evil Brahmin who exploits and tortures the Dalits. The Brahmin figure is much more visible than the weak and feeble Dalit, hence, when there is a scene of the Brahmin torturing the Dalit, the former occupies a much greater space in the image, somewhat obscuring the latter. The image of the Dalit, due to the exaggeration of its contrasting character (Brahmin), becomes too ordinary to be noticed.

## Conclusion

Mapping the growth of caste-based discrimination from past to present, *A Gardner in the Wasteland* provides a detailed insight into its daily worsening situation. Consequently, the text is beneficial for the understanding of readers new to the field of Dalit studies, and who are not familiar with the reason behind its continued existence. By recounting a story from the older times, when Dalits were treated as untouchables, to the present-day uproar around SC/ST reservations (Scheduled Castes represented by Dalits/Scheduled Tribes representing the minority tribes of India), *A Gardner in the Wasteland* provides comprehensive information about the Dalit situation, thus answering why and how Dalit studies are relevant in Indian society. Phule's *Gulamgiri*, a seminal text, offers insight into the prehistoric exploitation of Dalits but *A Gardner in the Wasteland* includes many events worthy of acknowledgement for today's readers. This novel in graphic form, in citing examples of the Independence movement, Babri Masjid, the Gujarat Riots and the Anti-Reservation protests, provides justification for why revisiting such a complicated subject as caste is important and deserves to be considered time and again. Looking at the anti-reservation protest in *A Gardner in the Wasteland* we are reminded of how even today protests and strikes continue to be held in the name of demanding equality for opposing reservation policy. It is quite ironic, however, that those people who now demand equality by critiquing the reservation policy of the Indian government were the ones who earlier denied it by creating caste divisions.

The last part of *A Gardner in the Wasteland*, namely 'The Seeds of Change', has been composed from Phule's other writings. In this section, Phule is seen stressing that education provides a solution to the problem of Dalit exploitation. *A Gardner in the Wasteland* seems to be carrying forward this belief of Phule by educating the masses via graphic deconstruction of Brahmanical myths. This emphasis to voice out an age old problem in new form is an attempt to inform about the problems faced by the Dalit population, but at the same time also suggest a way out of it.

## Disclosure statement

No potential conflict of interest was reported by the author.

## References

"Art Spiegelman and His Art." mausgraphicmemoir.blogspot.in. 2012. Web. 2 Mar 2016.

"Art Spiegelman Graphic Style." mausgraphicmemoir.blogspot.in. 2012. Web. 2nd Mar 2016.

Brosius, Christiane. "Hindutva intervisuality: Videos and the politics of representation." *Beyond Appearances? Visual Practices and Ideologies in Modern India.* Ed. Sumathy Ramaswamy. New Delhi: Sage Publication, 2003. Print.

Campbell, Eddie. "What is a Graphic Novel" *World Literature Today.* 81.2 (2007): 13–15. Web. 1 Mar 2016.

Chaney, Michael A. "Introduction." *Graphic Subjects: Critical Essays on Autobiography and Graphic Novels.* Ed. Michael A. Chaney. Wisconsin: The University of Wisconsin Press, 2011. Print.

Guha, Ramchandra. *India After Gandhi: The History of the World's Largest Democracy.* New Delhi: Picador India, 2008. Print.

Gordon, Ian "In Praise of Joseph Witek's *Comic Books as History." Subjects: Critical Essays on Autobiography and Graphic Novels.* Ed. Michael A. Chaney Wisconsin: The University of Wisconsin Press, 2011. Print.

Joglekar, Jaywant D. *Veer Savarkar: Father of Hindu Nationalism.* n.p.: Lulu.com, 2006. Print.

Marie, Rachel, Crane. Williams. "Image, Text, and Story: Comics and Graphic Novels in the Classroom" *Art Education* 61.6 (2008): 13–19. Web. 10 Mar 2014.

McLain, Karline. *India's Immortal Comic Books: Gods, Kings and Other Heroes.* Bloomington: Indiana University Press, 2009. Print.

Natarajan, Srividya and Aparajita Ninan. *A Gardener in the Wasteland: Jotiba Phule's Fight for Liberty.* New Delhi: Navayana Publishers, 2011. Print.

Omvedt, Gail. "Hinduism as Brahman Exploitation: Jotiba Phule." *Understanding Caste: From Buddha to Ambedkar and Beyond.* Ed. Gail Omvedt. New Delhi: Orient Blackswan, 2012. Print.

Varughese, E. Dawson. "Graphic Novels." Reading New India: Post-Millennial Indian Fiction in English. Chennai: Bloomsbury, 2013. Print.

Witek, Joseph. *Comic Books as History: The Narrative of Jack Jackson, Art Spiegelman, and Harvey Pekar.* Jackson: University Press of Mississippi, 1989. Print.

"Why Dr. Ambedkar renounced Hinduism." Web. 2 Mar 2016. <http://www.ambedkar.org/Babasaheb/Why.htm>.

# Watching *Zindagi*: Pakistani social lives on Indian TV

Spandan Bhattacharya  and Anugyan Nag

**ABSTRACT**

In this paper, we study some of the politics involved in representing neighbouring country Pakistan with reference to the launching of a new television channel in India, *Zindagi/Life*. *Zindagi* was launched on 23 June 2014 and owned by the Zee Entertainment Enterprises Ltd. which airs syndicated television shows from Pakistan. *Zindagi* became the first ever general entertainment channel (GEC) in India to air syndicated content from Pakistan. Our paper aims to explore how in the popular teleserials of *Zindagi* the representation of the 'other' (here Pakistan and its people) has become part of the viewing practices for Indian audiences. The present context of the Indian political and media scenario (after BJP came to power in the last Lok Sabha election in 2014) with national GECs' increasing involvement in telecasting Hindu mythological and historical serials makes the airing of *Zindagi* more interesting (In the last Lok Sabha elections (2014), Bharatiya Janata Party (which formed the government with maximum majority) campaigned extensively through state-run and private-owned satellite television networks. Following this, it is imperative to note how in the recent years National General Entertainment channels actively engaged in telecasting Hindu mythological and historical serials like *Devo Ka Dev Mahadev* (Life OK, December 2011–2014), *Mahabharat* (Star Plus, September 2013–August 2014), *Siya Ke Ram* (Star Plus, 2015–2016), *Sankat Mochan Mahabali Hanuman* (SONY, 2015), *Bharat Ke Veer Putra Maharana Pratap* (SONY, May 2013–December 2015), *Chandragupta Maurya* (Imagine/Dangal TV, March 2011–April 2012/ December 2014), *Dharti Ke Veer Yodha Prithvi Raj Chauhan* (Star Plus, 2006–2009), *Veer Shivaji* (Colors, September 2011–May 2012) and *Chakravartin Ashoka Samrat* (Colors, 2015–2016).). Amidst such a context of politics and television programming that fiercely focused around a monolithic construct of Hindu culture, identity and history, *Zindagi* enters the Indian satellite market by telecasting Pakistani social lives and raising questions on representing the 'other' for the Indian viewers. The channel has been well received by the Indian print and electronic media (For instance, one can see articles like '5 reasons that make Zee's new channel "Zindagi" a must-watch' (*dnaindia*, 20 June 2014) 'Bye-bye unending television dramas, welcome Zindagi' (Times of India, 1 July 2014), 'Zindagi Gulzar Hai: cross-border love on screen' ( Hindustan Times, 7 June 2014), etc.). Reports of rising TRPs of teleserials like *Humsafar* and *Zindagi Gulzar Hai* (on *Zindagi*) were published in the popular press, which along with social networking sites generated stardom discourses around actors like Fawad Khan.

With reference to the politics of representing a neighbouring country and Muslim identity on Indian television, our paper explores questions including couple space and conjugality in the teleserial narratives of *Zindagi*. Our article discusses two teleserials, *Zindagi Gulzar Hain* and *Humsafar*, focusing on how the portrayal of Muslim men and women on *Zindagi* marks a departure from the stereotypical representation of Muslim characters in Indian cinema and television.

## Watching Zindagi

A slow tracking shot reveals a young girl writing her diary, her words appear as a voice-over. She laments that life is not easy, especially for simple middle-class people like her. She blames Allah for making life a tedious and difficult journey. The next shot with multiple slow cross dissolves shows a young man writing on his laptop. His thoughts are heard too as a voice-over. He appreciates the beauty of life and thanks Allah for blessing him with a world that has so much to offer. This is perhaps a situation that has struck many Indian audiences who viewed the first episode of a Pakistani serial *Zindagi Gulzar Hai* – Life is a Rose Garden (*ZGH*, henceforth) aired on Zee Television's new channel *Zindagi*. The advertisement of this channel emphasized the phrase '*Jodey Dilon ko*' (Connecting Hearts), to highlight an initiative that is first of its kind to air Pakistani soaps and serials for Indian audiences (*Zindagi* began airing in India from 23 June 2014). The teleserials revolving around social/family dramas written and directed by Pakistani writers were handpicked, keeping in mind the sensibilities of the Indian audience. Chief content and creative officer of Zee Limited, Bharat Ranga states that the channel aims to offer 'alternative fiction content'.[1] Stories penned by authors like Umera Ahmad, legendary Pakistani author Saadat Hasan Manto and Samira Fazal have found their way into as many as 45 teleserials chosen for the initial airing. To begin with, the channel has aired a few shows such as *Zindagi Gulzar Hai, Aunn Zara, Humsafar* and *Kitni Girhain Baaki Hain*, set within a predominantly Pakistani middle class or upper middle class milieu. The modes of address and the realist aesthetics in the teleserial texts of *Zindagi* generate the pleasure of nostalgic viewing on Indian television. The teleserial aesthetics of *Zindagi* reminds us of the 1980s Doordarshan era when progressive melodrama about India's middle class and the stories of 'emancipation of women' entertained audiences.[2] But in *Zindagi*, the politics of representing the neighbouring country of Pakistan and the economy of media collaboration made its teleserials unique for Indian television viewers and their modes of 'seeing'. Since Indian media played an important role in the last Lok Sabha election and the media networks actively participated in the neoliberal right-wing politics, telecasting Pakistani social lives and the Muslim 'other' on popular television channel *Zindagi* intervened in the popular stereotype of Pakistani/Muslims on Indian television.

The representation of the 'other' becomes a crucial point in our discussion here, as these serials are from Pakistan and it deals with the lives of Muslims in Pakistan. India's contested political relations with Pakistan that go back to the early years of independence also marked the birth of two separate nation-states. Adrian Arthique (21–39) in his article 'Aggression and Transgression on the India-Pakistan Border' discusses the narrative construction of India-Pakistan border in Indian films. In this article, he refers Sanjay Chaturvedi who makes the argument defining elements of nationbuilding has been reflexive production of Otherness between the two nations, where geopolitical visions are constructed through

imaginative geographies in which 'inclusions and exclusions, as mutually reinforcing forms of peacemaking, have become central – rather indispensible – to the "nation-building" enterprise of the post-colonial, post-partition states of India and Pakistan' (Chaturvedi 149). Here Athique also refers to what Navtej Purewal observes: "The border not only signifies where the nation-states of India and Pakistan begin and end, but it also territorializes and nationalizes local populations and identities and is employed as a site for the construction of a dominant national consciousness" (Purewal 547). Artique discusses how Bollywood films like Border and Refugee naturalize the abstract barrier between India and Pakistan (2008). Several attempts over the last two decades have been made[3] to improve the relationship between the two countries, particularly through cultural exchange. Muslim communities and their everyday lives around the world have come under constant scrutiny since 9/11 owing primarily to American media's relentless construction of the image of the Muslim terrorist. In the context of BJP's earlier tenure from 1994 to 2004, Kishore Budha writes in 'Genre Development in the Age of Markets and Nationalism'.

> The War Film: In the political arena, Pakistan and India were used in gendered metaphors, that is to create imageries of the vulnerability of the Indian nation, necessitating extreme caution, military empowerment, and the normalization of violence against a Muslim Pakistan by avenging the wrongs of the past atrocities against a Hindu India.... the naming of the external Muslim enemy also functions to indirectly remind India of the internal manifestation of that enemy, the Muslim citizen. Emboldened by the US declaration of the 'war on terror', the BJP raised the stakes of the game by talking of a swift victory to teach a lesson … During the rule of the BJP from 1994 to 2004 many films were made with storylines and attitudes reflecting the party's conservative stance, emphasising family values and religious patriotism. A survey of the news media shows that the television and film industries had appropriated the Kargil conflict by announcing a slate of films, producing chat shows, inserting war into existing soap plots and releasing patriotic music compilations. (Bharat and Kumar 8)

Although Pakistan and India share several social, economic and cultural similarities, understanding of each other's everyday lives has been largely limited. With a strong anti-Pakistani rhetoric dominating the political discourses of the Hindu Right aligned with the current government in power, the serials on *Zindagi* dramatizing middle-class Pakistani lives opened up the possibility of establishing a dialogue between two cultures, so far, separated by real or imagined animosity. These serials from Pakistan narrating the everyday lives of its citizens engendered a counter-discourse to the unremitting demonization of Pakistan in Indian popular culture. In this connection, our essay examines the cultural politics of re-presenting and constructing Pakistan (and Muslim identity) on Indian television and to explore how television aesthetics and ideology inform such construction.

## Women's consuming images on Indian teleserials

In India, the teleserial as a genre emerged in the 1980s (with *Humlog, Buniyaad* and others that followed) as a major site of 'negotiation between the developmental states pedagogic project and emergent commercial popular'.[4] Over time, the thematic, narrative pattern and the overall format of Indian teleserial transformed. The 'edutainment value' was attached to Doordarshan's earliest teleserials like *Humlog*[5] [1984–1985] and others. Purnima Mankekar discusses how post-colonial nationalism in India constituted the emancipated gendered citizen-subject who was expected to serve as custodian of national integration (104–7). Women's issues[6] are an intrinsic part of the state's project of nation building, and thus earlier

teleserials on Doordarshan reflected the state's need to mobilize women toward development and modernization and to construct womanhood as the repository of authentic Indian-ness. However, in these narratives of development, Muslim characters had a limited portrayal on Doordarshan. Realism served as a necessary tool to construct the citizen subject in these teleserials. But in the era of satellite television and the globalized media economy, the functioning of realism has different commercial interests from the earlier period of Indian TV.

Star TV launched in India in 1992. As the first cable television network in the country, it pioneered satellite television channels in India. Zee TV was the first Hindi satellite channel that launched in India in October 1992 in partnership with Star TV. After Star ended its relationship with Zee, Star Plus was formed as a 24-h Hindi language channel. Sony Entertainment Television was launched in 1995. With satellite television channels in India, the politics of consumerism became central to their programming. Most of the programmes, especially the soap operas, centred on household space, crucial for the consumption of family products. Women, therefore, were the primary target audience, and the primetime slot focused on women's leisure and the time women could take off from regular domestic chores to sit comfortably before the television. Doordarshan introduced a daytime teleserial *Shanti* [7] in 1994 which was the first serial to be telecast five days a week. Hindustan Lever Limited sponsored a second afternoon serial, *Swabhimaan*,[8] which was written by the popular novelist Shobha De. *Shanti*[9] and *Swabhimaan's* success proved sponsorship of the afternoon slot to be lucrative and in 1997 Doordarshan set apart two hours on its national network for four afternoon soap operas, each with an approximately 30-min running time. Soon a large number of soaps like *Tara* [Zee TV], *Kabhie Kabhie* [Star Plus], *Saaya* [Sony Entertainment Television] aired, following the success of *Shanti* and *Swabhimaan*, pioneering the genre of Indian television soap.

Following the conventional strategies of American teleserials, these teleserials had a similar objective of targeting the women as the primary viewers. In later periods (post 2000s), Ekta Kapoor 'revolutionized' television with serials like *Kyunki Saas Bhi Kabhi Bahu Thi* (Star Plus, Balaji Telefilms, 2000–2008), *Kahaani Ghar Ghar Ki* (Star Plus, Balaji Telefilms, 2000–2008) and others by centring loyal, dutiful housewives. Shoma Chatterjee refers that Uma Chakraborty termed these stereotypical traditional Hindu women who wore lots of gold and stone encrusted jewellery and heavily made up faces 'the homogeneous women' (Chatterjee, page number not available). The tradition continues with contemporary teleserial narratives. *Zindagi* maps issues of religion and femininity differently, however. Regular Indian teleserials across region celebrate the consumerist dreams through their construction of *mise-en-scene*, make-over narratives of the aspirational female protagonists and celebrating occasions like Holi and Diwali. Often the teleserial narratives engage with the week-long marriage ceremonies of its lead characters or simply use product placement strategy within the narrative. The teleserials of *Zindagi* however offer an alternative TV aesthetics which is focused more on the characters and their bonding and less about the production of an idea of consuming viewers through its narratives.[10]

## Locating Zindagi in the contemporary period of Indian television

*Zindagi Gulzar Hai* has been one of the most watched serials of the channel *Zindagi*, and it was aired twice on popular demand. If one wants to ponder over the fact of its popularity and success, one cannot help but dissect the striking contrast of *Zindagi Gulzar Hai* from soaps and serials of Indian entertainment channels across regions. The usual overdose of

melodrama, loud costumes and make-up, artificially constructed ornate sets and the never-ending plot around scheming mother-in-laws and other female members of a joint family, mostly a Hindu upper class family in particular; these serials revolve around joint family issues and are heavily orchestrated with popular Bollywood songs as background music and also appear extremely glossy, over-the-top glamorous and far from reality. The channel *Zindagi* makes an entry amidst such a context and pleasantly surprises audiences, primarily with its content, treatment and dialogues. What strikes us first is the language of the serials in *Zindagi*, a mix of Urdu and Hindi (was commonly referred to as Hindustani).[11] This form of language is in fact not unfamiliar to Indian audiences who have been exposed to Bombay Cinema of the 40s, 50s and 60s and serials like *Dhoop Kinare, Tanhaiyaan, Ankahi* in the 80s on Doordarshan. Soaps and serials in Doordarshan too heavily used the Hindustani form of dialogue delivery up until the early 90s. But with the emergence of satellite and private TV network this linguistic flavor gradually disappeared. With these shows on *Zindagi*, serials that provide a slice of daily life from across the border seem to have made a comeback.

*Zindagi*'s popular series *Zindagi Gulzar Hai (ZGH)*, which is an adaptation of a novel by Umera Ahmad directed by Sultana Siddiqui, revolves around protagonist Zaroon Junaid (Fawad Khan) from a wealthy family and Kashaf Murtaza (Sanam), a woman from a lower middle class background. Osman Khalid Butt, a popular actor-director, writer and theatre artist who became famous through his comedy video blogs on YouTube, plays the character of Aunn in another popular serial *Aunn Zara*. Aunn plays a pampered son in an all-women household. He is the apple of his family's eye, a spoilt child, who does not like the fact that the women in his family do not let him live his life his way. The show also has popular Pakistani model, VJ (Video Jockey) and actor Maya Ali playing the lead, Zara. A tomboy, Zara, in marked contrast with Aunn, was raised in a disciplined environment in an all-male household. Zara eventually gets married to Aunn. Similarly, *Zindagi*'s other popular serials are *Maat, Kash mein Teri Beti na Hoti, Kitni Girhain Baaki Hai, Humsafar* etc. The plot lines of all these serials could perhaps be present in an Indian television serial too, but what stands out is its narrative development, its visual treatment and the performance of the actors.

*Zindagi*'s primary achievement lies in its content selection and packaging. *Zindagi* relies only on telecasting soaps and serials, which are time bound (all serials have fixed episodes and conclude with a final episode). These teleserials manage to generate tremendous popularity in the first month of their launch. Media and public discourses underline the positive acceptance of these serials that are self-reflexive, critical and nuanced in their representation.[12] And almost all social media sites mention a common point about these serials being realistic, anti over-the-top melodrama and minimalism as their uniform appeal.

Recently *Zindagi* has telecast a serial called *Humsafar* since July, 2014, which deals with couple space, conjugality and crisis of filial bond. The teleserial is produced by Momina Duraid and directed by Sarmad Sultan Khoosat and is an adaptation of Farhat Ishtiaq's novel published serially in a monthly periodical of Pakistan.[13] The narrative of *Humsafar* delves into the story of Ashar and Khirad's relationship and while mapping Khirad's journey from a naïve wife to a matured mother of her daughter Hareem. The first few episodes deal with Khirad's hesitation of fitting into a different class and status quo where she does not belong and Ashar's support as a caring husband. The tension arises from the jealous lover of Ashar, Zaara who is also his cousin. Through the later episodes, it is revealed that Ashar's mother also did not approve of this marriage between Ashar and Khirad and with Zaara she planned a conspiracy to end this marriage. When Ashar is out of town Khirad realizes

that she has conceived but she plans to surprise Ashar. In the meantime, Khirad is wrongly accused of adultery with one of her college classmates and Ashar misunderstands Khirad. Ashar's mother does not let Khirad meet Ashar and Khirad has to leave the home and the city immediately. The later part of the narrative deals with Khirad coming to Ashar for their daughter Hareem's treatment and how Ashar and Khirad reunite. In the last few episodes of this teleserial Zaara commits suicide and Ashar's mother descends into madness. The usual teleserial elements like jealous mother-in-law, envious lover, tension of class difference, novelty of motherhood and adultery constitute the plot of *Humsafar*, while significantly departing from conventional Indian teleserial narratives.

First, the class difference of Ashar and Khirad was not constructed with conventional trope of rich vs. poor dichotomy and the attendant drama surrounding it. Neither is richness shown as desired or aspirational nor poverty associated with the usual trope of virtue or simplicity. Instead, rapid cuts, stylized composition of frame and heightened non-diegetic sound bring out the inner tensions of the characters, and the melodrama comes through the dialogue delivery. The literariness constructs the appeal of all the important sequences of *Humsafar* and the institution of marriage and the discourse of romance are mainly created with it. Unlike the Hindi or other regional teleserials on Indian TV, the marriage ceremony itself is not highlighted in episode after episode of *Humsafar* and the idea of romance never comes with film songs or heavily stylized cinematography.

In this teleserial, the intimacy of the couple space is not highlighted through physical proximity or sexual tension between the male and female lead. Rather the literary dialogue played an important role in constructing the couple space and their intimacy. The exchange of words between Ashar and Khirad and well-crafted silence create a world of interiority between them. In serials like *Humsafar* and *ZGH*, the dialogue and sometimes the characters' voice-over create a pleasure of literary texts rare in the contemporary mega soaps of Indian teleserials. Along with that, the dialogues written for Khirad speaks about female desire and also criticizes some basic assumptions of patriarchal and patrilineal family structure. Sue Thornham referring Rosalind Coward's work in her essay writes that in popular media texts female desire is constantly lured by discourses which sustain male privilege and this process works through narrativizing 'publicly sanctioned fantasies' (Thornham, 56). Publicly sanctioned fantasies confirm men's power, women's subordination, even when aimed at women. The fantasy embodied in romantic fiction works to secure women's desire for a form of heterosexual domination and against active sexual identity. Sue Thornham discusses Janice Radway's study of the institutional matrix of romance fiction to conclude that romance fiction functions as an active agent in the maintenance of the ideological status quo (Thornham, 56–57). These ideological operations function in the popular teleserials of *Zindagi* as well and these romantic narratives followed by the formation of heterosexual couple formation that clearly act to limit feminine agency. But along with that *Zindagi* teleserials also attempt to 'voice' feminine desire and feminine agency through the course of the narrative and their closure. For instance, in the last episode of *Humsafar* after the reunion of Ashar and Khirad, Khirad asks that how could one not trust the person whom he loves most and what was the nature of that kind of love. And she also states that now it's really good that they are together again but she is not sure if she can transform herself into the innocent and naïve wife of Ashar again after these years of mistrust and misfortune. Thus, although the teleserial ends in the unavoidable conjugality through marriage and it depicts the satisfaction of female needs by traditional heterosexual relationship instituted

by marriage, the end also leaves room for the critique of this system and creates possibility of feminine agency.

## Battling stereotypes: questions of religion and nationality

In the post 1990 India, the imageries of global Indians projected in the Indian media (films, teleserials and advertisements) incorporates an idea of English speaking, polished citizen of India who is connected with the world outside his country but a traditional Hindu at heart. This is the moment when a new brand of Hindutva has emerged in India. This Hindutva is not resisting but giving alternative visions of globalization. The futuristic vision of twenty-first century India has become more significant in the post 2014 election when BJP formed the government without any coalition. This very idea of Hindutva was premised on the idea of 'Asmita', internalized India. And in these visions of globalization, the figuration of Muslims has been marginalized to a great extent in Indian media texts. Here also *Zindagi* maps issues of religion and nationalism differently and intervenes in battling Muslim stereotypes. An analysis of *Zindagi* teleserials helps us to understand whether and how the airing of *Zindagi* impacted Indian viewers' understanding of their neighbours within the post-9/11 and Post 2014 Loksabha election.

In serials like *Humsafar, Kahi Unkahi, ZGH, Aunn Zara* and several others, one sees glimpses of Muslim middle class and upper middle class societies dealing with everyday issues of patriarchy, marriage, and class struggle, emancipation of women, familial disputes, individual desires and aspirations. These serials do not cater to the clichéd imagery of Muslim lives and characters that Indian audiences experience in Bollywood films. For instance, the burqa-clad women, the cap and surma (Kohl for the eyes) wearing man, the ghetto next to a Mosque and so on are not regular features of these serials. These serials manage to provide a matter of fact representation of Pakistani lives, as Muslim people dealing with issues of class, gender, social and familial struggle ranging from the upper class section to the lowest strata of their society. Roshni Sengupta writes that:

> As news channels constantly look to expand viewership and advertising, they often end up pandering to what they see as the dominant component of their audience. This opens the possibility that the new private television networks, which less than a decade ago were hailed as 'a kind of liberation' (Page and Crawley 152–53, 166), may actually have ended up reinforcing existing inequalities and stereotypes, particularly when it comes to minority and marginalised groups. Television plays an important role in building perceptions about events and about communities and, as such, the way it treats India's minorities-in representation and portrayal-deserves to be examined in greater detail. By 2006, as many as 230 million Indians were estimated to be watching satellite television (National Readership Studies Council 2) and as the medium has become more powerful concern over a 'balanced' electronic media in a multicultural, multireligious society like India has only grown. (Sengupta, 87–102).

While the media plays a central role in building public opinion, there is also a long lineage of literature on media's role in creating stereotypes. Stereotyping is a familiar concept in the fields of political studies, sociology and social psychology. Stereotypes often have no basis in either experience or knowledge and lead to 'prejudice' and irrational behaviour. Once entrenched, these stereotypes tend to perpetuate through generations and create public opinion at large. The media is not simply a 'mirror' of society but plays a much more complicated role as a purveyor of social messages. In a highly fractured and divided society with a long history of communal strife and discord such as India, the perpetuation

of stereotypes is dangerous. In this context, a case in point is the continuing stereotyping and racial profiling of Muslims through television in the Western world. As Fox News and CNN battled it out on the airwaves in the post-9/11 scenario, a new racial and cultural idiom was born – the Muslim as an aggressive, violent, war-mongering individual. Muslims all over the world have suffered the disgrace of sharing their religion with the men who executed the 9/11 attacks.

Indian mainstream media and especially films like *Roja* (Mani Ratnam, 1991) *Sarfarosh* (John Matthew Matthan, 1999), *Mission Kashmir* (Vidhu Vinod Chopra, 2000), *Fanaa* (Kunal Kohli, 2006), *Aamir* (Raj Kumar Gupta, 2008), *A Wednesday* (Neeraj Pandey, 2009) or the recent release *Baby* (Neeraj Pandey, 2015) has associated the issue of terrorism with representation of Muslim men. And in many of these films, Pakistan has been portrayed as the enemy trying to provoke violence and communal abhorrence in India. On the other hand, there are instances of representing the loyal 'good' Indian Muslims as inspector Salim in *Sarfarosh* or the doctor couple in *Hum Aapke Hain Kaun* who remained subservient to the Hindu feudal family. The figure of the terrorists in many Bollywood films represents the religious and violent Muslim men and Muslim women who remained as burqa-clad insignificant figures in these films. The representation not only has remained within the dominant discourse but also invested in 'showing' the Muslim-ness on screen. Whereas the Hindu characters were represented within regular urban setting in Western attire the Muslim character has to be represented with some indexicality such as through wearing a beard, topi, salwars or burqas. Herein lies the difference of experiencing the serials on *Zindagi*.

The religious and national identities of Muslim characters on *Zindagi* are not hidden but are also not 'marked out' in their attire or behaviour. Especially when the 'love jihad'[14] panic is structured and circulated by a group of Hindu right-wing (mostly male) fanatics the characterization on *Zindagi* battles that stereotype successfully. Charu Gupta brilliantly argues how the stardom of Fawad Khan who plays the male lead in both *Humsafar* and *ZGH* allegories the intimacy. Gupta argues:

> This swooning over Fawad Khan by Indian girls and women of all ages reveals a religious and national liminality that can stump the hysteria over the constructed bogey of love jihad. The representation of Fawad Khan and the construction of love jihad, both in very different ways are part of fictive imaginations, myths and rhetoric, spectacles and obsessions. At the same time, they undercut each other, reflecting women's desires on the one hand and Hindu male fears on the other. Love for Fawad Khan personifies allegories of intimacy and romance, while the love jihad campaign embodies hatred and anxieties. One contests power, the other attempts to reinstate it. It is these disjunctive representations that make their juxtaposition stimulating. (Gupta, 2014)

However while looking at the not-so-stereotypical figuration of the Muslim protagonists on *Zindagi* and praising the battling of conventional representation one must be very careful about the other aspects of such figurations and representations. For instance, one should also be careful how the deterritorialized characters in the urban settings on *Zindagi* can lead to a dehistoricized and depoliticized imagination of the neighbouring country Pakistan on Indian television screens. Very recently a controversy has erupted with the telecasting of a teleserial '*Waqt Ne Kiya Kya Haseen Sitam*'[15] on *Zindagi* tv. This serial has attracted the attention of the I&B ministry and broadcast authority of India when some Indian viewers complained that the serial content was 'inflammatory in nature' and 'promoted Pakistan's

narrative of the partition.[16] The channel authority of *Zindagi* has promoted this serial which was based on partition tragedy as a 'timeless love story'. These promotions clearly did not focus on the historical dimension at all and promised its Indian viewers a regular relation-ship drama like *Humsafar* and several others. The serial was based on romance between Bano and Hassan and troubles and tribulations arising from 1947 uprising leading to their final separation. Along with this tragic narrative, the drama invested on the violent riots between religious communities, rape of Muslim women by Sikh and Hindu men and com-munal violence on the Indian Muslims. This account of partition trauma and tragedy from 'their perspective' raised lots of difficulties from the Indian viewers. Hence, the allegations against this serial were a consequence from a section of Indian viewers who are not habit-uated with this racial and communal vilification of the Indian Hindus and India in general. In this context, one can observe how certain 'limits' and 'regulations' were present in the acceptance of *Zindagi* teleserials by Indian viewers. When *Zindagi* teleserials attempted to break down stereotypes within certain deterritorilized reality and contemporary time (for instance the contemporary urban world of *Humsafar* or *ZGH*) the represented 'other' gained popularity. But breaking down of that 'limits' and situating the teleserial narratives in Pakistan's historical events like partition, riots or communal violence immediately led to difficulties and troubles for the same viewers from India. Therefore this kind of viewership patterns speaks of the limitations of trans-national circulation of cultural texts in present times especially between India and Pakistan.

## Conclusion

Television shows on *Zindagi* open an avenue for content from India's most contested and yet closest counterpart, Pakistan. If we consider the *Waqt* controversy as an exceptional instance, the programme packaging and audience reception of *Zindagi* so far has been extremely positive. Representation of the Muslim 'other' has not generated stereotypical discourses; rather, social media sites have welcomed the content, stories and diverse range of genres that *Zindagi* has offered so far. The 'representation' of Pakistani communities deserves a critical focus. Since the serials are written and produced by Pakistanis, this very idea of representation is therefore not so simplistic in assuming that Pakistan has been represented in a certain format for Indian viewers. One can rightly point out that when Pakistani producers and directors initially made these serials, the tie-up with ZEE was not yet decided upon.

In our limited study of a few serials, we are unable to map the complex dynamics of religion, community, nationalism and viewership from both sides of the border. We can keep this discussion open-ended for further discussion. But what we observe here is that in the present context of Indian television and popular entertainment programmes, *Zindagi* manages to appropriate these serials within the bouquet of variety entertainment channels, and interestingly, its difference is its unique selling point. The 'otherness' itself here is its biggest appeal. Therefore, representation of the 'other' (here Pakistan and its people) in fictional entertainment content has now become a household part of the Indian viewers. *Zindagi* brings a similarity between Pakistani social lives and Indian households and constructs a familiarity that perhaps a large section of Indian audience was craving for on television.

## Notes

1. 'Opinion-makers and influencers, those from the entertainment, political sectors, advocates, teachers, professors and housewives, watch Zindagi. The channel is clear about its audience and the mindset it is attracting. The genre is pretty well defined and people will turn out in large numbers, but it will take some time' (Srivastava 2014).
2. Purnima Mankekar discusses how post-colonial nationalism in India constitutes the emancipated New Indian Woman [*Nayi Bharatiya Nari*] as gendered citizen-subject who is expected to serve as custodian of national integration. Women's issue being an intrinsic part of the state's project of nation-building, earliest teleserials on Doordarshan reflected the state's need to mobilize women toward development and modernization and to construct womanhood as the repository of authentic Indian ness (104–7).
3. For instance, in 2010, two leading media houses The Jang Group in Pakistan and The Times of India in India initiated a campaign Aman ki Asha ('Hope for Peace'). The campaign aims for cultural exchange between two countries and development of the diplomatic and cultural relations between the two countries. It started on 1 January 2010. The Citizens Archive of Pakistan, a non-profit organisation dedicated to cultural and historic preservation took an initiative in 2013 which aimed at improving relationships between two countries involving the students of both these countries. The programme included an exchange of letters, postcards, pictures, artwork and videos and it encouraged Indian and Pakistani citizen to form their own opinions and have a clearer understanding of history and culture through cross cultural communications between India and Pakistan.
4. For detail, see Abhijit Roy (38). In this essay, Abhijit Roy discusses the history of developmental communication in India both as a site of hegemonic project and of the contradictions that characterize them.
5. Manohar Sham Joshi stayed in Mexico as an apprentice of television industry and after coming back to India he wrote *Humlog*. *Humlog* narrated the dreams and anxieties of a lower middle class family in urban India, consisted of Basesar Ram, his parents, his wife and their five children. The serial showed the eldest daughter Badki's conflict with her husband and her suffering that resulted from her engagement with activist politics.
6. See Purnima Mankekar, Also, Anjali Monteiro in her essay points out the necessity to make a distinction between female power (domination) and female strength. And thus it failed to critique the institution of patriarchal family or broader context of state and political economy. As the very project of New Indian Womanhood was constructed on normative experience of Hindu, in *Kalyani* or in *Rajani* the Hindu identity was naturalized. In 'Official Television and Unofficial Fabrications of the Self: The Spectator as Subject' – Anjali Monteiro (176–80).
7. *Shanti*, the protagonist, was a woman journalist who wanted to avenge her mother's rapists.
8. It was about struggle of Swetlana (played by Kitu Gidwani), the mistress of a dead industrialist, Keshav Malhotra Shanti's battle against industrialists Raj J Sing and Kamesh Mahadevan (who raped her mother) and Swetlana's struggle as the chairperson of Malhotra Industry opposing Malhotra family members, constantly disrupted male dominance in corporate patriarchy or hegemony of family. These serials had a similarity with a famous American serial *Dynasty* which presented a female character like Alexis.
9. *Shanti* had assured sponsorship from Procter and Gamble.
10. For earlier works on Star TV and Zee TV, See *Transnational Television, Cultural Identity and Change – When STAR came to India*, Melissa Butcher, Sage Publication, New Delhi, London, (147–63). ZEE TV Diasporic non-terrestrial television in Europe, Rajinder Dudrah, *South Asian Popular Culture*, 3:1, Routledge, London (163–81).
11. Some teleserials like *Humsafar* also introduced less familiar Urdu words providing its meaning during the telecast of the show as subtitle like text.
12. For instance see 'Zindagi Gulzaar Hai' Aired on Zindagi TV Stuns Indian Actors link: http://www.brandsynario.com/zindagi-gulzaar-hai-aired-on-zindagi-tv-stuns-indian-actors/, also see 'Zindagi Gulzar Hai: Top 7 reasons why this Pakistani serial is a big hit!' Link:

http://www.india.com/top-n/zindagi-gulzar-hai-top-7-reasons-why-this-pakistani-serial-is-a-big-hit-96695/, etc.

13. It was later published as a complete novel by Ilm-o-Irfan publishing house.

14. 'Love jihad' is an aggressive and systematic campaign started by some right-wing Hindu organisations in India under which young Muslim boys and men are alleged to forcefully convert vulnerable Hindu women to Islam through trickery and marriage. Right-wing organizations like RSS and Dharma Jagran Manch, held 'awareness' rallies in Uttar Pradesh against inter religious marriages. In 'love jihad' campaigning any possibility of Hindu women exercising their right to love, choice of life partner and conversion is completely ignored and a common 'Muslim other' was created out of the Muslim male to save or protect the Hindu women.

15. It was aired from 23 March 2015. The serial was originally named as *Dastaan* which was based on the novel *Bano*, byRazia Butt and dramatized by Samira Fazal.

16. For details see 'Notice to Zindagi channel on 'pro-Pak' serial' by Himanshi Dhawan, *The Times of India*, 10 May, 2015. Link: http://timesofindia.indiatimes.com/tv/news/hindi/Notice-to-Zindagi-channel-on-pro-Pak-serial/articleshow/47218707.cms. Access date 24 May 2016.

## Disclosure statement

No potential conflict of interest was reported by the authors.

## References

Arthique, Adrian. "Aggression and Transgression on the India-Pakistan Border." *Filming the Line of Control: The Indo–Pak Relationship through the Cinematic*. Ed. Meenakshi Bharat and Nirmal Kumar. New Delhi: Routledge, 2008. 21–39.

Bharat, Meenakshi, and Nirmal Kumar, eds. *Filming the Line of Control: The Indo-Pak Relationship through the Cinematic Lens*. New Delhi: Routledge. 2012. 8.

Butcher, Melissa. *Transnational Television, Cultural Identity and Change – When STAR Came to India*. New Delhi: Sage, 2003.

Chatterjee, Shoma. *Looking Back at Humlog*. 25 Jul. 2008. www.indiatogether.org.

Dudrah, Rajinder. "ZEE TV Diasporic Non-terrestrial Television in Europe." *South Asian Popular Culture* 3.1 (2006): 163–81. London: Routledge.

Gupta, Charu. *Love for Fawad Khan vs Jihad against Love*. Kafila, 3 Nov. 2014. http://kafila.org/2014/11/03/love-for-fawad-khan-vs-jihad-against-love-charu-gupta/

Mankekar, Purnima. *Screening Culture, Viewing Politics: An Ethnography of Television, Womanhood, and Nation in Postcolonial India*. Durham and London: Duke University, 1999. 104–7.

Monteiro, Anjali. "Official Television and Unofficial Fabrication of the Self: The Spectator as Subject." *The Secret Politics of Our Desires, Innocence, Culpability and Indian Popular Cinema*. Ed. Ashis Nandy. Delhi: Oxford University Press, 1998. 176–80.

National Readership Studies Council". The National Readership Study. New Delhi: National Readership Studies Council, 2006. Manuscript.

Page, David, and William Crawley. *Satellites Over South Asia: Broadcasting Culture and the Public Interest*. New Delhi: Sage Publications, 2001.

Roy, Abhijit. "Bringing up TV: Popular Culture and the Developmental Modern in India." *South Asian Popular Culture* 6.1 April (2008): 38.

Sengupta, Roshni. "Muslims on Television: News and Representation on Satellite Channels." *Television in India: Satellites, Politics and Cultural Change*. Ed. Nalin Mehta. New York: Routledge, 2008.

Srivastava, Prachi. *In Two Years, Zindagi Will be a Sought-after Brand': Bharat Ranga, AFAQS!*. Mumbai, 25 Sep. 2014. Web. 21 May. 2016. http://www.afaqs.com/interviews/index.html?id=420_In-Two-Years-Zindagi-Will-be-a-Sought-after-Brand-Bharat-Ranga.

Thornham, Sue. *Women, Feminism and Media*. Edinburgh: Edinburgh University Press, 2007.

## Newspapers and online Journals

AFAQS
*DNA INDIA*
Livemint
*Hindustan Times*
*The Hindu*
*The Times of India*

# War Cry of the Beggars: an exploration into city, cinema and graphic narratives

Madhuja Mukherjee

**ABSTRACT**

This short piece is an account of the making of the graphic novel, *Kangal Malsat* (/War Cry of the Beggars, Bengali, 2013), designed, written and illustrated by the author (The graphic novel was described as the 'first' graphic work in Bengali by the popular press, and featured on the bestseller's list). It presents a short introduction to the primary text, a Bengali novel by Nabarun Bhattacharya who was one of the most influential and controversial authors of recent times. The plot of *Kangal Malsat* (2002) presents the exploits of the *Fyatarus*/Flying Men and the *Choktars*/Black magicians. The article draws attention to the contexts within which the cult of Fyatarus emerged. It elaborates on the ways in which the narrative complexity and the political content of the literary text were adapted into a sequential art form, specifically, into a popular genre-like graphic novel. It focuses on the manner in which a transgressive style and three-way exchange between literary text, cinema and sequential art was achieved as Mukherjee worked in tandem with the cinematic adaption of the same text (by Suman Mukhopadhyay, in 2013). The article reflects upon such manifold transactions, and shows in what way a dense and polymorphous form may be forged by means of revisiting and reframing an existing text. In short, this piece discusses the dialogic, multifaceted and fluid structure of graphic narratives, its function within wider political-cultural debates and the fashion in which such exchanges may produce conditions for cultural negotiations.

It may be useful to introduce the primary text or the novel written by the radical Bengali poet, novelist and activist, Nabarun Bhattacharya (1948–2014), at the onset. Bhattacharya shot to fame and gathered a forceful (Left) support following the publication of his fiery book of poems *Ei mrityu upatyaka amar desh na* (/This Valley of Death Is Not My Country, 1982). In time, some of his poems inspired political slogans and street graffiti, and eventually Bhattacharya emerged as an alternative cult figure who was critical about both mainstream Left politics, and rapid rise of right-wing ideology. Besides, his (ultra-Left) political leaning and his lineage (only son of celebrated authors, namely Bijon Bhattacharya and Mahashweta Devi) were not unknown. Bhattacharya initially worked with *Soviet Desh* (Bengali) magazine, and his novel *Herbert* (1993) received the prestigious Sahitya Akademi award. *Herbert*

was immediately considered to be a contemporary classic, and was adapted into film by Suman Mukhopadhyay in 2005. Bhattacharya was also the editor of *Bashabandhan* (Bengali) journal. The import of his work developed through his powerful writing style and subjects, which addressed current (political) crises, the darkly city and its underbelly, the urban poor, disposed and marginalized peoples. Furthermore, the post-colonial city of his stories has many planes, and the poor are yet to become a political mass. His narratives involve social outsiders and unusual situations, which are laced with black humour, and pungent words (also abuses). Moreover, the technique of suturing of multiple stories and time frames produce multi-layered texts, which are pointed commentary on the political predicaments of West Bengal, India. While Bhattacharya's poems, short stories and novels triggered fervent debates, he garnered a massive cult status following the publication of the Fyataru series.[1] These are stories about (three) underdogs, who have mastered the *mantra* 'fyat fyat sain sain', and are able to fly. The Fyatarus (Flying Men) are by and large washouts, who survive on the margins of development and sometimes disrupt the rapid advances of globalization through extraordinary methods.

*Kangal Malsat*, the novel, involving the Fyatarus, encompasses a broad canvas, as the plot tackles multiple times, characters and political commentaries. Set in the last decade, the plot often wanders into a range of other stories in order to produce compelling historical links between present-day and nineteenth-colonial Bengal, as well as with larger politico-cultural turmoil through the twentieth century, and the extensive process of decolonization.[2] Briefly, Bhattacharya's text maps a broader history of economic deprivation and political insolvency. Thus, while during the daytime the characters loiter around, during the night they encounter – under 'normal' circumstances – dead political leaders, ghosts from nineteenth century and other nocturnal creatures. Effectively, while daytime deals with contemporary issues, night-time unravels the complicated social history, which eventually provokes mutiny and mayhem. The novel describes the exploits of two groups, namely the Choktars (a title like 'Doctor' bestowed upon black magicians) and the Fyatarus. While the Choktars are headed by a rather loutish character named Bhodi (also known as Marshall Bhodi); however, they are practically led by an old talking Raven, who is Bhodi's father. In time, the Fyatrus and the Choktars join hands, and form the scrounger's army. Finally, they declare 'war' against the Government, and attack government offices with a 'tiny-dicky' antique cannon, old pistols, knives, scissors, shovels cockroaches, and also throw shit, pee, etc. on the buildings. And yet, the rebellion fizzles out in the end, as they accept the treaty of peace, become petty agents in disparate departments and get inducted into the corrupted system.

The chief characters of the novel, the Fyatarus or the 'flying people', namely Madan the fatuous, DS the drunkard and Purandar the failed poet, have been extremely popular ever since they appeared on the Bengali cultural scene. Typically they are duds, and often fight processes of marginalization through various unusual means. For instance, in one occasion, Purandar earnestly requests certain *kavi sammelan* (poets' meet) organizers to let him recite some of his (awful) poems. He pleads that he would read out his poems during the tea break; at the point *samosas* (snacks) are served, without disturbing the main programme. Naturally, Purandar's plea is disregarded, following which they carry a sack full of cockroaches and let those loose inside the auditorium, which results in utter chaos and discontinuation of the programme. The accounts of Fyatarus are marked by black humour, and function as political-cultural criticism. Moreover, the Fyatarus journey through the city's underbelly and dingy backyards of (under) development. The novel, in reality, considers a group of people

who are neither 'proletariat' (because they are jobless), nor 'lumpen' (since they are harmless). Surviving on the edges of defunct factories, cemeteries, dirty streams, plush housing estates and shopping malls, they neither work nor hurt, and therefore, remain unaccounted until they do something devious or throw back the muck produced by large establishments. Anindya Sekhar Purakayastha, in his passionate tribute to Bhattacharya suggests,[3]

> In that way Nabarun succeeded in carving a niche for his own *genre* of writing, a *genre* which cannot be characterised by any specific school of Bengali fictional writing. It is a curious mix of the agitprop, the magic real, the absurd *gharana* [school], artivism [art plus activism] and the carnivalesque. One can find few parallels of Nabarun in Indian literary tradition and his unique creative domain emerges as a powerful weapon for dissent and constitutes what Jacques Rancière called, a *dissensual sensorium* ....

While Bhattacharya's style is unique and subversive, his writing draws attention to the absence of political direction. Moreover, the site for such intense negotiations is Kolkata, and thus, this 'post-colonial' city, as mapped by Bhattacharya, appears like a vast wasteland, teeming with social outsiders and jobless loafers. Kolkata seems to be buried under dung, garbage and remains of the past. It is through such stories that, as it were, one traverses the invisible sewerage of the city. Indeed, such intensities throb through all Fyataru stories, and in his landmark novel *Kangal Malsat*. Samik Bag, in his article on the filmic version of the novel writes how,[4]

> Bhattacharya's freethinking shows in Kangal Malsat. He is irreverent towards Bengal's largest media house and Bengalis in general ([therefore, Bhattacharya writes] 'an entire race [community] is heading towards Nimtala (a crematorium), cellphone held in a tight grip'). He is critical of the city: [and says] 'The polluted air lends to everything a sublime maya, and any gust of wind throws up large and small flying polybags like white doves of peace.' .... [However] 'The Fyatarus are watching everything,' he [Bhattacharya] warns. 'A day will come when they'll strike back.'

One may argue that, Bhattacharya's narrative style becomes evocative, particularly because of such idiom. The novel plays with slangs and swearwords, as well as with common and locally used English expressions, which describe everyday objects, actions, etc. Hence, instead of writing in sophisticated Bengali, making of which has a historical significance, Bhattacharya subverts by using the unstructured lingo of the common people.[5] As a matter of fact, the text is seething with everyday vulgar expressions, and even Hindi phrases, which invent a powerful and contemporary lexicon. Furthermore, his exceptionally discursive and meandering style is thought-provoking, and encourages conversations of multiple orders.

The density of a world that's falling apart, of 'God forsaken' places, and of the wretched of the earth, is troubling (to say the least), and visually intriguing. In connection to this, and on a personal note, it may be specified that I studied Literature and Cinema at the University level, and have some informal training in fine arts and music (Sitar). Nonetheless, while writing screenplays seem to be a logical outcome of learning and teaching Film Studies, attempting a graphicnovel – that too of this scale – appears somewhat 'outrageous' in retrospect.[6] I presume, it was the sharpness of the writing that encouraged one to imagine a world that is tangibly multidimensional. Additionally, the scene was opening up for me, so to speak. On one hand, while young people in the University initiated a journal of comic works, in which I contributed; on the other, my first directorial venture, *Carnival* (2012), an experimental feature without dialogues (and with English inter-titles), was screened at the 41st *International Film Festival Rotterdam* 2012, under the 'Bright Future' category.[7] I also

executed a solo media-installation (*Crumbled Papers, Fragments of Cinema*) *at* the Nieuwe Oogst foundation, which was hosted by the *International Film Festival Rotterdam*.[8] Direct encounter with World Cinemas, exceptionally creative film-makers, and contemporary forms of image making generated many (obscure) ideas and perhaps inspired one to take the risk. Thus, at the point I thought of adapting the vast canvas comprising political history and critical discourse, which are presented in an overtly dark tone, or as I aspired to design, illustrate and rework *Kangal Malsat* as 'graphic novel', it somehow materialized by churning the compost as it were, and through the density and forthrightness of manifold stories. The locations, characters, their actions and misgivings, drove one to make new engagements with the emergent graphic form (Figure 1).

## Speaking through graphic narratives

At the time Suman Mukhopadhyay adapted Bhattacharya's *Herbert*, it crafted fresh arguments regarding cinematic forms, and more significantly, about the networks of the post-colonial city, which are deeply scratched by accounts of refugee re-settlements and followed by chronicles of impassioned political movements.[9] Brinda Bose and Prasanta Chakravarty show how,[10]

> Suman Mukhopadhyay's film *Mahanagar@Kolkata* [2010] is predicated on the irrational, on the disparate threads that make up an almost macabre urban existence in contemporary Kolkata that is at once morbid, violent, ironic and romantic. ... [i]t does not affiliate itself to any particular tradition or even discursive course but tries to map urban and semi-urban angst, in what is an entirely new syntax of thinking cinema in Bengal. Indeed, Suman Mukhopadhyay's *Herbert* (2005) and *Mahanagar@Kolkata* have both been discussed in this context of searching for a new language of cinema that all at once speaks of, and to, the chaotic and the meaningful in Bengali contemporaneities.

In reality, the city ('morbid, violent, ironic and romantic' also 'chaotic', and dystopic) has been the locus of production in a range of seminal films including Ritwik Ghatak's post-partition trilogy and Mrinal Sen's films about 1970s political discontents.[11] Moreover, Bengali novels (beginning with Nobel laureate Rabindranath Tagore's *Chokher Bali*, published at the turn of the last century), short stories (for instance, those by Manik Bandyoapdhyay and others) and poetry (those by Kallol group et al.) as well as visual arts have relentlessly reconnoitered the city both as content and as context.[12] Therefore, the thought of adapting Bhattacharya's novel – considering its import within contemporary Bengali political-cultural milieu – into a graphic novel, via Suman Mukhopadhyay's film, appeared both audacious as well as foreseeable. In 2012, I approached Mukhopadhyay while he was planning the film (*Kangal Malsat*), and proposed that one could unpack the textures and layers of such multifarious narrative through formal experiments since, the practice of multi-planer page format of the graphic form may in effect facilitate one to explore the complexities evoked by the novel (Figure 2).

More important, during this period, I also met Nabarun Bhattacharya. As mentioned in the author's note of the graphic novel, on my first meeting with Bhattacharya (during January 2012) I enquired – somewhat waywardly – as to why there were no female Fyatarus or female flying figures. To this, Bhattacharya replied wistfully and said that, 'why, Kali [the sex worker] can be a Fyataru ... you work on it'. This meeting, one imagines in retrospect, was the beginning of a three-way relationship between novel, cinema and graphic novel.

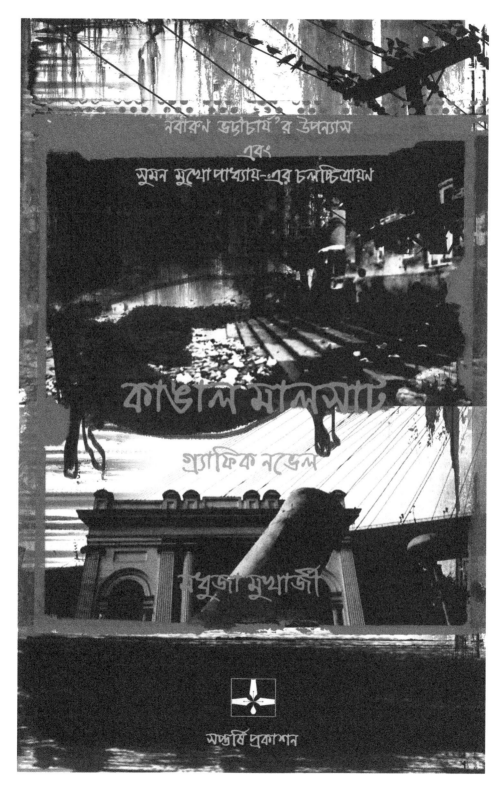

**Figure 1.** Cover page of *Kangal Malsat* graphic novel.

**Figure 2.** 'An explosion is brewing within' (page 9).

The objectives, however, were to produce ruptures within existing texts, genres, and also insert the question of gender within a text that tackles crises of masculinity and thereby forge newer modes of articulation. Eventually, *Kangal Malsat* as graphic novel, matured in collaboration with Suman Mukhopadhyay's film (of the same name), and through many conservations, trials and errors.

Prior to *Kangal Malsat* graphic novel, I had worked on a short graphic-narrative (titled 'Flaneuse wants bitter coffee' (2012)) on Kolkata and on the rapid growth of shopping malls on the premises of defunct factories.[13] Issues of gender, labour, changing cityscape, environment and public spaces became pertinent in that short work. However, the 'novel' format demanded much more rigour, patience and innovativeness. While Will Eisner's critical analysis *Comics and Sequential Art* (1985) as well as Scout McCloud's *Understanding Comics* (1993), along with his descriptions of the different 'panel types', figured as seminal arguments, the thin line between comics and graphic novel remained conspicuously fluid.[14] Furthermore, the visual style of the pages shifted as I did many drafts or gradually progressed towards the unpredictable climax. And yet, one may reason that, if popular comics are about columns, line drawings, speech balloons as well as about coloured panels and linear stories, then, contemporary (black and white) graphic works show how comics could potentially become more playful and hard hitting if one were to dislocate the panels through new designs. In fact, the comic style was reworked through (irregular) sketches, asymmetrical frames, vertical panels, texts, and even blank and silent pages. While the storyboard pattern seemed relatively easier to me because of my exposure to film-making, breaking away from the structure and format, therefore, became imperative. Besides, the idea of including a pool of popular imageries, along with sketches (done by me) and snapshots taken from the film, added to the difficulties of execution and complexities of the form (Figure 3).

Otto Nuckel's early works like *Destiny: A Story in Pictures* (1930) and Lynd Ward's *Madman's Drum* (1930), a wordless novel, had already cast a shadow and a spell on my thinking. While these 'silent' novels were created during the forbidding interim period between the two World Wars, Will Eisner's pioneering creation, *A Contract With God* (1978) that incorporates the saga of wartime immigrants surviving in an American ghetto, became decisive for my reflections and rethinking. Likewise, Vishwajyoti Ghosh's political tale *Delhi Calm* (2010), and Sarnath Bannerjee's *Harappa Files* (2011), along with his *The Barn Owl's Wondrous Capers* (2007) became crucial references. The prospect of imagining in 'black and white' and the scope of juxtaposing sketches and photographs with texts was a significant impetus. Specifically, imagining in terms of grey tones, and differentiating, for instance, between pink, blue and yellow through the grey-scale, required fresh ways of looking and deliberation. Furthermore, one tried to avoid contemporary nostalgia regarding black and white images and the production of images with typical celluloid 'glitches'. In addition, the mixing of established graphic form with fragments of cinema, with frame-grabs and found images for example, was both engaging and testing. The process, needless to say, also involved a so-called artistic quest, hence, I strived to seek my own 'style' so to speak. I therefore, explored the hybridity of the form. Somehow, multiple influences and training (in fine arts, Comparative Literature, Film and Cultural Studies) came together as I laboured to achieve a pattern that was not yet part of established graphic or visual cultures (Figure 4).

The skeleton drawings or basic sketches of the pages were initially drafted on paper and then scanned. Thereafter, still images from the film's footage/rushes, as well as certain popular and widespread images, like those of guns and flying saucers (which may be found

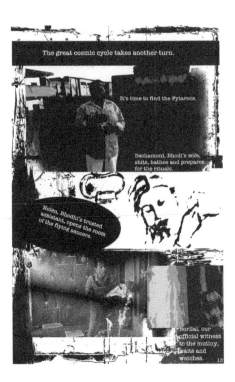

**Figure 3.** The news about 'dancing skulls' and preparations (pages 12 and 13, from the unpublished English version).

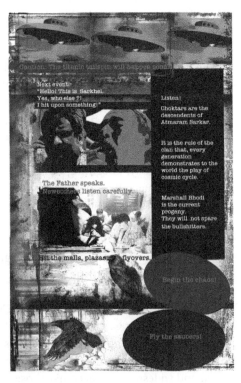

**Figure 4.** Pages 14 and 15 (from the unpublished English version).

on the Internet or other domains of the public sphere), were collated and added as new layers. Subsequently, sketches, photos and snapshots produced a tapestry of quotations. Thus, each page comprised drawings, imageries derived from multiple sources; moreover, I used photographs of Kolkata, some iconic images (of Terracotta soldiers, for example), as well as close-shots/cut-outs of faces of the actors (taken from the film's shots). While typical columns and panels were splintered, or were placed vertically (instead of horizontally) in relation to the texts/speech bubbles, or against blocks of colours and empty spaces, the purpose of the final illustrations was to create a dialogue between image, text and design.

Effectively, this work remains on the edge of many fields. And thus, both the content and the visual design of the work were imagined as distinct from both the novel and the film. For example, Suman Mukhopadhyay's (and cinematographer Avik Mukhopadhyay's) play with a specific colour palette – that included red, green and orange, because they referred to the Communist movements, the overall decadence, as well as contemporary political situation – was *not* adapted into the graphic novel. The palette in this case was asphalt black, charcoal, steel grey, ash, and various obscure shades of grey, as well as pale white and other muted tones, which were thereafter juxtaposed with bright red, yellow or green (complimentary colours). Through the graphic novel, I aspired to depict the sense of a rotting world; therefore, in this effort to produce murky zones, a wide range of layers and (digital) effects like mud, smoke, rusted metal, cobwebs, junk effects, etc., were applied, one after the other, in order to produce a fabric of despair. The overall ethos of the novel seemed to provoke the colour scheme. Briefly, the method of fabrication of each page entailed a primary sketch/design of the page done on paper, which was thereafter re-designed on the computer. Scans of my own drawings as well as frame-grabs from the film, and a number of other images, were put together within the design. Thereafter, texts were juxtaposed as one would add another set of images. Some of the pages eventually included more that 70 layers, which were later merged into one. Through etching, splitting of the frames and by (mechanically) devouring the edges, I wanted to craft an impression of a mucky milieu, which at the same time comprises black humour.

In reality, the 'plot' of *Kangal Malsat*, is somewhat bare. It involves the already notorious Fyatarus, who in this context encounter a superior group, that is the Choktars (the black magicians), and come under their spell. In due course, inspired by the black Raven, they team up to disturb and disrupt the state mechanism. In the end, as mentioned earlier, the rebels join the political parties and become local Government representatives. The 'narrative' of the novel, conversely, rambles into many other stories, situations and events. Moreover, Bhattacharya includes extensive political commentary, and passages regarding longer histories of colonial exploitations and post-colonial predicaments. Thus, with the nocturnal turn night fairies, petty ghosts as well as ghosts of British officers and Begum Johnson (Raven's lady-love) descend/rise from nineteenth century to interact with police officers and present-day political leaders. Furthermore, set in the Kalighat area (which comprises the famous Kali temple, a crematorium as well as red light area), the novel dwells on absurdities and plays with a dizzy exuberance along with a particular kind physical energy, that has been described as 'burlesque' by Mukhopadhyay (during a personal conversation in 2013).[15] Indeed, many such events, like digging for oil, the episode with dancing skulls, the night-time encounter of the local communist party leader with Comrade Stalin, the beheading of the police commissioner who, however, fixes his head and wears a collar to keep it straight, the attempts to produce AK-47 weapons locally and so on, produce an invigorating literary text (Figure 5).

**Figure 5.** Meeting with Com. Stalin following few pegs of Vodka.

To interpret, *not* the incidents, but the intent of the novel into a graphic-narrative form, thus, required certain degree of abstraction and stylization. For example, while the opening pages of the graphic novel were designed like a family tree, which explained the background of the characters, along with their co-relation with each other, a number of the early pages illustrated the context of Kalighat and its fetid milieu. Besides, a cinematic device like the 'interval' was integrated as a narrative strategy to underscore my own reflections and produce a narrative break as opposed to the episodic structure of the primary text. The attempt was to engage in a dialogue with the film as well as literary forms; furthermore, the effort was to find a liminal space that nurtures new vocabularies. In the graphic adaptation, the primary objective was to map the city of Kolkata, and shape new frameworks of storytelling. For instance, at the very the beginning, the graphic novel alerts the reader to an impending calamity, and a catastrophe that is approaching. Therefore, one can in point of fact locate a little cannon right from the start, although, both in the novel and in the film, Bhodi and his subordinate Sarkhel hit upon a 'tiny-dicky' Portuguese cannon much later (while digging for oil). Contrarily, one imagined that, for the graphic form it was imperative as well as possible to build suspense, and indicate a forthcoming action that was churning underneath.[16] Likewise, while the film focuses on Bhodi, and presents him as the protagonist (and ends with him), the graphic novel concludes with Sarkhel, who appears to be still digging even when all action is over. In effect, Sarkhel seems like a faithful representative of the Fyatarus and the Choktars, since he remains marginalized and hopeful, and does not get lapped into the powerful systems. The structure of the filmic plot became a point of reference to begin with; and yet, the purpose was to both refer to it, and break away from it.

The question of the city and gendered spaces remain close to my artistic concerns. Therefore, while one may argue that, though the novel does not subscribe to a masculine moral order and in effect, presents the meek and the famished, along with the crisis of masculinity, women, nevertheless (as mentioned earlier), do not grow wings, and do not fly. This thought was eventually extended to make Kali, the night-fairy, who is a passive character in the novel, into an active observer in the graphic novel or into yet another *Fyataru/Fyatarun* (or female Fyataru).[17] More important, the concept of using sketches of dragonflies attached to the cut-outs of the faces of the actors to produce the figure of Fyataru emerged as one walked in and around Kalighat area. Indeed, on one occasion, during the dusk, as I walked around Kalighat taking pictures of the city, about hundreds of dragonflies swarmed the sky above my head. This experience instantaneously generated the image of a dragonfly with a human head. Furthermore, the dragonfly was merely an insect, not any pretty bird. As a matter of fact, one may suggest somewhat artlessly that, perhaps it was the deep orange twilight, which provoked such musing and mutations (Figure 6).

### Recounting a few pages

Julia Round describes 'comics' as a hybrid form and elaborates on the notion of 'interacting signifiers'. Nevertheless, her critical formulation of 'heterodiegetic narration' could scarcely be applied in any straightforward way as one tried to give shape to something 'new' and outside the box. Round's writes,[18]

> [W]e may define comics narratology as based on an open half-narrative that relies on the reader both to interpret the panel contents and fill in the gutters. The panel itself is a hybrid signifier that represents a varying amount of story time ….

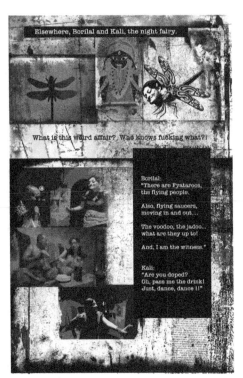

**Figure 6.** Pages 18 and 19 from the unpublished English version.

Indeed, as one worked on pages 13 and 14 or on 18 and 19 and so on, one deliberated upon the question of hybridity and 'story time'. One enquired, how does one glean a 'story' from the vast pool of information available in the novel? Which are the imperative and intriguing situations? How does the content lend itself to a/any visual design? More important, in what way can one transform the intensity and the ideological vigour of the novel into a graphic narration? Many of these issues were addressed through several trials and many errors. For instance, pages 13 and 14 present the plot and initiate the reader into the story. It brings together the episode in which Marshall Bhodi locates the Fyatarus. While three panels present three disparate moments, one intended to create unease through the placement of the 'shit-pot' sketch at the centre of the page, which is thereafter juxtaposed with the gentle face of Bechamoni (Bhobi's beloved wife and partner in mutiny). Similarly, the next page emphasized on Bhattacharya's point that the 'public are watching'. Therefore, a monocular eye, looking back at the mayhem and possible mutiny was used for the first panel. Three other panels and thought/speech balloons were framed bearing in mind a symmetrical pattern. Thus, on the left of the page one sees columns and texts, and on the right drawings are placed. These pen and ink drawings illustrate the putrid state of Ganga, on which dead bodies float like weed, while pigs devour the filth. In a similar way, one sketched discarded alcohol bottles, which are often used to carry home the holy waters. In addition, at the bottom of the page, Purandar is seen enquiring, 'who are Choktars?' Bhodi replies, 'They are titles, … like Doctors'. And, continues, 'we are not in news, not on Television; neither on radio nor on the net. None of those … shit!' These lines were (re)used to set the tone for

an impended revolution of sorts. In fact, while distinction between continuous time–space was deliberately blurred, one invoked a dual and sometimes contrapuntal mode of address. Thus, while on one hand, the panels are held together through a narratorial voice; on the other, the narrative is pushed forward or a narrative drive is created through a set of rather complex imageries, and through uses of different colours (especially red). Considering that text and images speak to each other, hence, texts function as images, while, images are used to tell the tale. Moreover, pages were imagined in terms of pairs and placed next to each other with regard to a visual symmetry.

Likewise, page 18 shows the Fyatarus actually flying, and looking down at the state propaganda machinery. Here, one used the face of the Raven (played by the influential singer-composer Kabir Suman), which is set against the figures of the flying men (with dragonfly bodies), to highlight the fact that, these flying creatures are 'watching' us. One also used Purandar Bhat's scandalous poems to stress upon the disquiet. For instance, Purandar writes,

My life has no exciting brawls/ therefore, on cotton fields I crawl. /

I have no dream either, only dregs/ Like a lizard, I eat bugs, I lay eggs. …

There are no headlines as I die/on palaces, I pee; the law, I defy …[19]

Additionally, one quoted from other texts penned by Bhattacharya, which in a prophetic manner described present political conditions about a decade earlier. Bhattacharya/Purandar Bhatt inscribed, 'CPIM blossoms in our orchard/Trinamul buds in the backyard'.[20] This page, nonetheless, may also appear as deceptively bare. Yet, the narration is not limited to the text; instead, through a series of shifts in perspective and images, along with specific silent panels, the aim was to craft a tension between the literary plot and the visual design. Furthermore, page 19 stages a set of three columns on the top-horizontal, and three on left-vertical. This page brings together the iconic and found image of Goddess Kali (of Kalighat, Kolkata), as well as a silhouette picture of a dragonfly, along with the visual design done for the character of Kali (the sex worker). Kali, the unsuspecting witness to mayhem and mutiny, now has decorated wings, and smiles in joy and dances in ecstasy. Images of Kali dancing were initially grabbed from the film; though the sequence was eventually deleted.

In conclusion, one therefore suggests that, Kali's reflective dance in the graphic novel (in absence of this exuberance in the film or in the novel) throw light on the question of female Fyatarus or Fyataruns (raised earlier). Moreover, muted tones were used for both page 18 and 19 in order to foreground the complexity of the situations and actions. In the process, one enquired if films interpret and visually transform literary texts, what is the function of graphic novel? Indeed, one may propose that, the graphic novel allows unforeseen juxtapositioning of image and text, or unique deployment of texts as images (and the vice versa). Moreover, the graphic form can present multiple times and fabricate images of a multilayered world within a single page or frame. Consequently, the discursive style of Bhattacharya was not transformed into events or actions; in fact, his political thought and radicalism were translated into images, design and colour. Thus, while writing and illustrating *Kangal Malsat* graphic novel I did not simply borrow from the primary text(s), rather, the attempt was to interpret, transform and intervene in order to create a set of dialogic and polymorphous texts. In my understanding, *Kangal Malsat* graphic novel is *not* a flawless adaptation of the literary classic; however, one may say that it signals the arrival of alternative forms, and an-other type of audio-visual and textual convergence, which is

outside mainstream media.[21] Also, the process highlights the ways in which the 'popular' may be re-imagined as something that is far more provocative, radical and innovative.

## Notes

1.  See Bhattacharya and Chattopadhyay.
2.  See Sengupta.
3.  See Purakayastha.
4.  See Bag.
5.  See Kaviraj.
6.  See Mukherjee 2015.
7.  The film was in competition at the 12th *Osian's Cinefan Film Festival* 2012 and has been screened at the 'Deconstructing Cinematic Realities' festival in Moscow during 2012, and in the University of Pittsburgh in 2014 and across Indian cities (see Trailer: http://www.youtube.com/watch?v=jJu_3Xql0tc).
8.  See Mukherjee 2013.
9.  Also see Biswas 2002; Mukherjee 2012.
10. Bose and Chakravarty (138).
11. See Mukhopadhyay, Biswas Ed. And Ghatak's own writings.
12. See Chaudhuri.
13. See Mukherjee 2012.
14. Also refer to Heer and Worcester, Eds.
15. It may be noted that, Kalighat area is in south of Kolkata and is central to Bengali (Hindu) public sphere. Besides the myth of the Kali temple, and the adjacent crematorium and the holy Ganga, the place has become volatile in the recent past because of the fringe growth including the expansion red light area and political tussles. Kalighat is also well known for the early twentieth-century Pat paintings done mostly Muslim artists. Also see Barbiani.
16. Also see Horstkotte and Pedri's reading of Marjane Satrapi, *Persepolis* (338).
17. The term Fyatarun signifying female fyataru is my own creation.
18. Round (323).
19. A number of English texts used in the graphic novel are a *reworking* of the subtitles of the film.
20. Translations author's own.
21. See Jenkins.

## Acknowledgements

I am thankful to Suman Mukhopadhyay, Avik Mukhopadhyay and Saurav Mukhopadhyay.

## Disclosure statement

No potential conflict of interest was reported by the author.

# References

Bag, Shamik. "Nabarun Bhattacharya | Offence Given, and Taken." 2013. <http://www.livemint.com/Leisure/hVBrf6IjV1TGHigZRNj7GP/Nabarun-Bhattacharya–Offence-given-and-taken.html> (accessed on 30 Jan. 2015).

Barbiani, Erica. "Kalighat, the Home of Goddess Kali: The Place Where Calcutta is Imagined Twice: A Visual Investigation into the Dark Metropolis." *Sociological Research Online* 10.1 (2005). <http://www.socresonline.org.uk/10/1/4.html> (accessed on 18 July 2015).

Bhattacharya, Sourit, and Arka Chattopadhyay. "Nabarun Bhattacharya: An Introduction". *Sanglap: Journal of Literary and Cultural Inquiry* 2.1 (2015). <http://sanglap-journal.in/index.php/sanglap/article/view/64/54> (accessed on 13 Jan. 2016).

Biswas, Moinak, ed. *Apu and After: Re-visiting Ray's Cinema*. Kolkata: Seagull Books, 2006.

Biswas, Moinak. "The City and the Real: Chinnamul and the Left Cultural Movement in the 1940s." *City Flicks, Cinema, Urban Worlds and Modernities in India and Beyond*, Occasional Paper, 22. Ed. Preben Kaarsholm. Denmark: Roskilde University.

Bose Brinda, and Prasanta Chakravarty. "Kolkata Turning: Contemporary Urban Bengali Cinema, Popular Cultures and the Politics of Change." *Thesis Eleven* 113.1 (2012): 129–140. doi: http://dx.doi.org/10.1177/0725513612457234.

Chaudhuri, Sukanta, ed. *Calcutta, The Living City*. Vol. 1 & II. New Delhi: Oxford University Press, 2005.

Eisner Will. *Comics and Sequential Art*. Tamarac, FL: Poorhouse Press, 1985.

Heer J., and K. Worcester, eds. *A Comics Studies Reader*. Tuscaloosa, AL: University Press of Mississippi, 2009.

Horstkotte, Silke, and Nancy Pedri. "Focalization in Graphic Narrative." *Narrative* 19.3 (2011): 330–357.

Jenkins Henry. *Convergence Culture: Where Old and New Media Collide*. New York: NYU Press, 2006.

Kaviraj Sudipta. *Unhappy Consciousness Bankim Chandra Chattopadhyay and the Formation of Nationalist Discourse in India*. Delhi: Oxford University Press, 1995.

McCloud Scout. *Understanding Comics*. New York: Kitchen Sink Press (An imprint of HarperCollins), 1993.

Mukherjee, Madhuja. "Flaneuse, Viewership, Cinematic Spaces: The Site/Sight of Theatres, Engendered Structures and Alternative Art Projects." *Media Fields Journal* 7 (2013). <http://mediafieldsjournal.squarespace.com/flaneuse-viewership-cinematic/> (accessed on 12 Dec. 2014).

Mukherjee, Madhuja. "Narratives of Development in South Asia." *The Mud Proposal* 1 (2012). <http://tmp.kaurab.com/madhuja-narratives-2.html> (accessed on 23 Dec. 2014).

Mukherjee, Madhuja. "Variegated Qissa: (Divided) Landscape of (Multiple) Longings." *Studies in South Asian Film and Media* 7.1–2 (Apr 2016 [2015]): 45–58.

Mukhopadhyay Deepankar. *The Maverick Maestro, Mrinal Sen*. New Delhi: Indus (An imprint of HarperCollins), 1995.

Purakayastha, Anindya Sekhar. "Fyataru and Subaltern War Cries." *Sanglap* 1.2 (2014). <http://sanglap-journal.in/index.php/sanglap/article/view/24> (accessed on 2 Feb. 2015).

Round Julia. "Visual Perspective and Narrative Voice in Comics: Redefining Literary Terminology." *International Journal of Comic Art* 9.2 (2007): 316–329.

Sengupta, Samrat. "Strategic Outsiderism of Fyatarus: Performances of Resistance by 'Multitudes' after 'Empire.'" *Sanglap: Journal of Literary and Cultural Inquiry* 2.1 (2015). <http://sanglap-journal.in/index.php/sanglap/article/view/69/59> (accessed on 19 Feb. 2016).

# Remnants of a separation: *a ghara and a gaz: from Lahore to Amritsar to Delhi*

Aanchal Malhotra

The streets were empty in a way that Delhi streets never are. It was an early Sunday morning and the bylanes of North campus lay bare of their usual commotion. There were no groups of loitering college students cutting classes, no hawkers selling food and other items, no chaos of the pedestrians manoeuvering their way through the traffic, attempting to cross the street, and no endless rows of rickshaws eagerly awaiting passengers outside the metro station. There was no cacophony of the horns and the general bustle of city noise.

On the contrary, there was an unexpected silence and in that silence, I noticed for the first time how wide the streets actually were. Sunday, it seemed, was the day that even North Delhi took hiatus.

The dark blue shirt of the *rickshaw-wala* fluttered in the wind before me as he peddled to our destination. I knew this route like the back of my hand: An initial left turn out Vishwavidyalaya – the university metro station parking lot. Then, a long, straight road with scanty trees on both sides and broken bits of pavement painted in yellow and black. Another left as the *rickshaw - wala* held out his arm to signal the turn; walls painted with logos of political student groups and two florists sitting at the end of the road, anticipating weekend sales. Arriving onto a roundabout that reached the outskirts of Kamla Nagar, the hub of Delhi University's main campus. Driving by a maze of intricate lanes and stores selling everything from clothes to furniture, a final right through a large black metal gateway opening onto a suburban street of Roop Nagar with multi-storey houses in a variety of styles. And eventually, to my destination – *Vij Bhawan* – a two-storied house, aged and frayed with an old-fashioned silver gate.

As far as I could remember, I had always thought this house to be old.

Not just the way it looked – simply existing, enduring time and weather, the off-white exterior yellowing and crumbling with the passing of years, but also for what it contained. Living within those ancient walls were the generations of my mother's family, my family. For me, it had stood as an age-old symbol of the firm bonds of ancestry and lineage and inside its archaic structure, I found comfort.

Standing before *Vij Bhawan* now, I realized I was experiencing it differently now than I had growing up. In that moment, I was looking at it from the eyes of an observer, a sort of detached archivist. This had everything to do with my friend, *The Delhi Walla*.

This article was originally published with errors. This version has been amended. Please see Corrigendum (http://dx.doi.org/10.1080/14746689.2016.1265202).

A few weeks ago I received a call from him telling me he wanted to do a short story on old houses of Delhi. He knew my mother's family lived in such a house in the northern part of the city, and wondered whether it was possible for me to take him there so he could speak to its residents.

A simple enough request, so I agreed.

We had met on a pleasant October afternoon, not too warm. Our rickshaw had followed the same route from the metro station, but this time through the North campus of a week-day, bustling with activity and chaos. We had arrived at the house and I had introduced *The Delhi Walla*, the connoisseur of all things Delhi, to my grandfather and his eldest brother, my grand-uncle- both of whom I called *nana* – grandfather.

They sat together for a long time, talking about the house and how the area of Roop Nagar was a part of the rehabilitation plans for refugees coming into Delhi from Pakistan at the time of independence in 1947, how the house had been renovated from the inside many times, yet still held within its crevasses, elements of its original structure.

They talked about its residents – how though my great grandfather was no longer alive, his desire for the family to be living together still was, how the 17 rooms and 5 kitchens were inhabited by three generations of 16 family members. They spoke extensively of the past, of the Partition of British India, of the modernization of Delhi, its many neighbourhoods, and of the importance of a now dwindling joint family structure.

Slowly, my grand-uncle rose and left the room. I watched his tall, lean frame walk out and close the door quietly behind him. He returned minutes later with an array of objects and placed them on the glass table in the middle of the room.

These were things that belonged to the past; that possessed a certain elegant old-world charm. The conversation came to a still as we examined them: There was an old lock of unusual shape – the kind one finds on the shelves of a museums of antiquated things. Alongside it was a key, equally old and quaint with a small, thick stem and a larger hand-carved bow in the shape of a flower – rusted, delicate. I wondered what kind of a door this lock had belonged to. There was also a long foldable bookend in a dark wood, hand carved in a filigree pattern of embellished leaves and flowers, the ends standing up in the shapes of smoothly carved elephants. There were some old photographs, dusty and yellowed with age.

I allowed my hands to graze lovingly over these items. But I noticed that he kept two things separate, a little to the side – a round-bottomed vessel and a long, thin metal stick. Both my grandfather and his brother looked at these objects somewhat differently than the rest.

'What are these?' I asked.

My elder *nana* straightened his lean frame, focused his large, beady eyes on me, and spoke slowly, enunciating each word.

'Well, those are just a few old things. But these …', he gestured to the pair, '*these* belonged to our parents. They brought them from Lahore before the Partition'.

I had visited this house more times than I could remember, but never before had I seen any of those things. These belonged to a time before the Partition. A vessel and a metal stick – these were what had withstood displacement, death trains, riots, fires, civil war, religious disparity, poverty, refugee camps and rehabilitation centres. I marvelled at the oddity of objects that had survived the test of time.

As he spoke, something changed in him. His whole demeanour became almost like that of a young boy. There he was, sitting in the living room with his brother, my friend and I. He

was physically there, but at the same time, he was not. Within those objects, he had found a quiet escape and had been transported someplace else, someplace closer to his parents, to another time, to Lahore.

He held the vessel in his hands. It was medium sized, round at the bottom with a graceful neck, made up of a combination of alloys, rusting in places as metallic hues of dark and light merged together on its surface. Engraved into the metal was the most delicate pattern of foliage and line work typical to the Indian subcontinent. It was not particularly heavy, but it weighed down his hands. As he drummed his fingers over its smooth exterior, it created a kind of hollow metallic sound.

'My mother churned *lassi* in this *ghara* for us when we were young'.

His eyes were dreamy and far away as he described how she would pour the milk into the vessel and churn it with a small wooden churner called a *phirni*. She would hold it in her hands and move forward and back gracefully with skill, creating clockwise and anti-clockwise ripples in the liquid.

As he spoke about it, I could tell that he too was re-discovering this quaint object. Through the action of remembering how the object had once been used, whom it belonged to and how it was passed down to him, he was re-creating the past in front of us, a past he himself has not visited in a long time.

"It is from Lahore. She brought it with her when she got married. In our days, bringing utensils to your husbands' home at the time of one's wedding was common for new brides. This *ghara* is made of German silver, if I remember correctly. She used it throughout her life and now I use it just like her – to make *lassi*," he smiled and laid it back down (Figure 1).

It was interesting. An object of such banality laid claim to such a rich past, travelling through the generations.

'And what about this? What is this?' the curious *Delhi Walla* asked, holding up the metallic stick.

"This is a yardstick. These days we use the meter to measure fabric, but earlier it would be measured by the *gaz*, the yard. This also came from Pakistan. My father used it in the clothing store owned by my grandfather in Lahore."

He stretched out his arms to the length of the stick. It was completely ordinary at first glance – not even straight, slightly bent in places – but upon closer inspection, there were markings at set distances that indicated specific measurements – ½ *gaz*, ¼ *gaz*, and so on (Figures 2 and 3).

The stick was smooth and cold to touch, made of a dark metal, maybe iron or lead. It was lightweight, as expected, since it would have had to be manoeuvered through layers and layers of fabric quickly.

'I haven't ever used it. All I know is that it is the only thing of his that remains from his childhood and our time in Lahore'.

'Did they bring these with them at the time of the Partition?' I asked.

"No, though these things are from Pakistan, we were already in Delhi at the time. We saw what happened in the old parts of the city, but were lucky to not have to cross the border in 1947. Who knows what people brought with them when they moved, *beta*. From what we have heard, they took what they could, but most of the time even those objects didn't survive the journey."

Seated on a low sofa, he placed both his hands on his knees and continued.

**Figure 1.** The *ghara* used to make *lassi*.

"If you were a refugee crossing the border, there were many, many difficulties at every step of the way. So from what we saw, people usually came with nothing, infiltrating into Delhi everyday. They staggered in with their clothes barely covering their bodies, their families barely alive, looking for any means to survive."

I nodded, thinking immediately to the photos I had seen and the books I had read about the Partition.

'But these things', he said, looking at the vessel and the yardstick, 'These things belong to my parents. They are from before the Partition.'

We surround ourselves with things and put parts of ourselves into them; they possess the ability to retain memory, to preserve the past and to a certain extent, keep alive those who have passed. Material memory works in mysterious ways; it envelops itself into our surroundings, it seeps into our years, it remains quiet – accumulating the past like layers of dust – and manifests itself in the most unlikely scenarios, generations later.

*Partition*, he had said. The event that had broken, had divided our history, our people into two: Pre and post-Partition.

Grandparents told tales of a time that India and Pakistan were one. They spoke of large houses, joint families, religious unity, carefree childhoods and a general sense of nonchalance towards the government: *pre-Partition*.

They told tales of a time that refugees swarmed in and out of the nation, homeless, unsure of their futures in their newly adopted habitat. They spoke of riots and the unimaginable horror of Hindus and Muslims slaughtering each other, of fires, civil war, religious disparity and displacement, poverty, squalor, refugee camps and rehabilitation centres: *post-Partition*.

The very weight of the word, the way it sounded as I said it out loud, how I enunciated its every syllable with clarity and care in a way that had been subconsciously ingrained

**Figure 2.** Standing with the *gaz*.

within me, how I used it with an almost extreme fragility, considering at all times its innate heaviness in the context of the Indian subcontinent – what it meant to be Indian, to be Pakistani, to be Bangladeshi – the entire concept of a cultural identity enveloped within a single event, a single word: Partition.

\*\*\*

For weeks I had thought of nothing else. I couldn't help but wonder about the people that had been displaced during the Partition. I knew that each of my grandparents was originally from what became Pakistan, but I had almost always, for some reason, simply grazed over this fact with a detached perspective. Never probing any of them for details, never even wondering how we got to where we were today. In turn, they too had never narrated any

**Figure 3.** A quick lesson in how the *gaz* was once used.

tales of their childhood – no stories of growing up, of their homes or villages, and most important, no testimony of having crossed the border into independent India.

My knowledge of their journey as refugees during the Partition was for the most part, shrouded in a silence they never acknowledged and until now, I never concerned myself with.

But my experience with the *gaz* and *ghara* led me to begin thinking more and more of the refugees that had travelled across the border with the expectation of a better future – Hindus and Sikhs to India, Muslims to Pakistan. I considered their plight and their conditions, piecing together details from books, films and photographs of the time.

I thought about what they brought with them; the objects that became their companions, ranging from household items to precious heirlooms. If those objects still survived today, they might seem mundane or banal to subsequent generations, but they would be a physical and aching reminder of a true home, of family, a feeling of belonging. They'd

be a reservoir for memory. The physical weight of the object would be outweighed by the emotional weight invested into it over the years. It would, in a way, occupy the weight of the past.

Furthermore, I thought about the silences that accompanied the event. The memories of the Partition were deep-seeded wounds buried for far too long. Feelings of grief, pain, displacement and shame had created a thick film over any recollection of 1947. It had led those who experienced it to feel like victims of displacement; it had fractured community and sense of belonging. Therefore, any conversation around it was shunned from society, avoided in the everyday and for the most part, swept out to the periphery.

The inability to talk about the event, and moreover, the disinterest from subsequent generations to understand and appreciate the sacrifices made of the part of their ancestors, had led the memories of Partition to recede into the pages of history and academia.

And so, to study the Partition, and by extension the memories and experiences of those who crossed the border, through material remnants would in a way be to remove – if only temporarily – the individual and to talk of only the objects they carried. The object would become the catalyst for narration of memory.

At the same time though, I thought of my grand-uncle and his relationship to their parents' belongings. I realized that the Partition wasn't just about those that crossed the border, but also about those that remained behind. In some ways, physical displacement was just one aspect of the event.

It was in fact, multi-layered – emotional displacement, loss, violence, a strange sense of beginning again and perhaps even in some cases, hope.

It affected even those that never moved and never had to. It affected those who had no harm done to their family in any way. It consumed even their lives because they had *remained* amidst the chaos. They too had seen the riots, the violence, the disorder, but from a different perspective. They had prevailed, successful in keeping their families together amidst the chaos of independence.

In considering the paraphernalia of the Partition, what became increasingly important now was not just the objects that were taken by refugees, but also those that had remained fixed in their place throughout the divide. In totality, I became interested in artifacts of old: objects and people that had outlived this colossal historical event and continued to exist in the present.

\*\*\*

And so weeks later, I found myself at the doorstep of the old house in Roop Nagar once again, this time alone.

I sat with my grand-uncle and his wife in the oldest wing of the house, the part that had never been renovated. It was as though everything had remained the same since its original construction. I looked around at all the nuances that, much like the *ghara* and the *gaz*, had stood the test of time. The house, like the objects, was infused with memory.

The simple wooden door with its vintage metal latch, the archaic electric switchboard, the walls that now rejected newer coats of paint, the stone floors with old fashioned tiles, the round bathroom mirror encased in a square wooden frame attached to a completely decrepit shelf upon which lay a pair of toothbrushes, and a sink beneath it with the original faucets, now obsolete in design (Figure 4).

**Figure 4.** Fragments of the old house in Roop Nagar.

But the most endearing section, though now significantly smaller in size due to the construction of additional rooms in the adjoining quarters, was the large open *aangan* – a courtyard – at the back of the house where we sat that afternoon. Sunlight spilled in generously, its deep yellow creating a stark contrast with the cool grey stone floors.

Returning to the house after many weeks made me acutely aware of two things: First, how though everything was exactly how it had always been, it seemed suddenly new to me, as though I were seeing every object for the very first time through the eyes of discoverer. There were nuances on every surface that I had somehow missed in the two and half decades of my visits here. The *verandah* seemed to hold within it the subtle yet delightful weight of an undiscovered secret … it all seemed much more intriguing than it had ever been. The discovery of the *gaz* and *ghara* seemed to be stepping stones into a world of unearthed memory that lived within the walls.

Second, it was not really the house that was different. In fact, it was exceptionally unchanged and ordinary. The beauty lay in the fact that *I* was different, my thoughts, my preoccupations were somehow different. All the time I had spent in thinking go of the past, of objects that remained and memories that lingered, had made me look at everything around me differently.

The house became altogether familiar yet foreign, holding suddenly the potential for so much discovery.

As we sat under Delhi's crisp winter sun, the couple spoke to me about a time that once was. He spoke first, his wife listening as intently. He talked slowly, laying emphasis on certain things, speaking mostly in English but pronouncing words the Punjabi way – *roits* instead of riots, *maiyer* instead of measure. I collected these little details; looked out for them in his speech, for these small nuances were the things that built his essence, his character.

"I was born in 1930 in Lahore, which is now in Pakistan. Both my parents grew up in Lahore. My mother went back to my grandmother's house for her delivery, as was the custom then, and so I was born in Lahore. My father's family left Lahore for Amritsar when he was a teenager. When he was 20 years old, they moved to Nairobi for a few years. I think there was a very large Indian population there at the time, so he moved there in search of employment. But during his stay there, he noticed the community was full of drunkards and smokers. Since he did neither, the people made him uncomfortable and he moved back to Amritsar. Upon his return, he began a jewellery business with three other partners."

*Pad-ner*, he said.

So subtle, so inherently Punjabi.

'How come he didn't join his father's clothing business? That's what your family used to do in Lahore, right?' I gestured towards the yard-stick in the corner.

"I don't know. He just chose to work with his friends. They began Bratha-ji Jewellers in 1932. They first opened a store in Amritsar, then here in Chandni Chowk in Delhi, and one in Bombay – three in all. The neighbouring shop owners in Chandni Chowk told us our store wouldn't survive here. They didn't like the competition; they were all anti-Punjabi, you see. I remember them say to us, '*Tumhe toh phook maar ke bhaga denge*.'"

He laughed jovially and held out his palm in front of his mouth and blew, demonstrating what the shopkeepers had said – that they would blow their business away in no time!

'What do you mean, they didn't like Punjabis? What were the other shopkeepers around you?' I asked.

"They were Hindu, from Delhi. They spoke Hindustani. We were from Amristar in Punjab. We spoke Punjabi. They were anti anyone who was not from here, anyone that posed as a potential threat or competition to their business. At that time, there were not so many Punjabis in Delhi. It was like when you make *roti*, you add a pinch of salt to the dough. At the time, the number of Punjabis in Delhi was like that pinch of salt – barely there."

'But that all changed when the Partition happened ...' I began.

'Oh, yes. Millions of Punajbi refugees infiltrated the capital then. The shop owners disliked them the most. The Punjabis are enterprising people, you see. They flooded into the country with nothing; no job, no future, no money. But everyone has got to eat and feed their families in some way. So they did whatever they could to survive.

They took the monopoly of trade away from the original shopkeepers, they posed as competition and most of the times, they even sold their goods at a cheaper price, at cost price, never making a profit but earning just enough to keep their families alive. They would sell items on the streets, in trains, on bicycles, however they could. They were relentlessly hardworking, a quality that Punjabis have managed to retain even today'.

His wife, a short timid woman with grey hair tied into a neat bun, now spoke.

'My uncle's family came to Delhi from Pakistan during the days of the Partition and had to stay in a hotel for a week before they could board a train to Amritsar, where they had chosen to live. One day, my uncle, a young boy at the time, went out to get food for everyone. When he got to the stall, he saw someone else was also buying lunch. Extending his money, he placed his order. The shopkeeper told him lunch was over, that there was no more food.

'*What do you mean there is no more food?*' he said, '*I am paying for it.*'

The shopkeeper gave him a nasty look and said, 'Go away! You don't belong here. You've run away from your country and now ...'

He didn't even have a chance to finish, since my uncle grabbed him by the collar and pulled him into the street.

"We don't belong here?? What do you mean – run away? We eat anything we can get because we need to survive. We even eat your bad grains, spoilt food because we need to live – we have nothing. Rather than helping us, you are telling us to go back where we came from? Go back to the riots, the violence? You don't give us food, in fact you increase the prices to make a profit when we buy anything. Do we complain? No, because we are dependent on you for survival right now. We are just like any other customer … we make money where we can and buy your goods just like any other customer and still, you curse us?"

My uncle was livid, he let go of the man's collar and left him in the middle of the street'. She sighed.

'It *was* really like that …' *nana* added, 'refugee or no refugee – Delhi wasn't always kind to those that weren't from here …'

'But your father's business, it survived?' I asked.

"Oh yes! Regardless of what the other shopkeepers said, our business grew! We fast became North India's leading jewellers. My father transferred to Delhi and the partner from Delhi moved to Amritsar in 1943. They had a very clever strategy that made them number one," he chucked to himself.

"They employed two Muslim painters to advertise the store on every possible wall surface they could find, beginning in Delhi and slowly making their way south till Bombay and west till Peshawar. Remember this was pre-Partition and the country was still one, so it was easy. We paid these painters two rupees per day and their meals were free."

'How much was two rupees in 1943?' I asked, wondering what one could buy with that sum now. Candy? A piece of chewing gum?

'*Oho!* In those days two rupees was plenty! Probably the equivalent of about 200 rupees now! You would get a *tolah* of gold, which is about 11.6 grams, for 20 rupees. Today, that would probably be worth over 40,000 rupees!

Anyway, we would pay these men to paint on any surface they saw – houses, offices, sometimes even cremation grounds – Bratha Ji Jewellers – Amristar. Delhi. Bombay. This guerilla advertising worked. It made us very popular all over India. Even I sat in the shop in Chandni Chowk every day after school.

We used to have the most beautiful designs as we would get them made from various cities – some from Jaipur, some from Madras, some from Bombay … so they would be new, different from local designs. Anytime someone tried to copy our designs, we would just stop selling them altogether and get new ones. But one thing was for sure, the price would be always be fixed! Just like the Bata Shoe Company-fixed prices always, all over India with no exceptions!'

He laughed at his own joke.

The open verandah let in the noise from the street – faint sounds of horns, fast footfalls of children running in the paved lane behind the house. There we were, sitting in the age-old family mansion, a *haveli* – *Vij Bhawan*, they called it, no ceiling above our heads, just the warm golden rays of the sun filling the space. Home!

'So where did you live when you moved to Delhi from Amristar?' I asked.

'Mori Gate, on Nicholson Road. Close to Kashmere Gate. We lived there until this house was built in 1955'.

'What kind of neighbourhood was it then? Was it affected during the Partition?' I asked. Mori Gate stood erect even today, an ever-prominent part of the old city.

'It was a predominantly Muslim neighbourhood with the exception of a few families. During the Partition, everyone – Hindus, Muslims, Sikhs – were scared. The riots broke out all over old Delhi. Our neighbours asked us to help them and of course, we agreed because they were all innocent people, just like us. They were our friends, we saw them every day. We told them that we wouldn't let anything happen to them but eventually, they moved to Pakistan anyway ... maybe for a better future.

There were announcements made informing people of the Partition. But one could tell in August 1947 that the *mohaal*, the atmosphere, was not okay. We heard stories about trains coming in and going out of Old Delhi Railway Station laden with dead bodies and injured passengers. We were told to stay inside our houses. Every day we saw new inhabitants in abandoned houses of our Muslim neighbours.

I remember, there was a middle-aged Sikh man who had come to visit his daughter in Mori Gate and amidst the riots, he decided to go back to his home in Punjab. Everyone told him not to go, that it was too dangerous, that there would be no trains, but he did not listen. He packed his bags, walked out about 200 *gaz* from the lane and asked a rickshaw driver to take him to the railway station. The driver, who happened to be Muslim, stuck a knife into his passenger's chest. Though middle aged, the Sikh man was significantly stronger and managed to throw the young driver off the rickshaw and ride it back into the lane till he reached his daughter's house. As he made it to the door, we saw him fall off the rickshaw into a lifeless pile on the ground'.

There was a long pause.

'My father told us that years before the Partition actually took place, there were rallies in Lahore with protestors yelling, *'Leh kar rahenge Pakistan!* We will take Pakistan!' and the city's Hindu residents would just laugh at the absurdity of the thought of the division of India.

Even after the divide happened, the people expected to stay where they were, continue to live in India or Pakistan, whichever side of the border they were from. They expected to continue to live there. No one anticipated what happened in 1947, no one was prepared for it and what followed. No one ever imagined the possibility of the communal hatred and conflict that eventually seized both nations'.

I nodded.

'*Nana*, what do you think would have happened if there wouldn't have been a Partition? How do you think today's world would be – India, Delhi, our family?'

"I don't know, *beta*. All I can say is that what happened was sad. Though it didn't affect our family personally and we were all safe, the consequences of Partition live till today. That is what makes me feel bad. But what is done, is done. And, Delhi ... Delhi has truly evolved, it has changed so much since I moved here in 1943. Life is faster, technology has changed the world. Delhi is progressing, moving forward."

'Do you think we are moving forward too fast? That we are forgetting our culture, our history in that progress?'

'*We* are not forgetting! The children are!'

He laughed.

I found it sad as slowly I realized that perhaps my generation had forgotten how to remember. We had forgotten how to store in our minds the minor aspects of life – those

that bound us to others – secrets, feelings, memories. We didn't pay enough attention to our surroundings simply because we didn't need to. Times had changed, we had so many new gadgets to remember things for us, to record, to archive and arrange our everyday so systematically that our brain rarely had to exercise its powers of recollection towards the mundane.

I wondered what objects we would hold dear in the years to come, what items would come to consume our memories, what would remain of our lives and who would remember us by them.

I studied his kind face as he smiled widely.

"The world can change as much as it wants to, Delhi can progress and evolve and transform, and it will. But some things will always remain the same. Our family. We lived together then – first in Lahore, then in Amritsar, through the Partition in Delhi – and we live together even today. I am lucky that that has not changed till now."

I looked around the *verandah*. Surrounding me were antique walls and tradition. What he said was true. Now the patriarch of the Vij family, he was indeed a lucky man. Right now, sitting before me with his wife under the resplendent glory of the Delhi's winter sun and memories of a lifetime, was a lucky man. His family lived together, still. Such a simple idea that he and his brothers were able to stay together, but one that brought him peace, solace and made him feel fortunate.

The memory and legacy of their parents had lived on in Vij Bhawan, just as it had lived on – accumulated, endured – in the *gaz* and the *ghara*.

Memory is a powerful thing. It is precious; it is generational. The memory of something lives on long after it has died, and through it, we keep our past alive. It seeps seamlessly through generations and finds itself in children and grandchildren in the form of awe, remorse, sorrow, spite or wonderment.

Such an endearing and important thing it was to realize how in their own ways, decades after independence, those that witnessed the partition, despite all their silence, had preserved their homes, their childhoods, their sense of belonging. And strangely, how the smallest of objects could contain this heaviness of their experiences, this weight of their past.

## Disclosure statement

No potential conflict of interest was reported by the author.

# Tamil comics: new media, revival, and the recovery of history

Swarnavel Eswaran Pillai

**ABSTRACT**

This essay focuses on the revival of Tamil comics mainly through a community of ardent fans and/or collectors during the last four years, by analyzing the blog by S. Vijayan, http://lion-muthucomics.blogspot. com, presently the editor of *Lion and Muthu Comics*. His father M. Soudrapandian founded *Muthu Comics* in 1971 which revolutionized the circulation of comics in Tamil Nadu and among the Tamil-speaking population in India and abroad. Most of the stories published were translations of the popular European ones, and several characters like The Spider, Tex Willer, and Lucky Luke became familiar names in Tamil households, the most popular being *Irumbukkai Mayaavi* or Steel Claw. However with the advent and ubiquity of cable channels and video, 1980s saw a drastic fall in the circulation of Tamil comics. This essay analyzes Vijayan's blog along with that of his peers to explicate how the internet and social networking sites have revived interest among fans leading to the reprints of old issues and the publication of new ones on a monthly basis from Vijayan's Company in Sivakasi, a small town in South India.

This essay details the revival of Tamil comics, particularly during the last six years, through the networking of avid fans and a preeminent publisher by means of their blogs. Such a revivification, made possible by the development and expansion of the internet and social networking sites, particularly of blogs which facilitate easier uploads of scanned pages from books and interactivity between the writer and the reader through immediate responses, has been mainly responsible for the resurgence of Tamil comics. The publication of Tamil comics dwindled from the 1990s onwards, mainly because of the advent and popularity of cable television channels and satellite broadcasting facilities which weaned away a vast majority of the regular comic readers to the television programs and serials that were based on animation. Many of these programs were imported from the West and were occasionally dubbed in Hindi and other regional languages.

After drawing attention to the renewed interest in Tamil comics mainly through the blogs of its chief publisher S. Vijayan of Lion-Muthu Comics, and the interactivity and the collaboration of its fans and bloggers, like the preeminent Muthufan and King Viswa, this essay will briefly sketch the history of Tamil comics through the contribution of three of

This article was originally published with errors. This version has been amended. Please see Erratum (http://dx.doi.org/10. 1080/14746689.2017.1280960).

its iconic figures, Soundarapandian, Vandumama, and Mullai Thangarasan, to argue for these three artists as the artists/publishers singularly responsible for the development and popularity of Tamil comics over the last five decades.[1]

## Vijayan's blog and the revitalization of the Tamil comic scene

The turn of the millennium saw interest among readers and consumers of Tamil comics dwindle sharply, leading to the discontinuity and long intervals in the publication of comic books by its preeminent publisher, the Lion-Muthu Comics group, and to the gradual decline and closure of its rival Thanthi Publications' *Rani Comics* in 2005. *India Today* (the Tamil edition) carries an article on the state of Tamil comics industry in 2003, and sheds light on the bleak state of affairs on the comic book front. Vijayan, though enthusiastic about the 'mega' issue of comics he is about to publish, attests to the 'discouraging situation' as far as Tamil comics are concerned.[2] K. Muralidharan, the author of the article, draws comparison between the situation of publishers in Tamil Nadu and the West: unlike here in Tamil Nadu, Rene Goscinny and Albert Uderzo, the creators of Asterix and Obelix, could buy an island from their income.[3] Nonetheless, Vijayan seems hopeful about the future as he predicts that the 'trend' will change when the audience shift their attention from (the monotony of) television to comics in the future.[4]

## Muthufan and King Viswa: blogging and the recovery of history

Muthfan started writing exclusively on Tamil comics by hosting his own websites like *Muthufan.tripod.com* and *MuthufanOcatch.com* between 2001 and 2005, before starting his popular blog-site (*Muthufanblogspot.com*) from 14 September 2008, as he found 'little or no encouragement' from the fans for his earlier websites.[5] He reasons his earlier infrequent updates to the difficulty in maintaining a website in Tamil because for adding information he had 'to edit the whole page or site, to upload the info, "cause the whole thing is in Tamil (and, therefore, it has to be edited using a Tamil editor), which is time consuming."'[6] However, blogs made uploading of information and scanned covers/pages of old comic books easy, befitting the schedule of a busy but unorganized software engineer like him.[7] This explains why the resurgence of Tamil comics is quite recent as blogging is a relatively new phenomenon when compared to the hosting of sites on the internet. Muthufan's entry into blogging in 2008 was followed by King Viswa the next year, leading to Vijayan's entry in 2011. The last eight years, thus, could be termed as one of the most productive period in the history of Tamil comics in terms of discussion and dissemination. For instance, Vijayan started the 'Comics Classic' series in 1999 to reprint the old classics from the Muthu-Lion archive, but his efforts have picked up momentum during the last three years only.[8]

Certainly, Muthufan's efforts have been instrumental in reinvigorating Tamil comics by arousing the interest of fans, collectors, and readers as explicated by other popular bloggers like King Viswa, Dr. Sevan, Rafiq, Ayyampalayam Venkateswaran, and Haja Ismail who, like him, now have blogs devoted exclusively to Tamil comics. Muthufan's blog, with its appeal to nostalgia in recovering the history of Muthu comics, as exemplified by the uploading of the cover of *Muthu Comics*' rare inaugural issue (January 1972), has been seminal, particularly in its influence on the most prolific and arguably the most committed blogger/writer on Tamil comics, King Viswa, who followed suit, by tracing and recording its lesser known history (Figure 1).[9]

**Figure 1.** Irumbukkai Mayavi (Courtesy: King Viswa).

As a female hero Modesty's place in the annals of Tamil comics is unparalleled: not only her comic books are in demand and reprinted by the Lion-Muthu group till this day, but renamed as 'Modesthi Blaise,' she had also been one of the main attractions of their competitor *Rani Comics*, apart from Phantom and James Bond. Vijayan informs us of the special demand for the Modesty Blaise narratives, particularly from the female Tamil comic fans, and how it has propelled him to publish a very recent edition ('Nizhalodu Nija Yudham (Face-off with Shadows),' January 2015) on her despite the very high cost of paying in 'pound sterling' which keeps steeply rising in its exchange rate with the Indian rupee. Besides, he has to toil with his team to assemble and convert a number of newspaper comic strips to a comic book, particularly in the modification of 'the edges that have to be painstakingly redrawn.' (Figure 2)[10]

In this context, King Viswa's observation regarding the differences in the recycling of Modesty Blaise's narratives for the Tamil comic readers is illuminating. In his blog, he discusses 'The Green Eyed Monster,' the 19th comic strip in the 96-part Modesty Blaise series, in detail: *Lion Comics* renamed 'The Green Eyed Monster' as 'Kanagathil Kannamoochi (Hide and seek in the forest),' and *Rani Comics* as 'Vairakkan Paambu (The diamond-eyed Snake),' for their Tamil versions. However, Viswa points to the centrality of translation in the 'understanding' and 'the success or failure' of a narrative imported from 'a foreign country': a significant aspect of the Modesty Blaise narrative is the relationship between Modesty

**Figure 2.** Modesty Blaise (Courtesy: King Viswa).

and (her sidekick) Willie Garvin which is that of deep and profound friendship, whereas *Rani Comics* by portraying them as predictable lovers made their relationship tame and the narrative dull. Similarly, while adapting the Belgian Thorgal for the Tamil audience, his wife Aaricia was transformed into his younger sister. According to Viswa, 'it indicates the (in)sensitivity of the translator,' and takes away the narrative pleasure for the average reader who does not have access to the original.[11] Nonetheless, King Viswa credits the Thanthi Group for publishing their bimonthly *Rani Comics* on time, unlike *Muthu Comics*, and at an affordable price for 19 years from 1984 onwards.[12]

It would be productive at this point to briefly discuss the preeminent artists of the Tamil comic industry who were sensitive to the cultural specificity of their readers but, unlike the translator mentioned above, refused to be presumptively conventional or conservative in their attempts to tread a new path.

## The trinity of Tamil comics

According to King Viswa, who has been involved in a detailed research 'on the history and the evolution of Tamil comics' over the last six years, apart from the pioneer Soundarapandian, the founder-editor of Tamil's longest running *Muthu Comics* detailed above, Vandumama (pronounced as Vaandumaama) and Mullai Thangarasan are the other two iconic figures without whom any history of Tamil comic books will be incomplete.[13] Therefore, discussing about Vandumama and Mullai Thangarasan is in order here.

V. Krishnamurthy, who wrote under the pseudonym of Vandumama, is acclaimed as a trailblazer of children's literature in Tamil by the prolific and informed blogger on Tamil comics, Ayyampalayam Venkateswaran.[14] He details Vandumama's contribution through the children's magazine *Poondhalir* (Tender Shoots) wherein one-third of each issue was devoted to picture-based stories, and argues for Vandumama as being responsible for initiating the vast majority of Tamil readers into comics.[15] Paico, the publishers of *Poompatta* (Butterfly), the popular children's magazine in Malayalam, started *Poondhalir* on 1 October 1984. During that period, there was an abundance of chidren's magazines: nine in Malayalam, and the popular *Ratnabala, Balamitra, Ambulimama, Gokulam, Pappa,* and *Manjari* in Tamil.

Since Paico entered into an agreement with India Book House, the publisher of arguably India's most famous comic book, *Amar Chitra Katha*, Vandumama could translate and often reinvent many of the famous characters. These characters had already become popular through India Book House's other famous children's magazine *Tinkle*, which had 67 issues published before *Poondhalir* was launched, thus giving Vandumama rich reserves to draw from. Nonetheless, *Poondhalir*'s most famous character Kapish originated from *Rang Rekha Features* from the Indian comic icon Anant Pai's pioneering Comic and Cartoon Syndicate.[16] Tinkle's Kalia became Kakkai Kaali (Crow Kaali) in *Poondhalir*; the simpleton Suppandi was retained at times as Suppandi in the Tamil version as his origins was from Chennai, as exemplified by Vandumama's 'Suppandiyin Sagasam (Suppandi's Adventures),' but metamorphosed into Annasami during other occasions[17]; and Shikari Shambu (Hunter Shambu) was transformed into Vettaikkaara Vembu (Hunter Vembu).[18] The translation and the renaming of characters in the Tamil comic world were not only national but often international. For instance, the chubby Harish from the famous Kushiwali school, one of the final creations of Vandumama, recalls 'Billy Bunter' form *The Magnet*, the weekly boys' story paper from the UK (Figure 3).

Similarly, the other Tamil comic icon Thangarasan and artist Chellam localize a stereotypical technology-driven narrative about an evil scientist and a superhero with 'electrical' powers for a contemporary audience by positing the characters in the very familiar environment of the 'Udupi' (South Indian) Anjaneya hotel, with finger-sized men creeping over the arms of the chair, which is named after Lord Hanuman, the Hindu God who is the (mythical) son of wind. The juxtaposition of the ancient with the modern marks Thangarasan and Chellam's authorship, not only in the first panel but also the concluding one, both being full/splash pages: A very traditional family of four – mother, father, daughter, and son – are moving toward us, inattentive to the ordinary man (actually the superman Mayavi) alongside, who has restored the normalcy of their lives, just as the resourceful 'Bank of South' is sitting quietly next to the Queen's Hotel and the electric shop.

Chellam's drawings seem to swing Dr. Sathish toward a vivid recollection of Mullai Thangarasan and Chellam's collaboration through the Minnal Mayavi (the Lightning-like/ Fleeting Invisible Man) series, which was certainly designed to exploit the popularity of Irumbukkai Mayavi among Tamil comic readers. Though Dr. Sathish illustrates meticulously the pages 4, 5, 7, 8, 12, and 13 to substantiate his claims regarding the imitation of 'Lawrence and David stories,' and pages 20, 30, 53, 54, and the last page to prove that this Mayavi is just an offshoot of the original one published earlier by Muthu Comics, the very first response from reader Salim is in counterpoint.[19] He thanks Muthufan 'for this article on some rare gems though they may be imitations.' He expresses his surprise at 'such nice drawings' by Chellam. Salim, in fact defends Mullai Thangarasan, as he 'probably deserves partial credit

**Figure 3.** Kushiwali (Courtesy: King Viswa).

for coining the term Maayavi' and keeping 'our comics superstar' in circulation. Therefore, 'he had some right to use a variation of it.'[20]

## Moving into the future

In 2015, Vijayan published the Tamil version of Alejandro Jodorowsky's graphic novel *The Bouncer*, as 'Bouncer: Rauthiram Pazhagu (Bouncer: Practice Anger, Jan. 2015),' signaling Muthu Comics' foray into a new but related area. His expectations regarding the reception of the first volume of the Tamil version of the *Bouncer* was quite high as could be seen in his blog. However, the adverse responses from some of his demanding fans, draws an explanation from him in his post on 8 February 2015, wherein he points to the unreasonable comparison they have made with the (color) quality of the comic books released by him a year earlier in January 2014. He explains how one of his businesses is the buying and selling of the secondhand printing machines from the West, and how a high-quality printing machine, which he cannot afford, was with him waiting for a buyer, and the way it enabled the relatively higher quality of those books during that period, but at a formidable cost. Nevertheless, he is proud of his books published then and now as he knows he has done his best, and wants his readers to focus on the material in hand and to criticize discerningly.[21]

Even more important, is Vijayan's sensitivity as a comic publisher and his commitment toward the values of his highly diverse readers: not only does he use the speech balloon and the heightened sound effect to diffuse the gory effects of a rape (13) in the Tamil version and a brutal beheading scene (26), but also uses his experience as a translator for transforming the climax into a physical as well as philosophical experience. During the climax in *Bouncer* (Part 2, 59), when Ralton discovers the diamond, he says: 'She hid it in her Vagina. The Wily old bitch,' Vijayan, however, gives it a twist, by changing it to 'Vairaththai *thanakkulaeye* pathukki vaithirunthaal …/She hid the diamond inside herself…' (italics mine, 115), Thus, the desire (for diamond) leads to its source in more than one sense, opening up possibilities of multiple interpretations without changing the original narrative. Vijayan, thus, is a creative publisher, who symbolizes the hope for Tamil comics' future.[22]

## Notes

1. Muthufan (*Muthufanblog.blogspot.com*) was the first popular blogger on Tamil comics who started his entries on his blog on 12 October 2005, but his blogging has been irregular as he is a busy software engineer from Singapore who travels a lot. Thereafter, the major intervention was through King Viswa, who has played a major role in mobilizing the interest in Tamil comics around his popular blog Tamil Comics Ulagam/The world of Tamil comics (*Tamilcomicsulagam.blogspot.com*), from 14 September 2008 onwards. Viswa is also a serious historian of Tamil comics as exemplified by his painstaking and scholarly documentary on the origin and evolution of Tamil comics which has been in production from 2009 onwards. Prakash Publishers or the Lion-Muthu comics group, founded by the publisher/editor Soundarapandian, and now managed by his son S. Vijayan, at Sivakasi, a small town in South India, famous for its printing presses, is still active. This essay, therefore, will delineate the trajectory of Prakash Publishers which starts with the publication of Muthu comics in the 1970s and expands to include the Lion in the 1980s, and later its offshoots Mini-Lion, Junior Lion, and Thigil, particularly during the fecund years of 1986–1989, considered to be the 'golden period' of Tamil comics, wherein many of the popular titles were published. See Yuvakrishna (151) for details. Mayavi is pronounced as Mayaavi.
2. See Muralidharan (42) for details.
3. Muralidharan 43.
4. Muralidharan 44.
5. See: Muthufan (*Muthufanblog.blogspot.com*, 12 Oct. 2005) for a discussion on comics.
6. Ibid.
7. Muthufan also informs us of his 'casual blog style,' apart from the language as the 'the major difference' between his hosted sites and his blog: 'I'll not be posting anything in Tamil … It is too much of a hassle to do the typing in Tamil and hosting it as HTML.' He wonders whether 'this will make it more/less attractive!!!' See: Muthufan, Ibid. Whereas, King Viswa and most other bloggers seem comfortable blogging in both Tamil and English.
8. S. Vijayan, *Personal Interview*, ibid.
9. See: Muthufan, *Muthutripod.com*, Date n/a Mar. 2005, Accessed 31 Dec. 2014.
10. Vijayan also hints that 'the cost of the Modesty Blaise issues will be higher or the pages will be lesser than the usual.' S. Vijayan, *Lionmuthucomicsblogspot.com*, 28 Sept. 2014, Accessed 5 Jan. 2015.
11. See for details, King Viswa, *Tamilcomicsulagam.blogspot.com*, 19 Oct. 2014, Accessed 4 Jan. 2015.
12. King Viswa, Telephone Interview, 9 Feb. 2015.
13. *Personal interview* with King Viswa at Chennai on 6 Jan. 2015.
14. Ayyampalayam Venkateswaran (*Ayyampalayam.blogspot.com*, 9 June 2009) claims that it was Vandumama who changed the typical understanding of children's literature as limited to 'songs, puzzles, and short stories.' He proved through *Poondhalir* that children were attracted to

stories told through pictures. See for details, 'Comics Pookkal: Poondhalir Marakka Mudiyatha Siruvar Ethazh (Comics Flowers: The Unforgettable Children's Magazine Poondhalir).'

15. Ibid.
16. Ibid.
17. See, King Viswa (*Tamilcomicsulagam.blogspot.com*, 9 Mar. 2010) for details.
18. See Rafiq (*Comicology.in*, 25 Feb. 2009) for details on the brief history of *Tinkle*, and its influence on *Poondhalir*, particularly for the details on the recycling of its popular characters.
19. Rafiq, *Comicology.in*, 25 Feb. 2009.
20. Rafiq, *Comicology.in*, 25 Feb. 2009.
21. See for details, S. Vijayan (*Lionmuthucomicsblogspot.com*, 8 Feb. 2015).
22. See for details, Jodorowsky and Boucq, trans. Donague and Donague (11, 24, and [Part 2] 59); and Jodorowsky and Boucq, trans. S. Vijayan (13, 26, and 115) respectively.

## Disclosure statement

No potential conflict of interest was reported by the author.

## References

Eswaran Pillai, Swarnavel. "Traces of the Studio System: A Certain Tendency of the Tamil Cinema." *Madras Studios: Narrative, Genre, and Ideology in Tamil Cinema*. New Delhi: Sage Publications, 2015, 239–46. Print.

Iravukkazhugu Comics Rasigan (Nighthawk Comics Fan). "Comics Puthayal (Comics Treasure) XV-Mayajal Stories Collection." *Kittz.info*. Sept. 2012. Web. 23 Jan. 2015.

Ismail, Haja. "Engum Comics (Comics Anywhere): Viral Manithargal (Finger Sized Men) – Minnal Mayavi in Viral Manithargal (The Lightning-like Invisible Man in the Finger-sized Men)." *Hajatalks. bligspot.com*. 5 Mar. 2010. Web. 24 Dec. 2014.

Jodorowsky, Alejandro, and Francois Boucq. *Bouncer: The One Armed Gunslinger*. Trans. Quinn Donoghue and Katia Donoghue. Hollywood, CA: Humanoids, 2011. Print.

Jodorowsky, Alejandro, and Francois Boucq. "Bouncer: Rauthiram Pazhagu (Bouncer: Practice Anger)." *Lion Comics*. Trans. Quinn Donoghue and Katia Donoghue. Tamil Trans. S. Vijayan. Sivakasi: Prakash Publishers, 2015. Print.

Muralidharan K. "Tamilnadu Today – Chithiram Pesuthadi (Picture Speaks)." *India Today* 16 Apr. 2003: 42–4.

Muthufan. "April 2004 Updates: Muthu Comics History." *Muthutripod.com*. 16 Apr. 2004. Web. 31 Dec. 2014.

Muthufan. "Comics Patriya Oru Alasal (A Discussion on Comics): Wednesday, October 12, 2005." *Muthufanblog.blogspot.com*. Web. 4 Jan. 2015.

Muthufan. "Comics Patriya Oru Alasal (A Discussion on Tamil Comics): Friday, December 22, 2006." *Muthufanblog.blogspot.com*. 22 Dec. 2006. Web. 2 Jan. 2015.

Muthufan. "Comics Patriya Oru Alasal: (A Discussion on Tamil Comics): Tintin in Tamil)." *Muthufanblog.blogspot.com*. 3 Feb. 2006. Web. 2 Jan. 2015.

Muthufan. "Muthu Comics First Issue Cover." *Muthutripod.com*. Mar. 2005. Web. 31 Dec. 2014.

Muthufan. "Muthu Comics List 151 to Current." *Muthutripod.com*. 16 Apr. 2004. Web. 31 Dec. 2014.

Rafiq. "Tinkle: Kalia, Suppandi, Shikari Shambu." *Comicology.in*. 25 Feb. 2009. Web. 29 Jan. 2015.

Venkateswaran, Ayyampalayam. "Comics Pookkal: Poondhalir Marakka Mudiyatha Siruvar Ethazh (Comics Flowers: The Unforgettable Children's Magazine Poondhalir)." *Ayyampalayam.blogspot. com*. 9 June 2009. Web. 6 Jan. 2015.

Vijayan, S. "Editorial: Singathin Siru Vayathil (During Lion's Childhood)." In 2007 "Cowboy Special," Lion Comics, Issue No. 200, p 223. Muthufanblog.blogspot.com. 3 Feb. 2006. Web. 2 Jan. 2015.

Vijayan, S. Personal Interview. 5 Jan. 2015.

Vijayan, S. "Sunday, 8 February 2015: Ranamum … Kalmum (Bleeding … Wounds)." *Lionmuthucomicsblogspot.com*. 8 Feb. 2015. Accessed 9 Feb. 2015.

Vijayan, S. "Sunday, 11 January 2015: Puthu Puthu Arthangal (New Meanings)." *Lionmuthucomicsblogspot.com*. 11 Jan. 2015. Accessed 23 Jan. 2015.

Vijayan, S. "Sunday, 18 January 2015: 200…!!" *Lionmuthucomicsblogspot.com*. 18 Jan. 2015. Web. 23 Jan. 2015.

Vijayan, S. "Sunday 28 September 2014." *Lionmuthucomicsblogspot.com*. 28 Sept. 2014. Web. 5 Jan. 2015.

Vijayan, S. "Sunday 28 December 2014: Goodbye 2014 …!" *Lionmuthucomicsblogspot.com*. 28 Dec. 2014. Web. 2 Jan. 2015.

Vikram, V. Personal Interview. 5 Jan. 2015.

Viswa, King. "Advertisements in Comic Books: A Walk Down Memory Lane." *Tamilcomicsulagam. blogspot.com*. 5 Apr. 2009. Web. 2 Jan. 2015.

Viswa, King. "Chithirangalin Charithiram (History of the Pictures)." *Dinaethazh*. Chennai ed. 25 Jan. 2015.

Viswa, King. "Chithirakkathai Seithigal/Comic Book News (19 October 2014)." *Tamilcomicsulagam. blogspot.com*. 19 Oct. 2014. Web. 4 Jan. 2015.

Viswa, King. Personal Interview. 6 Jan. 2015.

Viswa, King. Telephone Interview. 9 Feb. 2015.

Viswa, King. "VanduMama (21 April 1925 – 12 June 2014) Vaandu thesathin Maamannar (Emperor of Vaandunation)." *Tamilcomicsulagam.blogspot.com*. 17 June 2014. Web. 2 Feb. 2015.

Viswa, King. "Vandu Mama: The Greatest Ever Story Teller for Children off All Ages – TCU Special Post." *Tamilcomicsulagam.blogspot.com*. 9 Mar. 2010. Web. 23 Dec. 2014.

Viswa, King. Video Interview. 7 Jan. 2015.

Yuvakrishna. "Irumbukkai Mayavi Ippothu Illai (The Invisible Man with the Steel Claw is No More)." *Dinakaran*. Deepavali Special Issue. 2014: 151.

# 'IMPOSTERS': an interview with graphic artist and designer Orijit Sen

E. Dawson Varughese

## Artist's statement

As a graphic artist and designer, I have always been interested in posters, particularly screen-printed posters. In some ways, the traditional printed poster is a marginalized form now – with the shrinking public spaces in our cities now dominated by large-scale, commercial digital printing; and with the Internet and social media having become the medium of choice for the delivery and consumption of announcements, publicity and propaganda of all kinds. Of course, posters continue to survive within certain specific contexts – such as at mainstream political rallies, or as part of the organizing efforts of social movements, or in college campuses. The very limitations of the old media – limited colours and tones, higher production costs and logistics of dissemination, etc. gave rise to graphic forms that were distinctive and beautiful. I am particularly fascinated by the ways that posters balance the need to grab attention with arresting graphics and type, and then draw the viewer into a more nuanced or layered exposition of the subject at hand. 'Imposters' explores the language of posters through a series of limited edition screen prints. Unlike conventional posters – such as announcements, which would usually speak to the future – these 'imposters' are retrospectively created, using full advantage of hindsight to investigate and play upon some of the influential events, people, cities and ideas of our time. In unpacking the iconic imagery of traditional poster art, these graphic renditions move between homage and spoof, between the real and the imaginary, between fiction and fact. Seen collectively, the images and texts on these posters also constitute a personal commentary on the many cultural and political histories we simultaneously strive to live with and live by.

**Orijit Sen 2016**

**Figure 1.** 'Imposters' by Orijit Sen.

**EDV: Orijit, in your 'imposters' series, you have taken iconic international figures as the muse for your poster art, why did you choose international personalities over solely Indian ones?**

**OS:** There was no reason for me to restrict myself to solely Indian figures. I was interested in the mixing of international and Indian poster iconography and texts because I found this offered a way of expressing a peculiarly Indian perspective of the world – while providing an opportunity to reflect back at the same time on Indian society and its conditions. I have always been inspired by the way the artists of the Shekhawati murals of Rajasthan, or the Kalighat pata painters of Bengal, freely played with imagery from a variety of sources – mixing graphic elements from European commercial art with motifs and scenes from Indian mythology and so on. I think of these as the beginnings of a very vital and energetic trend that emerged in various forms from the late1800s onwards in India, that carries on to the movies later – especially in the characterizations of villains and vamps, to music such as the Western pop and Indian folk blended compositions of R.D. Burman and others in the 1960s and 70s. The trend carries on today in the persona of someone like Ram Rahim Singh in his avatar of a rock star guru. From murals to calendar art to movies and music, examples of this trend abound in virtually every sphere of popular culture – once you really start looking for it. In this proclivity towards free borrowing and re-shaping, I see inherent qualities of appropriation and play, of subversion and protest. Such appropriations break away from the stiff tyranny of realism, logic and of contextual and social correctness – to fashion alternative meanings that resonate with the Indian imagination.

With Imposters, I was looking at icons that entered the Indian lexicon in various ways and contexts during the 1960s, 70s and later. Che Guevara and Karl Marx, for example, are well-known figures that regularly appear in political graffiti on walls of the left-leaning city

I was born in – Calcutta. Bruce Lee remains a demi-god style hero for many people in the northeastern states, and Bob Marley was recently the source of controversy when Kerala Police attempted to ban the sale of T-shirts featuring him smoking ganja.

For me, these figures are also interesting in another way: before each of them was international icons, Guevara was an Argentine, Marley a Jamaican, Bruce Lee of Chinese ancestry and Helen of Indo-Burmese-French descent. They grew out of their distinct and specific histories and geographies, and I chose them to be my allies in confounding simplistic, colonially determined binaries of Indian and Western, brown and white, traditional and modern, and so on.

**Figure 2.** Bob Mali.

**Figure 3.** Chai Guevara.

**EDV: What is so interesting to you about the 'in between' space of real and imaginary in these posters?**

OS: I want to spoof the stereotypes that are inevitably created around the propagation and denial of these people and their ideas, while also paying homage to them, and reflecting on who they really might be. I am interested in reviving their iconographies by adding new – hopefully thought provoking – layers, particularly for my Indian or India-centric viewers. I feel one way of doing that is by introducing some radical fiction to the mix of history and mythology that already exists around them.

At the same time, it's all very real. Let's take Chai Guevara for instance (see Figure 3, above). Che was real – everyone knows him, at least from books, movies and T-shirts. The chai walla is even more real – I drink at his tea stall everyday. They belong to different realities, but these realities may collide some day. Once, while watching the chai walla sweat over his pots and pans and glasses, the thought occurred to me that the next revolutionary could be this man – young, strong, daring – yet reduced to eking out a struggling migrant's life in a corner of the city. Perhaps one day, he will finally have had enough of corrupt municipal departments, bullying policemen and the rest of it, and rise up for justice. I'd like my comfortable middle-class viewers to consider that possibility for a moment. It is great to wear your hero on a T-shirt, or quote her on Facebook – but how would you feel if he showed up today in your neighbourhood? That's the question that hangs in the space between the real and the imaginary in these posters.

**EDV: In *Baba Marx* you bring together motifs of British pop culture, political thought and Hinduism. Is this a personally inspired collection of cultural artefacts or would you say that this combination speaks to a generation of Indians? Or other audiences..?**

**OS:** In a general sense, I would say this is partially answered in my response to your earlier questions. My works quote texts, names and metaphors that are drawn both from the real world we inhabit, and the imaginary ones we share as Indians and global citizens. So, while they may speak more resonantly to some, they are accessible to anyone who has a basic understanding of twentieth-century history and pop culture. At the same time, I ask for an effort – of the imagination, of observation, deduction and research – from both Indian and international viewers, if they wish to reach deeper into these images.

With Baba Marx (see Figure 4), I got a range of reactions. Some people were absolutely delighted to encounter this strange mix of references that seemed to make perfect sense together – including an influential Marxist writer and professor from New York. Others saw it as a portrayal of Communism as religion, and were offended. Still others felt I was mocking Hindu iconography. There were even a couple of reactions from John Lennon fans who didn't like the famous words of their 'peaceful dreamer' being associated with the ideas of a political theorist whose 'ideas have inspired much bloodshed'! Anyway, I'm very pleased that I managed to delight and anger so many different types of people at one go, and consider that fact a measure of the success of this piece!

**Figure 4.** Baba Marx.

**Figure 5.** Pahe Lee.

**EDV: Can you explain a little behind the craft of these works please. Which materials did you work with and how? Did you blend contemporary methods and older methods to achieve this 'look' of the posters? What was in your mind in terms of crafting these posters when you approached the work? And how long did you spend on producing the posters (in terms of 'making')?**

**OS:** Some of the works were originally created as a series of drawings on paper (on and off through the second half of 2013) and later adapted for screen printing, while the rest were done from the outset as artworks for screen printing (produced intensively through April and May 2014). I drew them on a Wacom Intous digital stylus and tablet for the most part. After preparing the colour-separated artworks, I worked with a screen-printing studio in Bangalore. This studio is among the last of its kind, where they still retain the skills and infrastructure to produce large sized multi-colour prints. Almost no one does this kind of work for commercial purposes anymore.

I was conscious of the textural and material qualities that are unique to screen printing, and attempted to highlight them through my choice of papers, inks and colours. As I have mentioned in my artist's statement about these works: 'The very limitations of the old media – limited colors and tones, higher production costs and logistics of dissemination etc., gave rise to graphic forms that were distinctive and beautiful'. I revisited and built upon the styles, techniques and tricks I had learnt as a graphic design student in the pre-digital era, to show-case this distinctiveness of screen printing. At the same time, I used the greater control and precision offered by digital media to produce more complex and precise colour separations. In one piece 'Love in the time of climate change', I was able to use specific digital tools to actually

achieve screen printed effects that would have been extremely laborious or even impossible with the older methods of artwork production. It was an experiment that turned out well, and I'm happy that I was able to employ the powers of digital technology in the service of an older hand skill-based printing process. I plan to explore this aspect further in the future.

I'd like to add that the unique look of the posters emerged purely from carefully crafted, high-quality execution, and had nothing to do with any artificially induced 'old' look or style. As an artist, I am not nostalgic about 'looks' that remind us of certain periods, but I value the skills, experimentation and knowledge that produced those styles.

**EDV: I'd like to explore the role of language in this series. You make the language work as part of these posters and aspects of language often appear as a linguistic 'imposter'. The language challenges the reception of these works beyond the artwork itself. How aware were you when you were making this series that language would play such a significant role?**

**Could you talk a little about the choice of font and style in terms of capturing the 'old' that you speak of in your artist's statement above? The coming-together of the Hindi script and the English script?**

**OS:** Many people in India are multi-lingual, and comfortably interpolate words, phrases and idioms from one language in another. I personally enjoy multi-lingual puns and word-play that produce new meanings by spanning different cultural and linguistic genres. Hence, I would say that the role of language is quite central and emphatic in Imposters. It is like the key that opens the lid on all the packed meanings and associations.

The origins of the first piece of this series provide an insight about the role of language, I think. I'll try to recollect it in detail: I was at a friend's house one evening in Delhi. He had just returned from Patiala in Punjab – where he had spent several weeks on a film project. We were smoking some rather high quality ganja (marijuana), which he had acquired in Patiala, so I asked him how he had managed to source such good stuff despite being an outsider to the town. 'Oh, we were put up at an old palace that had been converted into a hotel, and it had huge gardens around – which were tended by a team of malis (gardeners)' he said.

> So I thought that the best people to tell me about herbal intoxicants would be one of them. And of course, when I asked the head mali, he laughed and said that he grew some of the best ganja in Punjab himself!

Even as I laughed at my friend's little tale, I was struck by the idea of a ganja – smoking head mali, and exclaimed 'So you met Bob Mali!' Later, the thought stayed with me as I reflected on the various associations of 'mali' in India. In poetry and songs, the mali is often a metaphor for the spiritually awakened – as one who tends to the earth, takes devoted care of delicate things, produces order, beauty and fragrance through his work. On the other hand, a mali is also a member of the underclass – usually a landless labourer who looks after other people's lands. Those with no skills or education are well qualified to become malis, since all the expertise that the profession requires can be learnt on the job. Such musings on the 'valuelessness' of a figure that embodies such refined spiritual, ecological and aesthetic values led me to think about the politically constructed nature of valuation itself. And that's when I thought of Gandhi's famous, oft-repeated words: 'There is enough in the world for everyone's need but not for anyone's greed'. I remember laughing out loud when I realized that I would just have to replace the word 'need' with the everyday slang for marijuana – 'weed', to not just contextualize Bob Mali perfectly, but also puncture a hole in the balloons of all those politicians and world leaders who find it convenient to quote Gandhi, while carrying on with business of drilling for more oil or starting a new war!

So that's how I designed the multiple layers of language: the main Hindi – English combination pun on the name is the first layer, which sparks immediate recognition simultaneously with a major contextual rupture. The quotations in the speech balloons then tease out a secondary layer of meanings and associations, and at times I have included a third layer which is a comment upon the comment – such as Salvador Diwali's melting clock telling us that 'The time is ripe', which begs the question 'for what?' (see Figure 6) – or, in a more surreal sense, the visual suggestion that it is so ripe that it is rotting like a discarded banana peel.

The relationship between the images and words in Imposters is simple at first glance, but becomes complex when you look deeper. The body language of Bob Mali (see Figure 2) captures, for anyone who has spent time in India, the close-to-the-ground squatting posture that malis, labourers and impoverished rural people in general adopt. It is humble, even submissive. It speaks of a lifestyle that is unused to furniture and belongings and used to bosses and overlords. Predictably, he is wearing a simple lungi and a workman's shirt. But when combined with the upward tilt of his head, the assertive dreadlocks, the direct gaze and the self-confident laugh of Bob Marley himself, the figure begins to probe us and question our assumptions.

As for the style of the hand lettering, it is a hat-tip to the style that movie poster painters developed back in the day when such posters were usually hand-painted. These posters often spelt out the movie titles in Roman script as well as Devanagari or other Indian scripts, combining them in interesting ways – which is exactly what I was attempting with my posters. My lettering, however, also owes much to my training as a graphic designer – and all the ingrained lessons in the balance of negative and positive space, kerning, stroke weights, simplicity of font character etc. etc.!

**EDV: Orijit Sen, thank you.**

**Figure 6.** Salvador Diwali.

**Figure 7.** Helen of Bombay.

## Disclosure statement

No potential conflict of interest was reported by the author.

# Index

Note: *Italic* page numbers refer to figures and page numbers followed by "n" denote endnotes.

*ACK see Amar Chitra Katha (ACK)* comic series
Ahearn, Laura 19
Ahmad, Umera 63
Ahmedabad 6, 8, 10
Alawadhi, Hend 38, 44
Amanat, Sana 34, 38, 41
*Amar Chitra Katha (ACK)* comic series 2, 3, 37, 48, 102
Ambedkar, Bhimrao 49, 53
Ambedkar, B.R. 13, 49, 53
Amritsar 94, 97
Anderson, Perry 13
*Ankahi* serial 63
*Annihilation of Caste* (Ambedkar) 13
*Arab Comic Strips* (Douglas) 38
*Art and Multitude* (Negri) 10, 13
Arthique, Adrian 60
art market 11
*Aspiring to Home* (Mani) 36
*Aunn Zara* serial 63
The Avengers 45n1

Babar, Mughal emperor 54
Babri masjid (mosque) 54
Bannerjee, Sarnath 77
*The Barn Owl's Wondrous Capers* (Bannerjee) 77
Barthes, Roland 7
*Bashabandhan* journal 72
Behan, Teju 6, 8, 11–15
Bengali novels 74
Benjamin, Walter 16
Berlatsky, Noah 40
Bhatt, Vijay 52
Bhattacharya, Nabarun 71, 73
Bhattacharya, Spandan 3
Bhatti, Shaila 1
'bias crimes' legislation 33
Bose, Brinda 74
*The Bouncer* (Jodorowsky) 103, 104
Bourdieu, Pierre 10

Brahmanical projection 51
Brahminism 13
Brahmins 48–56
Brosius, Christiane 52
Budha, Kishore 61
Burman, R.D. 108
Butt, Osman Khalid 63

cable channels, rise and proliferation 19
Campbell, Eddie 48
*Carnival* (2012) 73
caste discrimination 14
Chakravarty, Prasanta 74
Chaney, Michael A. 50
Chatterjee, Shoma 62
Chaturvedi, Sanjay 60
*Combined and Uneven Development* 7
*Comics and Sequential Art* (Eisner) 77
*A Contract With God* (Eisner) 77
Coward, Rosalind 64
cross-racial identifications 3
cultural identity 90
cultural production field 10
'Culture is a Verb' (Street) 20

Dalits 48, 49, 54–7
'dancing skulls,' news *78*
Danvers, Carol 34
*darshan*, concept 1
'Death of Merit' 54
Delhi 86–97
*Delhi Calm* (Ghosh) 77
*Destiny: A Story in Pictures* (Nuckel) 77
*Dhoop Kinare* serial 63
*Discourse, Figure* 12
distant reading 7
domestic readership 2
'The Dotbusters' 32, 33
double entanglement 22
double marginality 3

Douglas, Allen 38
*Drawing from the City* 3; art, liberated labour
    8–11; drawing, multitude 11–14; figure and
    text, reading 6–16; girls with bicycles 8–11
*drishti*, concept 1

Edison, Thomas 32–3
*Ei mrityu upatyaka amar desh na* poem 71
Eisner, Will 77
electronic media 19
Escobar, Arturo 21
*Essentials of Hindutva* (Savarkar) 52
'an explosion is brewing within' *76*
expression, traditional forms 9

Freedom Defense Initiative 43
Freitag, S . 1, 2
*Fyataru/Fyatarun* 81, 84n17
Fyatarus 72

Gajarawala, Toral Jatin 14
Gandhi, M. K. 53, 113
*A Gardner in the Wasteland: Jotiba Phule's fight for
    Liberty* (Ninan and Natrajan) 47–9; alternate
    mythologies 50–2; history in 49–50; nationalism
    52–3; past and present 53–4; Savitribai, role 55;
    techniques of illustration 55–7
*gaz* 86–97
Geetha, V. 7, 9
'Genre Development in the Age of Markets and
    Nationalism' (Budha) 61
*ghara* 86–97
Ghatak, Ritwik 74
Ghosh, Vishwajyoti 77
Gilmore, Leigh 50
global capitalism 8, 13–15
Gold, Ann Grodzins 16n2
Golwalkar, M. S. 52
graphic autobiography 11, 12
graphic narratives 12; recounting few pages 81–4;
    speaking through 74, *76*, 76–81, *78*, *80*, *82*
graphics, of multitude 6–16
Grillo, R. D. 23
Guevara, Che 108, *110*
Guha, Ramchandra 48
*Gulamgiri* (Phule) 47–8, 50, 55
Gupta, Charu 66

Hall, Stuart 20–1, 26
haptic visuality 1
*Harappa Files* (Bannerjee) 77
Hardt, Michael 16n3
Helen of Bombay *115*
*Herbert* (Bhattacharya) 71–2, 74
hierarchical discrimination 13
hierarchy-based caste system 48
'Human rights and comics' (Smith) 47
*Humsafar* serial 63–5, 68n11

imposters 107–15
*India after Gandhi* (Guha) 48
India Book House 102
Indian teleserials, women's consuming images
    on 61–2
*India's Immortal Comic Books* (McClain) 37
*International Film Festival Rotterdam*, 41st
    (2012) 73
Irumbukkai Mayavi *100*
Ishtiaq, Farhat 63
Islamic Republic of Pakistan 18
Islamization, policy 18

Jaffrelot, Christophe 16n1
Jodorowsky, Alejandro 103
Jogi caste 7
Jogi performances 16n2
Jogi visual narrative 9
Johnson, Begum 79
joint family structure 87
Joshi, Manohar Sham 68n5
Junaid, Zaroon 63
*Justice League of America* 38

*Kahaani Ghar Ghar Ki* serial 62
Kali, Goddess 83
*Kangal Malsat* (Bhattacharya) 72–4, 77, 79;
    cover page of *76*
Kapoor, Ekta 62
*kavi sammelan* 72
*Khuda aur Mohabbat* 23, 24
Khurshid, Ayesha 26
Krishnamurthy, V. 102
Kushiwali school 102, *103*
*Kyunki Saas Bhi Kabhi Bahu Thi* serial 62

Lahore 86–97
Landis, Winona 3
Lee, Bruce 109, *112*
'less developed areas' 22
liberated labour 11
*Lion Comics* 100
'Love jihad' 69n14
Lyotard, Jean-François 12

Mackinnon, Catharine 21
McClain, Karline 37, 42
McCloud, Scout 77
McRobbie, Angela 20, 22
*Madman's Drum* (Ward) 77
Malhotra, Aanchal 4
Malti-Douglas, Fedwa 38
Mani, Bakirathi 36
Mankekar, Purnima 61, 68n2
Manto, Saadat Hasan 60
*Manusmriti* 49, 51
Marley, Bob *109*, 114; body language of 114
Marx, Karl 108, *111*

mass culture 20
material memory 89
Mathur, Saloni 9
*Maus* (Speigelman) 56
MDGs *see* Millennium Development Goals
    (MDGs)
media advertisements 27
memory 4, 89, 92, 97
Mernissi, Fatima 24
Millennium Development Goals (MDGs) 21
Millet, Kate 21–2
Modesty Blaise 100, *101*
Mohammad-Arif, Aminah 39
Moi, Toril 21–2
'Monster, Terrorist, Fag' (Rai and Puar) 39
Moretti, Franco 7
Morton, Stephen 16
*Ms. Marvel*: diasporic (dis)identification,
    participatory fandom 32–44
Mufti, Aamir 15
Mukherjee, Madhuja 4
Mukhopadhyay, Suman 72, 74, 79
multitude: *Drawing from the City* 11–14;
    graphics of 6–16
Muñoz, José Esteban 34
Al-Mutawa, Naif 38
'My Own Private India' 32

Nag, Anugyan 3
Napier, John 7
Narayanan, P . 2
Natrajan, Srividya 47, 50, 56
Negri, Antonio 10, 11, 13–14, 16n3
Ninan, Aparajita 47, 50, 55, 56
*The 99* (Al-Mutawa) 38, 39, 41
Nuckel, Otto 77
Nussbaum, Martha 21

OBC *see* other backward classes (OBC)
Omvedt, Gail 50, 52, 53
oral narratives 7, 9, 12
*Osian's Cinefan Film Festival* 84n7
other backward classes (OBC) 6, 10, 13,
    16n1, 54

Pai, Anant 48–9
Pakistan 87–90, 94, 96; cable channels in 18–19;
    development discourse and media 20–2; focus
    groups, data 25–7; literacy rates 19; media
    advertisements, images 27; research setting
    and methods 22–3; romance, courtship and
    sexuality 25; television fiction, women images
    in 23–5; theoretical insights 20–2; Valentine's
    Day, at public sector 19–20
Pardhan Gond art: commercialisation 9;
    movement 7
partition 87–92, 94, 96, 97; paraphernalia of 92
*Persepolis* 36

Phule, Jotiba 47, 49–55, 57
Pillai, Swarnavel 4
Pinney, Christopher 1
*Poondhalir* 102
post-9/11 contexts 39, 41
'Post 9/11 Shift s in Racial Formation'
    (Roshanravan) 39–40
poster iconography 108
post-partition 89
pre-partition 89, 95
Procter, James 8
Puar, Jasbir 39
Purakayastha, Anindya Sekhar 73
Purewal, Navtej 61

Radway, Janice 64
Rai, Amit 39
Rajasthan 6, 8, 10–11
Ranade, M. G. 52
*Rani Comics* 99–101
*Ra.One* (film) 1
*Reading New India: Post - Millennial Indian
    Fiction in English* (Varughese) 48
remnants, of separation 86–97
*River of Stories* (1994) 3
Roshanravan, Shireen 39–40, 42
Round, Julia 81
Roy, Abhijit 68
Roy, Arundhati 13
Rushdie, Salman 14

Sachs, Jeffrey 21
*Salaam America: South Asian Muslims in New
    York* (Mohammad-Arif) 39
Salvador Diwali *114*
Savarkar, V. D. 52–3
Schlund-Vials, Cathy 33
SDGs *see* Sustainable Development Goals
    (SDGs)
Selvam, Salai 7
Sen, Amartya 21
Sen, Mrinal 74
Sen, Orijit 2–4; interview with 107–15
Sengupta, Roshni 65
Shah, Haku 6, 9
*Shanti* serial 62, 68n7, 68n9
Sheik Abdullah 40
Sinha, Anubav 1
skill-based printing process 113
Smith, Sidonie 47
South Asian diasporic population 32
*Soviet Desh* magazine 71
Spiegelman, Art 56
Stein, Joel 32, 33, 44
stereotypes 65–7
subaltern aesthetics 14
Sustainable Development Goals (SDGs) 21
*Swabhimaan* serial 62

Tahir, Sabaa 38, 45n4
Tamil comics 98–9, 104n1; Muthufan and King Viswa 99–101; trinity of 101–3; Vijayan's blog and revitalization of 99, 103
*Tanhaiyaan* serial 63
Tara Books 6
television fiction, women Images in 23–5
Thornham, Sue 64
Tilak, Bal Gangadhar 52
*Time Magazine* 32
traditional printed poster 107

*Understanding Comics* (McCloud) 77
*Uraan* 3, 23–5

Valentine's Day 19–20, 29n1
valuelessness 113
Varma, Rashmi 9
Varughese, Emma Dawson 4, 48
Venkateswaran, Ayyampalayam 104n14
VHP *see* Vishva Hindu Parishad (VHP)
Vishva Hindu Parishad (VHP) 52
visuality, role 1, 2
visual narrative 7, 12

visual realm 1
Viswa, King 101

Wacom Intous digital stylus 112
*'Waqt Ne Kiya Kya Haseen Sitam'* serial 66
*War Cry of the Beggars* 4
Ward, Lynd 77
War on Terror 39
Warwick Research Collective 7
Weedon, Chris 21–2
'Why Does Marvel's Reboot Succeed?' (Tahir) 38
Williams, Raymond 20
Willis, Paul 20
Wilson, G. Willow 34, 41, 42
Witek, Joseph 48, 55, 56
Wolf, Gita 7, 9
Woolf, Virginia 21–2
world literary space 7

*Zindagi Gulzar Hai* (ZGH) 60–1, 64, 66; contemporary period of Indian television 62–5; religion and nationality 65–7
Zubair, Shirin 3

Printed and bound by CPI Group (UK) Ltd, Croydon, CR0 4YY

23/10/2024

01778253-0005